THE ENDLESS ENIGMA
DALÍ AND THE MAGICIANS OF MULTIPLE MEANING

MUSEUM KUNST PALAST, DÜSSELDORF

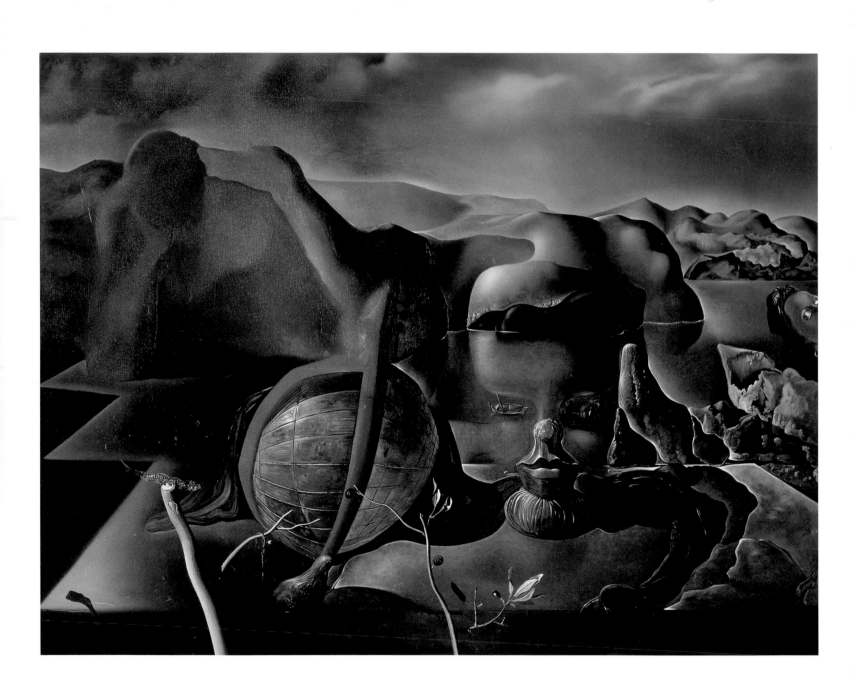

THE ENDLESS ENIGMA
DALÍ AND THE MAGICIANS OF MULTIPLE MEANING

JEAN-HUBERT MARTIN

STEPHAN ANDREAE

IN COOPERATION WITH

UTA HUSMEIER

museum kunst palast

HATJE CANTZ PUBLISHERS

CONTENTS

FOREWORD

The older style of art history did not usually take double images or picture puzzles seriously. Many such works were produced during the Renaissance, but they were closely associated with the cabinets of curiosities. The formation of a classical canon of art pushed double images aside into the realm of popular art; they were considered mere curiosities. The artist Giuseppe Arcimboldo, for example, fell almost entirely into oblivion from the seventeenth to the nineteenth century.

The surrealists were the first to rediscover Arcimboldo and to explore realms of art that were considered peripheral. On the scholarly side it was Ernst H. Gombrich whose book *Art and Illusion*, published in 1960, made double images topical again. Gombrich was interested less in the classical themes of art history (he never wrote a single monograph on an artist) than in thematic contexts, especially in the relationship of art and psychology. He accepted art in its full range and variety, and he pushed it in an anthropological direction by concentrating on the processes that take place during viewing. It is characteristic that in this context the talk is not so much of art as of images, and the current discussion of art history as the study of visual culture takes up that thread.

It is not just the research disciplines that need to be expanded along Gombrich's lines; the cultures beyond Western Europe and North America have to be considered as equals. The Orient also has images where figures are composed of various motifs just as in the work of Arcimboldo. It would, of course, be interesting to know whether Arcimboldo was influenced by Arabic miniatures or whether his unmistakable creations may have influenced eastern artists. Is it always necessary, however, to assume a causal connection as soon as two similar forms arise? Might it not be that there is a repertoire of formal possibilities that people everywhere are exploiting to the same degree? Questions like these were already in the air in the exhibition *Magiciens de la terre* in Paris in 1989, and perhaps the "magicians of ambiguity" will provide another piece in the mosaic of a global understanding of art.

Proceeding from such ideas, I invited Stephan Andreae to be a guest curator and work with me to create an exhibition on the complex of themes related to ambiguity and double images. He developed a series of twelve sections that—corresponding to the images shown— "would permit a second level of observation: that of a path through a kind of enchanted forest." I would like to thank him for bringing this idea to life. My thanks are owed equally to the project director, Uta Husmeier, for her tireless commitment in driving the exhibition forward and for her many stimulating comments on its content. She also had a decisive role in the preparation of the catalog, in which task she was supported by Heidi Irmer, Dieter Scholz, and Andreas Zeising, and assisted by Alessia Mesirca. Corinna Gramatke and Dorothea Nutt mastered all the questions of transport and insurance, and we have Mattijs Visser to thank for the effective presentation of the works in the exhibition spaces.

Such a large and ambitious project can only be realized with the collaboration of many hands and heads. Thus I would like to thank all of the other participating colleagues and assistants from the museum kunst palast just as much as the artists and lenders who made their artworks available and the authors who provided texts. Our colleagues in the Kunst- und Ausstellungshalle der Bundesrepublik Deutschland in Bonn and many others assisted our task with many suggestions. I owe thanks in particular to Dawn Ades, Montse Aguer, John Berger, Elisabeth Bronfen, André Buchmann, Beverly Calté, Tony Cragg, Yasha David, Suzanne David, Barbara and Bruno Decharme, Robert Descharnes, Maria Anna Dewes, Claudia Dichter, Volkmar Enderlein, Hartmut-Ortwin Feistel, Marcel Fleiss, Ian Gibson, Vittorio Giulini, Claus-Peter Haase, Kay Heymer, Regina Hickmann, Hank Hine, Pontus Hulten, Wenzel Jacob, Jacqueline Jacqué, Yannick and Ben Jakober, William Jeffett, Hélène Joubert, Michael Kalmbach, Joseph Kiermeier-Debre, Peter Klaas, Susanne Kleine, Stefan Kraus, Joan Kropf, Milan Kunc, Jean-Jacques Lebel, Vera Linhartova, Catherine Loisel, Sven Ludwig, Brigitte Majlis, Raoul Marek, Karin von Maur, Abdelwahab Meddeb, Sigrid Metken, Herbert Molderings, Alessandra Mottola Molfino, Alain de Monbrison, Maria Müller-Scharek, Werner Nekes, Philippe Peltier, Antonio Pitxot i Soler, Barbara Räderscheidt, Markus Raetz, André Raffray, Thomas Rehbein, Hubert Ringwald, Karin Rührdanz, Sarkis, Adele Schlombs, Klaus

Schneider, Eva Thomkins, Nicolas Thomkins, Barbara Thumm, Lucien Treilhard, Konrad Vanja, and Susanne Zander.

Finally, I would especially like to thank E.ON AG, as the exclusive sponsor of the exhibition and a supporter of the museum kunst palast, as well as the City of Düsseldorf and the members of our board of trustees. Together they have made it possible to show an exhibition that fortuitously combines the museum's four main strengths: older art, high modernism, contemporary art, and non-Western art.

Jean-Hubert Martin
Director
museum kunst palast

SPONSOR'S FOREWORD

The exhibition *The Endless Enigma: Dalí and the Magicians of Multiple Meaning* is another highlight in the brief history of the museum kunst palast since its reopening in the fall of 2001. There are many indications that it will match the huge success of *Joan Miró: Snail Woman Flower Star.* That great display of works, with several of Miró's most important paintings and sculptures, resonated well beyond Düsseldorf and clearly underscored the significance that the museum kunst palast has regained in the world of art and exhibitions in North Rhine-Westphalia.

Now another highly ambitious exhibition concept has been realized. Some 250 works from a wide range of epochs and cultures give a clear impression of the ways in which such imaginative artists as Giuseppe Arcimboldo, M. C. Escher, Max Ernst, and René Magritte have played with human perception. Their fantastic and artificial play, filled with enigmas and ambiguities, always astounds and bewilders the viewer. This very bewilderment makes for unexpected insights into a reality that is sometimes far more ambiguous than it might seem at first glance. The viewer suddenly sees things in a new light—sees differently and sees more.

I am pleased that E.ON, as the main sponsor, was again able to play a not insignificant role in the preparation of such a brilliant exhibition, for which so many of the world's most illustrious museums have provided loans. That the "magic of ambiguity" is so evident here is thanks to a public-private partnership that will set new standards.

We are committed to a comprehensive and long-term partnership with the city of Düsseldorf, and it is this that created the conditions necessary to revitalize the old Kunstpalast. The vitality it has since regained and the "energy for culture" that can be unleashed through such cooperation are demonstrated by this exhibition as well. I hope that it will attract many visitors who will find themselves fascinated by the "endless enigma."

Ulrich Hartmann
Chairman of E.ON AG

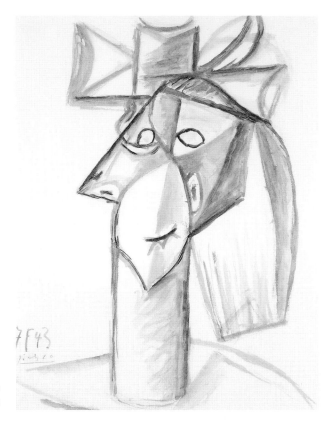

Pablo Picasso, *Tête au chapeau*,
1943

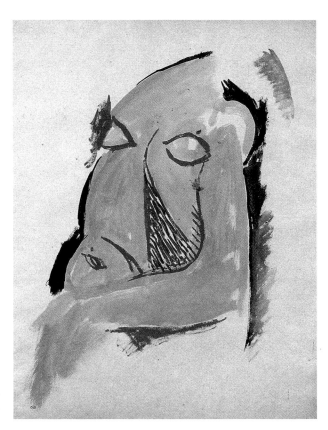

Pablo Picasso, study for
La demoiselle accroupie, 1907

Jean-Hubert Martin

DOUBLE IMAGES

What links a sixteenth-century painting by Arcimboldo to a Mogul miniature dating from around the same period? Why do visually ambiguous images appear in cultures that are distant from one another? Do such images represent a common, latent stock for humanity, which are reactivated according to specific philosophical contexts, or the rediscovery of similar forms thanks to the unending flow of artists' imagination? What is a double image? A composite or reversible image, a superimposition of images, a riddle, an anamorphosis, Rorschach test, false perspective, a "dreamstone," or anthropomorphic utensil?

It is a vast subject that has never before been treated in such a broad way, and a mazelike exhibition in which readers are invited to lose themselves! Ostracized by positivism to the cabinets of curiosities, the theme made a strong comeback with Surrealism, Dali and his paranoiac-critical method. And except for a few Japanese prints, the phenomenon's transcultural dimension has never before been shown. The sometimes difficult task of deciphering will have its effect on all those who delve into the double images: in the end, every image will seem to conceal another.

A Worldwide Phenomenon

Appearances can be deceiving—this idea influences all of Western thinking about painting. Since the Renaissance and the invention of both easel painting and the artist-genius, the demiurge, painting has been systematically credited with having an additional value that gains in importance the closer it comes to illusion. There is no painting that does not make sense and does not justify an exegesis—that never manages to exhaust its subject in any case. Nor is it surprising, in view of the absolute dominance of classicism, that the deviant trends with regard to "retinal" representation come to light during the two periods of intense experimentation that fall before and after classicism.

Modernity makes a break with the past and is affirmed above all in the negation of both naturalism and representation according to the laws of perspective. The dialectic of the visible and the invisible is accordingly reinforced. With cubism, the vocation of transforming painting into a rebus or an ontological activity rapidly turns into the dogma of modernity. The distortion and schematization of forms results in the working out of a system of signs, the deciphering of which entails infinite exegesis. A long quarrel that raged throughout the twentieth century opposed the partisans of an abstract art totally independent of any reference to reality, and those who always claimed to discern the trace or reminder of a visual perception.

Past master in fiddling with forms, Picasso offers several major examples of transformations. The great still life *Bread with a Bowl of Fruit on a Table* actually springs from a gouache sketch, *Carnaval au bistrot*.[1] Picasso transformed into obvious French baguettes the arms of the figures leaning against the table or with their elbows squarely planted on it. Given Picasso's virtuosity in playing with forms, which he would bend to his whims in the course of various derivations and assimilations, one is tempted to push the usual interpretation further and see possible double images in certain sketches for *Les Demoiselles d'Avignon*, as in that study of a face (fig. p. 10)[2] in which a black circle in the upper right can only be understood if it is read at the same time as a female bust whose shoulder is in fact represented by that circle. The image of a face depicted both straight on and in profile, stereotypical to the point of becoming a caricature, corresponds to the model of the double image, all the more so in that cubism on the whole claims to give us an overall view of objects, one that is not dependent on a single point of view.

The idea of this publication, however, is not to propose the enth interpretation of cubism and Picasso, but rather to bring together works of widely varying age and origin that harbor a semantic ambiguity both inherently and phenomenologically. For modernity, it was Dali who assumed the role of theorizing this phenomenon. The artist did not so much seek to create a new repertory of forms as to pervert the old system and add a hallucinatory aspect to it. Until now these efforts have been thought of as unconventional or marginal practices, again according to a Western point of view and a hierarchy of values based on the superiority of the system of visual perspective and the kind of representation it leads to.

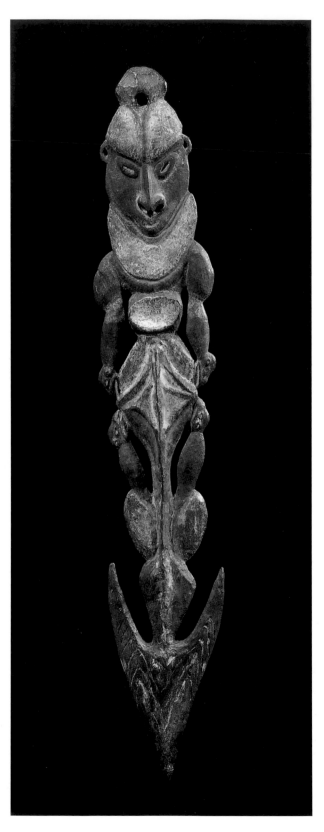

In religious art, there are few gods that are not the result of some hybridization and whose representation does not combine several living beings, including all kinds of animals and sometimes man. The result is generally more along the lines of a collage or assemblage than a real intermingling of forms. There are exceptions, however, like the Eleks of the Baga (fig. p. 13).[3] The back of these large birds, whose plumage ends in a point, reveals an elongated human face in profile. The ambivalence is truly semantic, moreover, since tradition refers to both interpretations.

The Arcimboldo-Effect and the Cabinet of Curiosities

Giuseppe Arcimboldo, the central figure of the multi-meaning image, remains largely an enigma. Born in Milan, where he would return at the end of his life, he was to spend twenty-five years in Prague at the court of Emperor Rudolf II, who made him a peer, just as Maximilian had done for Titian. This gives some idea of the importance the sovereign attached to the painter. As Pontus Hulten put it, interpretations of his work run from an artist's simple and original fantasies, to a serious attempt to lend concrete form to some philosophical conception.[4] The temperamental and disturbing personality of Rudolf II, who devoted much of his time to practicing magic, has lent credence to the hypothesis that an esoteric theme runs through the work. In this interpretation, the two series of paintings called the *Seasons* and the *Elements* would be signposts or emblems of sorts introducing different sections of the emperor's private *Wunderkammer*, his cabinet of curiosities. Commentary by several contemporary scholars (Gregorio Comanini, Giovanni Battista Fonteo, Giovanni Paolo Lomazzo)[5] defines the paintings as allegories in any case. It could be said that they are even paroxysmal examples of allegories. To avoid having to turn to the written word in painting, artists developed systems of identification, the keystone of which was the attribute. In the play of con-

Anonymous, figure, Sepik, Papua New Guinea, twentieth century

nections between the human figure and the object, it is the latter that becomes the mark making recognition possible (fig. p. 15). It is only a crutch or auxiliary. Arcimboldo reverses this proposition so that the elements of identification or the parts confer form and constitute the whole. The method of *pars pro toto* is replaced by a personification of a concept in which the subtle arrangement of beings and objects creates an anthropomorphic appearance. The artistic feat here lies in perfectly adapting the visual to the semantic. Whereas the attribute only confers meaning by deduction, Arcimboldo manages with his allegories to translate both the need for an order that enables man to interpret the world, and a feeling of chaos due to the swarming mass of elements making it up. It is a task that is forever before the artist, the very essence of art, namely to bring order to the disorder of the world.

The Renaissance eagerly set to work in this regard. Intellectual explorations and artistic adventures are legion during this period of epistemological reevaluation. In a world that had yet to know the disenchantment of the rational whole and the functional whole, all kinds of complex links between beings and things were created. There was an intertwining of macrocosm and microcosm, which took the form of a cabinet of curiosities. Collections brought together rare natural curios

Anonymous, bird, Elek, Baga, Guinea, twentieth century

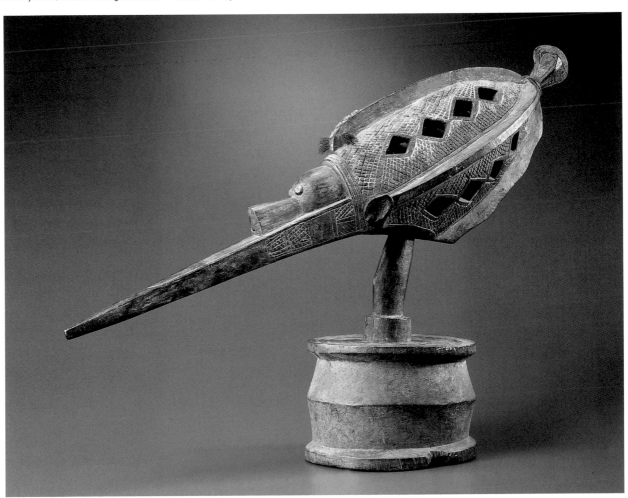

and human works inasmuch as the latter possessed some strange, bizarre, or extraordinary aspect. They were proofs in the testing of a reality that remains to be deciphered. Cabinets of curiosities were also called *Wunderkammer* or *Schatzkammer* in German, or even "theaters of the world" like the great collection of commonplaces that Giulio Camillo designed for France's King Francis I,[6] a kind of encyclopedia that was placed at the sovereign's disposal. The objects brought together were narrative aids that mixed fable, legend, and magic that were often drawn from the literary heritage of Greece and Rome and which amounted to a kind of dogma. Correspondences between natural things gave rise to endless speculations. The enigma of the world was deciphered using the sorts of rebuses found in heraldry and emblems.

For Arcimboldo's two quadrilogies, some of the pictures' meanings are accessible to us. They symbolize the emperor's power, which extends even to the elements and the cycle of the seasons, the time that marks off vitally necessary harvests. Yet the male and female faces also point to life's different ages, while certain attributes like the Order of the Golden Fleece and the flint allow us to identify the Habsburg dynasty and more precisely Maximilian II in the "Fire." Other correspondences, however, remain a mystery, such as the indication on the back of one painting that spring is associated with the element of air (fig. p.145).[7]

The portraits of nobles at the court are made up of instruments and objects that are characteristic of their owners. It is a reification of the person by his function that absorbs him to the point of becoming his very substance. The two poles of an anthropomorphization of surrounding reality, in keeping with the progressive ideology of God's ouster by man, can be seen in Arcimboldo's portraits and the landscapes traditionally attributed to Josse de Momper (fig. p. 62–65). The former are the result of an internal process of elaboration in which a framework of plants and animals culminates in a human face. The latter are due to a modeling of the landscape that draws its contours from an external shaping. In one case, there is a subtle assemblage of dissimilar constituent elements, in the other, a reworking of the entity of one of painting's genres in order to lend it a face.

What makes Arcimboldo's system attractive today is not the complex symbolism that can be penetrated by experts on the period, but rather its value as a prototype vis-à-vis collage and assemblage such as they were largely used throughout the twentieth century. For the sake of clarity, the selection in this publication is limited to Arcimboldo's legacy in terms of the image, in other words, in the domain of two-dimensionality, and will not address the question of the art of assemblage, which has been addressed in its own right elsewhere.[8] Man's relationship to the world and his integration or immersion in what is called nature represents another reason for the renewed interest in Arcimboldo. Although human beings' proximity to "nature" was far greater in that day and age, to the extent that daily life depended on it, man's privileged and dominant position was gradually asserting itself. Contemporary thought has revived that relativization as well as the concept of human beings' integration in the whole of life on our planet, no longer from a religious or relational point of view, but from an ecological one. Numerous works of art show evidence of this, such as Claudio Parmiggiani's *Malangan* (1972) or Sigurdur Gudmundsson's *Spijt* (1976). The transformation of the human body into plant matter as it traditionally appears in the representation of the myth of Daphne seems to correspond better to the naturalization of man than hybridizations with the animal that confers on him the quality he is symbolically attributed.

What the Body Consists Of

The show also contains the first display of such a large group of Islamic miniatures, most of which are from India of the Mogul period. The works are scattered throughout a number of major museums. An in-depth study would surely reveal the existence of others, for even the print collection of the museum kunst palast possesses four such miniatures, although is not specialized in the field. One group—in which the hand of the extraordinary draftsman Siyah Qalem (fifteenth century) can be seen—offers a perfect illustration of animism by decking out stones and trees with tiny human faces, a reminder that these are living beings (fig. p. 91, 92). A second group represents a surprising parallel with Arcimboldo's work, with which it has never been seriously compared until

now. It features camels, elephants, horses, wild animals, even a chimera. The animals are identifiable thanks to their silhouette, which contains an incredible hodgepodge of other beasts, an unlikely mix of living beings, both human and animal, swarming and intermingling beneath their skin. From what is currently known, most Mogul miniatures date from the seventeenth century. They would be only slightly more recent than Arcimboldo's work then. It would be amusing to speculate on a contact of some sort, which remains unsubstantiated to date. There are two noticeable differences. Arcimboldo painted only heads whereas the Eastern miniatures show only four-legged animals. The other argument is of less importance since it is stylistic in nature. Arcimboldo portraits are constructed volume-wise by an

assemblage of elements, while the animals featured in the miniatures are clearly-delineated silhouettes that are filled with a robust extravagance.

Although it is premature to try to establish a chronology and a lineage among the drawings, it is already clear that common models do exist. The head and ears of the camel formed by a kind of large rat are found in three examples on display. The belly of each of them contains scenes of gallantry and the good life: lovers, a servant pouring out a libation, and especially musicians, who are almost identical in two instances. The quality seen in the execution varies greatly. Three are remarkable for the refinement and precision of their draftsmanship: a horse containing several wrestlers (fig. p. 153), but even more so a camel (Museum für Islamische

Heinrich Göding (?), *Allegory of Fire*, c. 1600

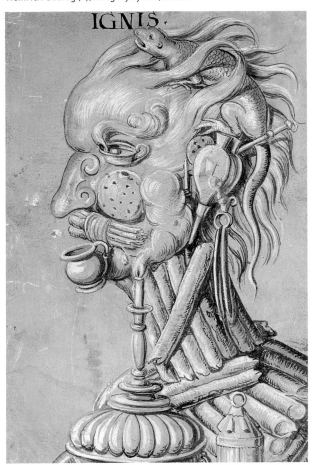

Heinrich Göding (?), *Allegory of Air*, c. 1600

Kunst, Berlin) and an elephant (Bibliothèque Nationale de France, Paris, fig. p. 158, 161). The two latter pieces might well be by the same hand. Grisaille is used with great mastery to suggest the animals' masses. The overlapping arrangement of bodies is so ingeniously laid out that to read it demands a careful examination in order to disentangle the complex skein of figures that extends well into the elephant. Without going further into our analysis, several especially happy solutions on the artist's part are worth mentioning. There are the claws of wild animals formed by the heads of birds with their beaks, and the light-colored fur of the underbelly indicated by a fish, which might also figure the tusk of the elephant, whose head and trunk become a crocodile, and so on.

If we consider their output from today's point of view, it is surprising that Josse de Momper[9] and his fellow landscape artists did not give in to the temptation to conceal human forms in their wholly imaginary rocks more often. As can be seen with Picasso, the urge is indeed great for artists to play with the ambiguity of forms as their brush moves across the canvas.

Nowadays Josse de Momper's twin caves, which plunge deep into the rock like two parallel cavities before opening onto bright landscapes, can hardly fail to suggest the cavity of a mouth or simply a pair of eyes. The artist's intentions, however, remain a mystery.

Eyes represent the primordial "hook" for any identification of concealed images. Two dark points on any surface inevitably evoke the possible presence of a face, if only for a fraction of a second even, in the mental process of deciphering images. Indeed, when we think we can make out a head in a crag depicted by Dali, Max Ernst, or a mannerist painter, our first urge is to look for the eyes. Everyone well knows the role they play in painting, whether the eyes of the represented figure "meet" the viewer's gaze or not. For babies from the earliest age, it is an essential point of reference and the first sign of recognition. Among animals, the proportionally large eyes of the young allow recognition with respect to adults.

Anonymous, bezoar, Spain, first half of the sixteenth century

The Moods of Nature

Where contemporary thought looks to determine the laws governing living things according to principles of cause and effect, the Renaissance steeped itself in correspondences between nature's kingdoms, as well as things, images, and words. Scholars held forth at great length about fossils and bezoars.[10] The latter, mineral concretions that occasionally form in the stomachs of cows and horses, were so mysterious that they helped to build up a theory that placed the origin of stones in those mammals' digestive apparatus. These rare and precious objects supposedly possessing magic powers were mounted in jeweled settings of great refinement. Moreover, how was one to explain the inscription of a fish or shell in the stone of a mountain without the aid of some concept of an evolving world? Even though the

Open Work—Open Reception

Sexuality and its suite of desires make up one of the fundamental mechanisms of creation for artists constantly in search of new sensations. To expand the capacity of one's perception and the domain of the senses, the use of drugs is surely tempting. In Picabia's transparencies (fig. p. 208) or Max Ernst's landscapes (fig. p. 74, 75), the extreme overlapping of forms and their ambiguity certainly give the impression that they were elaborated under the influence of narcotics. And Dali achieved the same effect by following his paranoiac-critical method and concentrating on the metamorphoses of the image. His ability to withdraw from the *stetigen Sehen* in favor of *Aufleuchten*, to borrow Wittgenstein's terms,[24] was exceptional, leading him to moments of altogether uncommon visual delirium. Henri Michaux made overt use of drugs, but his drawings point more to a suggestive, informal art evincing an obsessive, repetitive character rather than evoking the double image.

Picabia's transparencies,[25] like the *malanggan* of New Ireland, reveal a remarkable capacity for mixing forms and multiplying levels of interpretation, as if one's increased mental faculties suddenly made it possible to identify a series of images in a complex, though unique, form. The equivalent in language would be a word having at least three syllables yielding several two-word homonyms of two syllables plus one more, or of one syllable plus two more. Identifying one of the meanings is always tied to the respective context. For the works mentioned above, identification demands an intense effort of concentration to focus on each of the superimposed, intermingled elements. In that sense, they correspond to Umberto Eco's concept of an open work of art since several viewers will see different subjects there depending on what they focus on.[26] Abstract art has made full use of that faculty. The particularity of the examples given here lies in the accumulation and overlapping of layers designed and intended by the creator of the piece, whereas the viewer has no choice but to see an indescribable muddle, or to isolate mentally and visually just one of the semantic elements. Picabia's transparencies represent an exceptional instance in painting for they are neither traditional images, in which the conjunction of the retinal and the mental

takes place instantaneously, nor artwork-riddles that require a deciphering of their signs. They appear as an indistinct confusion that only the patient work of focusing in depth can slowly decode. They confound the common ability of painters to offer at first glance an amazing amount of information and demand time to isolate their numerous strata.

Another group of works concerns a particular kind of double image in which a representation is superimposed over an object whose shape clearly expresses its function. A large number of objects from Oceania and Africa belong to this category. We might consider the instrument's functionality here as constituting its image, to which is added the image of its metamorphosis into a human being. African drums are occasionally transformed into a trunk resting on two legs. The ambivalence becomes even more pertinent when the object

Anonymous, king's mask from Kah community, Bamileke, Cameroon

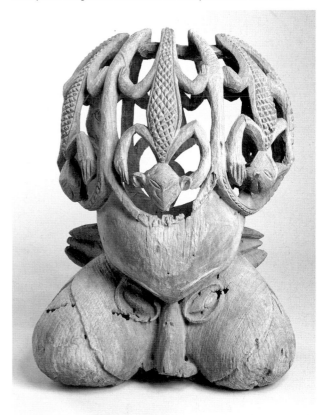

Stephan Andreae

DAWNING – THOUGHTS ON THE EXHIBITION THE ENDLESS ENIGMA IN DÜSSELDORF

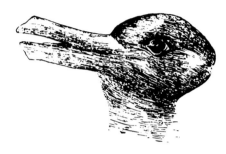

It can be seen as a rabbit's head or as a duck's. And I must distinguish between the "continuous seeing" of an aspect and the "dawning" of an aspect.
– Ludwig Wittgenstein, *Philosophical Investigations*, trans. G.E.M. Anscombe, 2nd ed. (Oxford, 1997), 194.

Endless Enigma? Magic? Ambiguity?

There have been several exhibitions on optical phenomena in the visual arts, some of which were for children, some for those interested in techniques and so on, one of which was even held in the old Kunstmuseum Düsseldorf. Some of these exhibitions took place in folk art museums, and all of them seemed to have something in common in the way they were received: a lack of deep artistic seriousness, or at least of what is generally taken for that.

We felt that that was unjust, or at least in need of correction, so we defined a theme that would in fact be limited in formal terms entirely to double images in artistic expressions. The difficulty here was that no one knew exactly what double images were. It was much easier to assert what was not a double image. It was clear that we did not want to open the door to anamorphic views and all sorts of other perspectival finesse, because then we would indeed have been putting formal optics in the foreground. For us, however, the concern was always the possibility of seeing one image in several ways and of interpreting it accordingly. It is especially interesting in this type of "picture puzzle" (another term whose definition is a matter of divergence among the dic-

tionaries) how the visual objects—perceived as double or in sequence—relate to each another. In the case of genuine double images that go beyond the perspectival approach, we have, of course, allowed in several anamorphic images. Excurses in the exhibition and in the accompanying program are also intended to demonstrate how such related disciplines as film or music have approached the phenomenon of "hidden contents."

The very nature of the double image meant that it would defy any logical structure in the exhibition. One could imagine, for example, an exhibition organized by artist or by chronology. It would also be possible to organize by types of images (composite images, picture puzzles, double images, etc.). All of these would have been unsatisfying, however, since they could not do justice to the poetry of the images. Their ability to be read in several ways means these images always slip free of the coherent thread that we all take to be reason.

The only remaining option was to structure it as a *fiction* that, like the images exhibited, would permit a second level of observation: that of a path through a kind of enchanted forest from the "Appearance" to "End and Heaven." This resulted in twelve stations where the works of the individual artists (for example, Markus Raetz and André Thomkins) could be kept together—with the exception of Salvador Dalí, who "dawns" in various sections of the exhibition with his paranoiac-critical method.

This exhibition about double images is a completely new development, since there were no predecessors on which its planners could have drawn. The result before you is the fruit of about a year's research, and it can and should be continued. Nowhere on our search did we stumble on an abundant "nest"; rather we found things here and there, spread out through all periods and all cultures. This, then, is a beginning, a challenge to all interested parties to approach the picture puzzle with a "puzzling" gaze—a school for seeing.

The novelty of the new task suggested to me the idea of presenting, in lieu of an essay, citations from the notes I made in the course of preparing the exhibition.

Excerpts from My Collection of Notes on the Exhibition

"If we were able to be sure of the difference between the definable and the undefinable, then we would be able to understand the undefinable within the framework of the definable. What remains unclear is whether a thing is ascertainable or not."
– Barbara Johnson, quote retranslated from German

"... the artist [Salvador Dalí] insisted that the paranoaic image is 'consubstantial with the human phenomenon of sight' and traced it back to prehistory. To the caveman who, in the irregularities of the walls of his primitive dwelling, has a vision of 'the precise silhouette, the truculent profile, of his nutritive and magical obsessions, the hallucinating contours of the veritable prey of his imagination, these animals which he engraves merely by accentuating or retracing certain of the "stimulating" irregularities'. Aristophanes in *The Clouds*; Leonardo da Vinci in his *Treatise on Painting*; Bracelli and Arcimboldo; Freud in his *Leonardo de Vinci and a Memory of his Childhood*: these had laid 'the epistological and philosophical cornerstone of the majestic edifice of imminent "paranoic painting"'. Dalí also claimed that his obsession with the double image, reaching back ten years, had left its mark on Surrealism and, to a lesser degree, Neo-Romanticism. Only in his recently completed *The Endless Enigma*, however, had he embarked on a 'systematic investigation' of the 'paranoaic phenomenon'. Clearly, the message was, his public could expect more from him in this direction."
– Ian Gibson, *The Shameful Life of Salvador Dalí* (London, 1997), p. 389.

The question *what* something means, is fundamental. Only with the answer to this question does the object take its place in the context of the world.

Researchers, artists, and scientists question systems of order; they labor in their chambers on new networks and test their viability, whether these new order systems are of any use or not.

Giving something meaning is nothing new; we have grown used to metaphors and interpretations—here and there a little shift, but otherwise...

But if an artist goes and violates the law of clarity at the *formal* level, then he or she falls within theme of *this* exhibition and *this* book.

"Polymorph"—what a wonderful word!

Somebody says, "Reality is that which refuses to disappear when someone has doubted whether to believe in it."
 But what I am to do with a reality in which I do not believe? Whether or not it disappears ...

"let us not lose sight of the fact that the idea of surrealism aims quite simply at the total recovery of our psychic force by a means which is nothing other than the dizzying descent into ourselves, the systematic illumination of hidden places and the progressive darkening of other places, the perpetual excursion into the midst of forbidden territory."
Translated from André Breton, *"Seconde manifeste du surréalisme,"* Œuvres complètes, 1:793

No science, not even natural science, has described the vague, the imprecise, better than art has. Only here is ambiguity a noble property. Blurring, doubting, not knowing precisely—only art creates formulations and images for those things.

The double image is always an internal dialogue, not a compromise. But what happens at the moment of its transformation? Wherein does the threshold lie? What happens in the magician's top hat? Careful! Might not this curiosity have fatal consequence?

Decomposition, disinfestation. How much of their horror they lose when confronted with a well-made double image.

Paranoia is an alternative description of the world. Its appeal is that it is logical, rounded, and conclusive in

itself. Paranoia constructs unassailable parallel worlds, like those that exist in physics. What is true on a large scale need not be true on a small scale. Only the standpoint of the observer breathes something like reality into them. It is impossible to see them or think of them *simultaneously*.

The visible and the invisible. To the extent that one dawns, the other sinks into the fog.

Composite images—conjurers of unity. Everything is contained in everything. An artistic assimilation of the idea that the creature always carries within it the whole world, with all of the past and probably the future as well.

"When you paint, always think of something else."
— Salvador Dalí

What does it *mean* that things can be seen this way or that? At least that one of their truths lies in the transformation itself. Anticonservative!

The appeal of the optical lies in the profound wish to be able to transform. I cast a spell on you!—a form of exercising power.

The images stand still—and yet they have something cinematic about them, something that proceeds. They do not themselves change, but the viewer is forced to transform them. This process takes place either in the viewer's head or actually physically in the form of walking around (for example, Markus Raetz's sculptures and ribbed images).

Mornings: the gaze in the mirror. On this side, the person raises his right hand; on the other, he raises his left. We like to explain this incongruity along a vertical axis in physical terms. The double image declares that both sides are equally valid and does not worry about axes of symmetry or about states of affairs. Everything is valid! A manifesto of poetry!

Parallel lives. Neither can assert of itself that it is the *true* one.

The draftsman's line dances precisely on the threshold between the intended and the unintended. Matisse painted, as he said, not things but the difference between things. The line thus marks the point of transformation.

At that moment when the artist wishes to give shape to antimatter as well, vision becomes an occupying force, imperialistic. Dalí did like freedom, because he said it was formless—like spinach.

Visual people have great respect, even fear, of the non-material. The eye introduces no structure to it.

The sense of sight is the least reliable mode of perception.

Nothing is unambiguous. Even "nothing" is not unambiguous. With all our interpretations we cannot shake off the nothing, however we may twist and turn. Maddening, but it also gives us hope.

It is impossible to paint just *one* thing. For when I try to paint it, I always get the thing plus that which it is not. The first is impossible; the second is everything.

The artist becomes the chef of the broth of ideas, the chemist of the gunpowder of ideas. Can be bland—or explosive.

Dalí was enthusiastic about the mystical spiritualism of Planck's quantum mechanics, which we now know works, but we do not know *how* it works. Dalí himself remarked of his paranoiac-critical method: "I do not know what it consists of, but it works very well."

Double images are disorderly in a certain way; they incite anarchy by propagating hermeticism. They are always question and answer at the same time, though both the former and the latter are met with skepticism—the artist continues to doubt. These images are funny, not just in the sense of explosive laughter or grinning, but also in

the sense of a disconcerting "What should I think of this?" or "What am I getting into here?" In themselves they do not demand anything special, but anyone who wants to understand them must be ready to submit to a pendulum of meaning that is like a swing, which can only be enjoyed by those willing to give in to its motion. Everyone else gets motion sickness.

Picture puzzles in music: listening to the rests as well.

These images shimmer, flicker; they are characterized by visual instability.

Reality is beyond hope.

This agitation! This convulsion! This inability to let go! The *whole* territory of the image must be occupied. Form and negative form. Even the shadows and holes become vassals. One is tempted to say: Liberate the images and words. Let them hover, rather than occupying them. Do not tie them up by applying meaning. Let them unfold, even if you do not know how they will develop. Instead you force them into the corset of your meanings and thus strangle them.

Critics reproach multivalent images with having introduced a kind of mechanism (focus, shutter) to seeing that thus inhibits seeing rather than opening its horizons, because the artist anticipates the possibilities of interpretation. Dalí responded, rightly, to this, "If you have understood me, let me know, and I will try to make you uncertain again."

This exhibition is not an investigation; it is something more like an opera. It is concerned as much with producing a rhythm as with interpretation. That is the experiment, the gamble, since unlike a poem it only becomes public when one sees or reads it oneself for the first time. The surprise, to the extent there is one, is entirely on our side.

An exhibition on the unclear must at least be clearly structured, even if it is a pseudo structure (and those are the best structures!). If the levels of meaning are constantly slipping away, then at least the structure should act as if everything is hunky-dory.

Mathematics operates as a matter of course in the region below zero, and it works only because its framework has been formulated accordingly. In the world of phenomena, even that of artistically depicted ones, it is, however, unimportant whether I am missing one apple or four (unless they have already been paid for, but that is mathematics again); in both cases, we are left with "nothing."

It is interesting, however, that the inconceivable falls into our lives through structure.

The world of fog butts in, and in this exhibition it finds its platform.

Do not expect any fundamental scientific explanations! Only a few first attempts existed, and they have taken a few steps further in this project. But the field is still wide open! That spurred us on!

Visit this exhibition frequently. In different moods, in different weather, and always take a new path through it. You will make new discoveries every time.

You can perceive the exhibition as artistic sound. But you can also approach it as a sport, trying to discover the images behind the images.

"The new usually arises through the integration of previously independent systems into a higher unity. In the process, changes occur in them that make them more suitable for working together within the system. The parts become more different, such that the unity of the system that results from them grows out of the differences among the parts."
— Konrad Lorenz, *Die Rückseite des Spiegels* (Munich, 1997)

In this contribution I have shied away from pinning myself down in any way. I would also cast doubt on any definition that attempts to speak of this theme in general. Any determination would immediately transform, vanish like a restless spirit. For that reason, I only dare to place fragments on the table. Experience the images, then choose your favorite fragment or invent a new one.

Working with these images was a permanent journey from heaven to hell and back again. This exhibition thus begins with the room "Appearance" and ends with the room "End and Heaven," though the two are thematically similar.

The indecisiveness that speaks in the ideas presented here is by all means programmatic—and programmatic to the chosen images. We will have to live with our doubt, and in the best case we will also be content with that, since even if it is dark sometimes, something is always sure to dawn.

This exhibition is dedicated to Fantômas the elusive.

DALÍ'S INTEREST IN PARANOIA

Dalí's interest in paranoia . . . is inseparable from his interest in double and multiple images. By the time he wrote "The Rotten Donkey" he had added a third image, that of the lion, to the picture mentioned in the lecture. Finally entitled *Invisible Sleeping Woman, Horse, Lion* [fig. p. 125], this work, he stated later, was inspired by his contemplation of the rocks of Cape Creus, whose fantastic shapes and metamorphoses had fascinated him since childhood. Dalí's efforts to induce in the viewer a state akin to paranoiac delirium as he studies the picture are not entirely successful, however, and the limbs of both horse and woman undergo considerable distortions in the process of accommodating them to the scheme of the double image. In the contemporaneous *The Invisible Man* the man's head and the general outline of his seated figure are far more immediately visible than Dalí intended (he doesn't suddenly "appear", as does the rabbit in *The Lugubrious Game*), and his right arm, for example, cannot be read as such but only as a naked female seen from behind (in a posture identical to that of the woman at the end of *Un Chien andalou*), just as his left hand can only be interpreted as a hand. The right hand, however, does have a more hallucinatory quality, as does the woman-horse, quoted from *Invisible Sleeping Woman, Horse, Lion, etc.*, in the left background, behind the by now ubiquitous jug motif representing an idiotic Dalí and his sister Anna Maria (the angry lion appearing in the forefront of the painting is presumably an allusion to Dalí's father).

By the summer of 1930 Dalí had invented what he called "paranoiac-critical thought", in which the double image played an integral part. The word "method" was not substituted for "thought" until, probably, 1932. It was a brilliant trouvaille, suggesting as it did that there was a technique for provoking and experiencing the sort of paranoiac phenomena with which Dalí was concerned. But if the term "paranoiac-critical method" was soon famous (Dalí made sure of that), the "method" itself remained elusive in the extreme—so elusive, indeed, that Dalí said in later life "I don't know what it consists of but . . . it works very well!" The purpose of the "method" was another matter, however, as Dalí was to explain in *Diary of a Genius*. "In general terms," he wrote, "it's an attempt to achieve the most rigorous systematization possible of the most delirious phenomena and materials, with the intention of making tangibly creative my most obsessively dangerous ideas."

Dalí never identified these obsessively dangerous ideas, nor did he ever suggest that if, from 1930 onwards, he was increasingly fascinated by paranoia it was in part because of the revelation that his paternal grandfather, Gal, had suffered from such serious paranoiac delusions that they had driven him to suicide. It is difficult to believe that that discovery, attested as we have seen by his cousin Montserrat, did not shake him profoundly, not merely because an unsuspected skeleton had suddenly appeared in the family cupboard but because, pondering on the behaviour of his father and of his Uncle Rafael, at times as seemingly crazy as that of their unstable progenitor, he must have wondered if he himself had not inherited a paranoiac tendency. It can be argued that it was in order to reduce this possibility, to defuse

this fear, that Dalí elaborated a "method" which, by confronting paranoia through its simulation, sought to bring the potential incidence of the illness under control.

How much did Dalí really know by 1930 about paranoia (meaning "disordered mind" in Classical Greek, the word had been appropriated by psychiatry in the nineteenth century to designate delusional insanity and, in particular, persecution mania of the kind apparently suffered by Dalí's grandfather)? Certainly he would have come across several passing references to the phenomenon in *The Interpretation of Dreams*, but, more importantly, he may have read, or had his attention drawn to, *Introductory Lectures on Psychoanalysis*, in which Freud reiterates his conviction that paranoia "regularly arises from an attempt to fend off excessively strong homosexual impulses". Knowing Dalí's fear of being homosexual, one can easily imagine that this sentence stopped him in tracks. Perhaps his "paranoiac-critical method", as well as being a bid to preclude paranoia and harness the unconscious, was designed as a deliberate defence against a sexual temptation that racked him with anxiety.

"The Rotten Donkey" was read with fascination by a young French psychoanalyst who was writing a thesis on paranoia at this time, Jacques Lacan. It seemed to Lacan that Dalí was right in seeking to harness the energy of paranoia for creative purposes, for active intervention in the external world, and he contacted the painter. Lacan does not appear to have described the encounter, and Dalí's amusing account in the *Secret Life* may be somewhat exaggerated; but there is no doubt that "The Rotten Donkey" and the meeting with its author influenced the development of Lacan's thinking on paranoia, even though he never acknowledged it, while Dalí was encouraged to proceed in the way that he was going.

Ian Gibson, The Shameful Life of Salvador Dalí *(London, 1997), pp. 254–6.*

DALÍ—PICTURE AND SPACE

The Puzzle Picture.

Of the visual deviations Dalí used, the puzzle picture is undoubtedly the most spectacular. These pictures dominate the painting of the so-called Surrealist Epoch. When they are used their point of departure is always the unusual, the better to conceal their presence. The depiction of deformations—the buttock in *The Enigma of William Tell* or the exaggerated table/leg in *The Ghost of Vermeer van Delft, which can be used as a table*—relates directly to the puzzle picture, that geometrical realm that Nicéron called "the artificial magic of wondrous effects." Dalí knows exactly where the puzzle picture fits into the history of perspective, he has a clear sense of its role in art's portrayal of the third dimension, and he knows Bracelli and his puzzle pictures. But in Dalí's hands there is no longer any question of a realistic element, as there had been in the work of eighteenth and nineteenth-century artists; Dalí's double-meaning pictures cannot be properly studied by taking Arcimboldo as a starting point. Moreover, his puzzle pictures cannot be directly related to those of preceding centuries, which are still no more than perspectival curiosities. During Dalí's surrealist years these pictures belonged in the domain of psychoanalysis, and today they rank among the experiments that pointed the artist towards new ways of re-establishing space, especially through holography. Those puzzle pictures that depict death—or rather a skull— are the most successful. They optically deform, legitimately extend and stretch existence as far as the sparkling network of interference that, thanks to the coherent light of the fugitive laser, today gives us the immortality of pictures captured with holography.

The Virtual Picture.

The virtual picture is the stoutest and trustiest warhorse that Dalí bestrode in his quest for reality. Permeated by the paranoiac-critical method, Dalí's virtual picture tunes in and lights up on demand. In the guise of the double-meaning image, it pops up everywhere and then fades out. Dalí used the same procedure in both his writing and his painting. "If everything gets too clear, too blinding, then one tries to veil the ideas (or the pictorial concepts) and so to honor dark Heraclitus and Tantalus, if the readers become fatigued by what is too clear or too dark." Very soon the reader sees the figures and scenes of his choice, where he wants to see them.

"The discovery of invisible pictures definitely influenced my destiny. At the age of six I astonished my parents and their friends with my extraordinary mediumistic gift of 'seeing things differently.' I always saw what others did not see, and what they saw, I did not see. Out of many examples, one stands out as belonging to this period of my life. Every Saturday I received a children's newspaper (my father took out a subscription for me), and on the last page there was always a pictorial puzzle. It would show, say, a forest and a hunter—and in the deep, dense undergrowth the artist had hidden a hare that one had to find. Or else one had to look for a doll that a child had lost in an apparently empty room. My father brought me the paper, and he was astonished that I found not just one hare but two, three, four—not simply one doll but several, for there

was always another one that the artist had hidden. Still more astonishing was the fact that my hares and my dolls were clearer and better drawn than the ones that had been hidden deliberately. No sooner had I drawn round their outlines in pencil than, to their expressed surprise, everyone saw them as clearly as I could.

But seeing several hares where others, after long and painstaking perusal, could see but one was not the end of it. In the same picture, and every bit as clearly as the hare, I could detect a fly, an elephant, a bathtub, or something else—and it was actually that which was the astonishing thing.

For this mysterious gift of being able to see anything I wanted—and still, to some extent, anything I want—I later found an explanation in psychopathology. I was paranoiac. . . . One of the most fascinating and favorite games of my childhood consisted of making fantastic shapes take on clearer and clearer form, perhaps while gazing at damp patches on an old wall. In the same way, in the constantly changing shapes of the clouds I could see almost anything—and thereby is pinpointed the source of paranoiac visions."

The virtual pictures that arose out of photographs under Dalí's hand are numberless. He let the *Face of Mae West* appear as the cover picture of a magazine.

"I must first establish a diplomatic compromise between my double-meaning images by transforming them and bringing them into consonance. That applies to the *Invisible Bust of Voltaire*. In *The Two Crusaders* the photo of a female face is reproduced intact and without any retouching. It is only the magic emanating from the pictures alongside that makes one think one is looking not at a woman's face but a warhorse."

In the same way Dalí allows a troop of mounted warriors to surface in *The Battle of Tetuan*, using for the purpose the typographical "rivers" (white space between words, which, over several lines, can form irregular patterns) from a daily paper. The red chalk drawing *Hercules and Gradiva* in the Figueras Museum is another example. Starting with any printed page—in this case synodal statutes—Dalí has the document photographed and then enlarged, deliberately fuzzily, so that the words are blurred and the white space becomes more dominant; it is then reproduced on a standard paper. By now the original has disappeared, and nobody would suspect that all the visible mythological figures have been carefully abstracted from printed text.

Translated from: Robert Descharnes, "Dalí, das Bild und der Raum," in Salvador Dalí: Retrospektive 1920–1980, *exh. cat., Musée national d'art moderne, Centre Georges Pompidou, Paris (Munich, 1980), p. 391–6. © Demart pro Arte B. V.*

APPEARANCE

The lace-maker had always been seen as a very calm, very tranquil image, but for me it is full of a wild aesthetic force to be compared only to the recently discovered antiproton.

SALVADOR DALÍ*

■ Fragmentation and atomization as metaphors for a collection of paintings which take something and make something else of it. For Salvador Dalí in the 1920s and 1930s, nuclear physics was an essential element of the prevailing *zeitgeist*.

This chapter stands for the release of energy, the initial metamorphosis brought about by cell division, the beginning of life, incarnation in the mother, who appears as a saint. Dalí exposed the respectable *Angelus* by Jean-François Millet as a highly erotic scene, as a symbol of the unification of man and woman. In Leonardo da Vinci's *Virgin and Child with Saint Anne* Freud saw an early, unconscious example of a picture puzzle which Dalí later included in his theory of interpretation. In his treatise on painting, Leonardo da Vinci makes a reference to interpreting chance spot formations on walls. The first chapter closes with images of childhood and describes the beginning of a genesis through change. *StA*

* Translated from: *Dalí sagt ...*
Tagebuch eines Genies
(Munich, 1968)

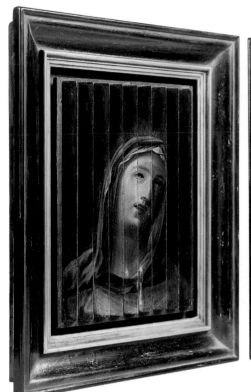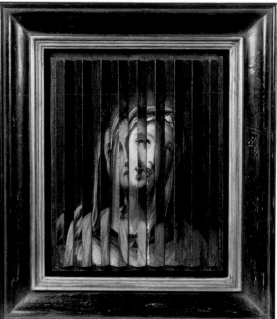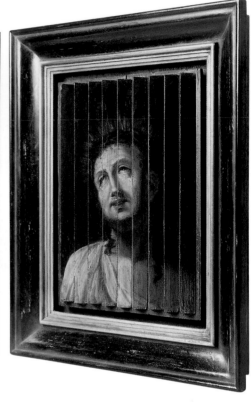

Circle of Guido Reni, "ribbed image" with depictions of Jesus and Mary, first half of the seventeenth century

■ "Harp images" and "ribbed images" contain several picture planes (for more on this, see Chapter 7). Their peculiar structure—which enabled different motifs to coexist, independently and yet in unison, on a single backing—made them particularly suitable for representing symbolic subject matter. Hence "ribbed images" were used, for example, for portraits of married couples, to symbolize the spouses' unity. A related subject from Christian iconography is the "double portrait" of Mother of God and Head of Christ. Another striking example is the Holy Trinity: God the Father, Christ, and the Holy Spirit appear in "harp images" in symbolically interwoven form. *AZ*

Leonardo–Angelus Thesis

LEONARDO DA VINCI
** 1452 in Vinci near Empoli,*
† 1519 at the Château de Cloux
near Amboise. Florentine
artist, scientist, and writer,
apprenticed to Andrea del
Verrocchio in Florence,
probably in 1466, and admitted
to the painters' guild there
in 1472. He was influenced not
only by Verrocchio but also by
Antonio Pollaiuolo and,
to a lesser extent, by Sandro
Botticelli. Vasari mentions the
first painting and sculpture of
his early years in Florence.
By the spring of 1483 Leonardo
is known to have been in
Milan. The invasion by Charles
VIII of France and the fall of
Lodovico Sforza caused him to
leave that city in 1499 and
return to Florence, via Mantua
and Venice. In 1506 he returned
to Milan and soon entered
the service of the French king
Louis XII as court painter.
Then, in 1513, he left for Rome
and the court of the new pope,
Leo X, before answering
Francis I's summons to France
in 1516.

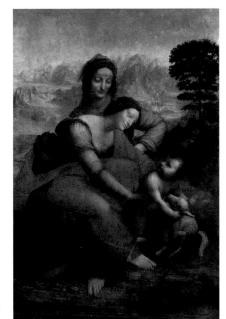

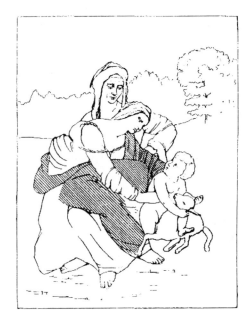

Leonardo da Vinci, *Virgin and Child with Saint Anne*, 1506–13

Schematic drawing of Leonardo da Vinci's *Virgin and Child with Saint Anne*, from: Oskar Pfister, "Kryptolalie, Kryptographie und unbewusstes Vexierbild bei Normalen," *Jahrbuch für psychoanalytische Forschungen* 5 (1913): pp. 117–56

■ In a review of Sigmund Freud's famous essay "Leonardo da Vinci and a Memory of His Childhood," Oskar Pfister interpreted Leonardo's *Virgin and Child with Saint Anne* as an unconscious puzzle picture. He sees in the Virgin's robe the shape of a vulture: the vulture that is supposed to have attacked the young Leonardo in his cradle. *StA*

MILLET. — PRÉCAUTION MATERNELLE (Musée du Louvre).

MILLET. — LES MOISSONNEURS.

PRÉSENTATION ANTICIPÉE DE QUELQUES DOCUMENTS DEVANT SERVIR A L'INTERPRÉTATION DU *SIMULACRE CRÉPUSCULAIRE : L'ANGÉLUS*, DE MILLET.

MILLET. — LE VANNEUR (Musée du Louvre).

VINCI. — LA VIERGE, L'ENFANT JÉSUS ET SAINTE ANNE (Musée du Louvre).

Comment l'image, sublime d'hypocrisie symbolique de *L'Angélus*, obsession des foules, aurait-elle pu se soustraire à une si flagrante « furie érotique » inconsciente ?

L'ensemble constitué par la bouche de l'enfant et la queue du célèbre et invisible vautour maternel interprété par Freud dans le tableau de Léonard, coincide intentionnellement avec la tête de l'enfant dans *Les Moissonneurs* de Millet.

MILLET. — LES BATTELEURS DE FOIN (Musée du Louvre).

67

Salvador Dalí, *Minotaure* 1 (1933):
p. 65

■ Of this pictorial motif, Dalí said in the journal *Minotaure*, no. 1, 1933: "The whole configuration formed by the child's mouth and the tail of the famous mother-vulture, interpreted by Freud, deliberately coincides with the child's head in Millet's *The Gleaners*."

SALVADOR DALÍ

** 1904 in Figueras, Spain, † 1989 in Figueras. The Catalan artist, draftsman, sculptor, and stage-set designer studied at the RABA de S. Fernando in Madrid from 1922 to 1926. His early works are characterized by a descriptive precision and measured structure which betray the influence of post-Cubist neoclassicism and Catalan Nucentisme. In 1923 Dalí encountered the writings of Freud and Surrealism and in 1926 met Picasso for the first time. Inspired by his reading of Freud, and with the help of psychoanalysis, he found the origins of his personal obsessions and the source of his themes and visual motifs in key events in the life of his family. In 1930 Dalí invented his paranoiac-critical method, by means of which he was able to produce conceptual images of concrete irrationality with an extremely tangible precision. He was also interested in surreal objects with a symbolic function. In 1941 he worked as a scene-painter for theater and television in the USA. In the 1970s he built the Teatro-Museo Dalí in Figueras, which after his death became his mausoleum.*

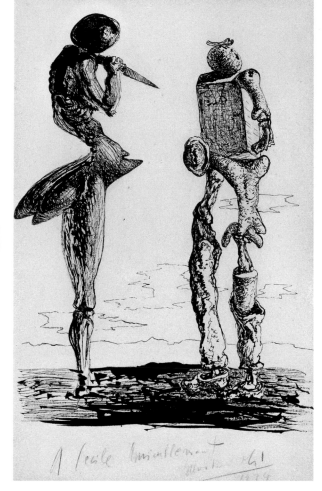

Salvador Dalí, *Hommage à Millet:*
Dessin dédicacé à Cécile
amicalement
Homage to Millet—for Cécile,
in Friendship, 1934

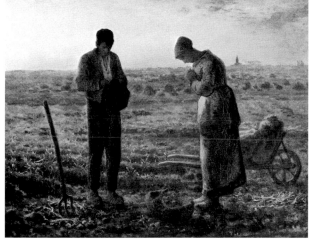

Jean-François Millet, *L'Angélus*
Angelus, 1857–9

■ Isidore Ducasse, Comte de Lautréamont (1846–70) wrote *Les Chants de Maldoror* in 1868–9. The central theme of the songs is an indictment of the Creation and its negation. Like the Marquis de Sade's writings, this provocative text was of special interest to the surrealists. . . . In his illustrations for it Dalí first quoted visually from the *Angelus* of Jean-François Millet. "As beautiful as the chance encounter of a sewing-machine and an umbrella on a dissecting table"—this famous phrase of Lautréamont's inspired him to equate "umbrella and sewing-machine" with "peasant man and woman."

Translated from: Karin von Maur, in Salvador Dalí 1904–1989, *exh. cat.*
(Stuttgart, 1989), p. 420.

DALÍ'S ESSAY "THE TRAGIC MYTH OF MILLET'S ANGELUS"

In 1940 Dalí wrote an essay about Jean-François Millet (which was published only in 1963) entitled *The Tragic Myth of Millet's Angelus*.

The essay is undoubtedly Dalí's most original contribution to art criticism. It is also deeply revealing of his inner conflicts in the early 1930s. Refining on the technique of pseudo self-analysis employed in the controversial "Reverie", and with Freud's *Leonardo da Vinci and a Memory of his Childhood* very much in mind, Dalí attempts to get to the root of the fascination exerted over him from childhood by Millet's seemingly banal painting. The only explanation for the huge popularity of the picture, he argues, in tune with Freudian dream theory, is that its *manifest* content masks a much more significant *latent* one. And that latent content, he concludes, relates to oedipal anxiety: to the male child's desire for and simultaneous fear of the mother. Observe, asks Dalí, that in the painting the husband is of slighter build than his wife (who, to judge from her stout profile, may well be pregnant); his eyes are cast down because he is praying, certainly, but he has a suspiciously ashamed look, has he not? Why? Because his hat is hiding an erection. The fork stuck into the earth is an obvious allusion to intercourse, as well as to swallowing. And the wheelbarrow? Does it not symbolize a hesitant, *trundling* sexuality? In fact, does the man not look more like a son than a husband? Like a son who desires his mother?

The essay recruits memories of stories read to Dalí as a child (tales populated with exotic flora and fauna set in Tertian twilight) and of places visited in those early years: a hill with fossils outside Figueres, the rocks of Creus (with their weird transformations), a damp meadow near Port Lligat inhabited by frogs, grasshoppers and ... praying mantises. When, probably in Madrid, Dalí read about the praying mantis in Fabre's *The Life of Insects* (a book beloved of Buñuel), he had been astonished to discover not only that the female kills her mate after copulation but sometimes does so *during the act*. Is not the woman in the *Angelus* standing in a posture akin to that of the mantis, is she not about to pounce? The suspicion becomes conviction: the *Angelus* scene is "the maternal variant of the immense and atrocious myth of Saturn, Abraham, the Eternal Father with Jesus Christ and of William Tell devouring their own children".

Ian Gibson, The Shameful Life of Salvador Dalí *(London, 1997), pp. 311–2.*

Atomization

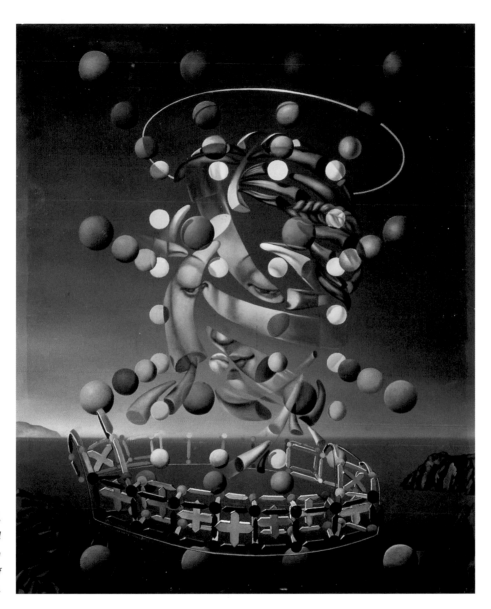

Salvador Dalí,
La Madone de Raphaël
à la vitesse maximum
The Maximum Speed of
Raphael's Madonna, 1954

■ "We must keep in mind that whatever we observe is not Nature itself, but Nature as exposed to our way of framing questions."

Werner Heisenberg

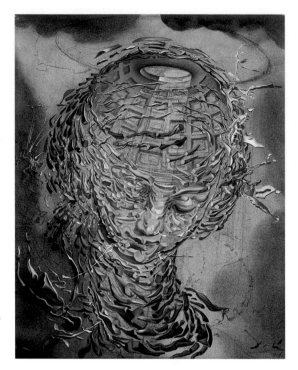

Salvador Dalí,
Tête raphaëlesque éclatée
Raphaelesque Head Exploded,
1951

ANTIMATTER

If physicists can produce antimatter, then painters—who already specialize in pain-
ting angels—should be allowed to paint it. "In the Surrealist Age I wanted to create
an iconography of the inner world: the world of wonders of my father Freud. I succee-
ded. Today the external world—the world of physics—has transcended that of
psychology. Today Dr Heisenberg is my father." And who is this Dr Heisenberg, who
appears so suddenly? The inventor of a new equation that "on the basis of the Marcu-
spian Constant, of the formula for the speed of light established by Einstein, and of
the internal diameter of the atom, in my view could lead to a formula for the unity of
matter.... Physics inspires me. I recently had to spend a month and a half in hospital to
get over a complicated appendix operation, and during my convalescence I had the
leisure to occupy myself with nuclear physics. After I had thought it over and in the
process explained it to myself, I understood Heisenberg's theses; I became aware that
I am just as intelligent as I pretend to be, having just reached the same conclusions as
the scientist. And on this basis I, who have hitherto admired only Dalí, admire Heisen-
berg, who resembles me." Dalí decides to paint the beauty of angels and of reality
with pi mesons and the fuzziest and most gelatinous neutrinos. Or, at any rate, he hopes
to do so soon. What does he strive for? Over and over again he seeks to integrate the
experiences of modern art into the great classical tradition.

Translated from: Robert Descharnes and Gilles Néret, Salvador Dalí 1904–1989
—Das malerische Werk *(Cologne, 1993), pp. 455–6.*

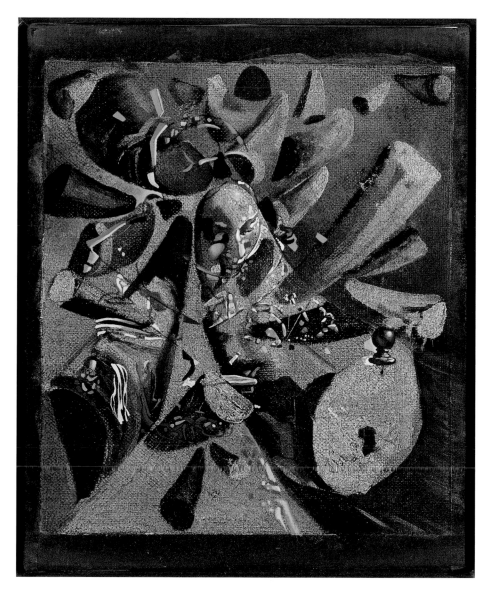

Salvador Dalí,
Peinture paranoïaque-critique
de la Dentellière de Vermeer
Paranoiac-Critical Study
of Vermeer's Lace Maker, 1955

■ At about the time that the DNA molecules began to pullulate in his work Dalí decided that Vermeer's *The Lacemaker* was also composed of rhinos' horns, surprising the staff at the Louvre with the "copy" they allowed him to do from the original, in which the picture became an explosion of cones. Dalí commented darkly at a later date: "These horns being the only ones in the animal kingdom constructed in accordance with a perfect logarithmic spiral, as in this painting, it is this very logarithmic perfection that guided Vermeer's hand in painting *The Lacemaker.*"

Ian Gibson, The Shameful Life of Salvador Dalí *(London, 1997), p. 479.*

Mother

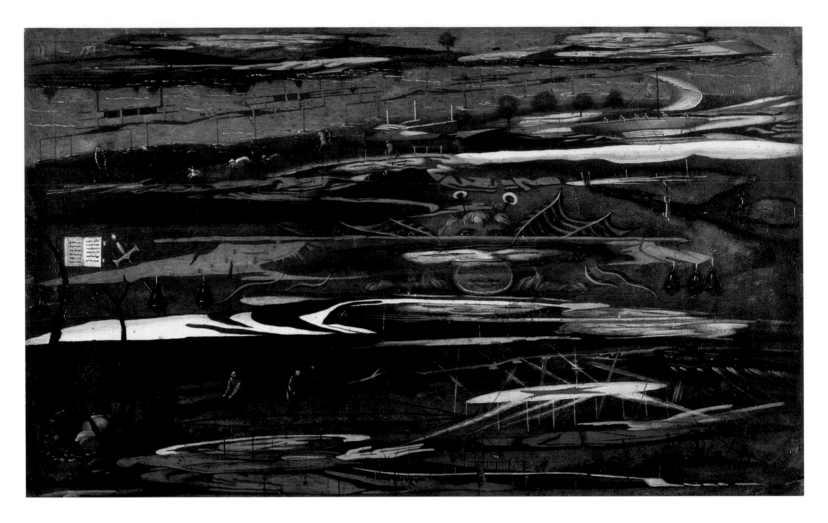

Anonymous, anamorphic image,
southern Germany, c. 1550

■ The subject matter of this painting, which dates perhaps from around 1550, seems to be transformed all of a sudden, the moment one looks at it obliquely from one side. From this angle the strange and rather gloomy appearance of a landscape with figures becomes a tableau of God's works. Immediately, the impressive anamorphosis reveals several Christian themes. In the upper third of the picture one can identify the figures of the Apostles Peter and Paul; beneath them the figure of Christ on the Mount of Olives, with an angel handing him the cup. In the center of the panel the gargoyle face of a devil changes into the sudarium of Saint Veronica, bearing the well-proportioned image of the Savior. Finally, in the lower third, we can make out the Virgin and Child and Saint Francis of Assisi receiving the stigmata. Through the anamorphosis the profane leads into the holy, and earthly existence seems to be transformed and transcended. *AZ*

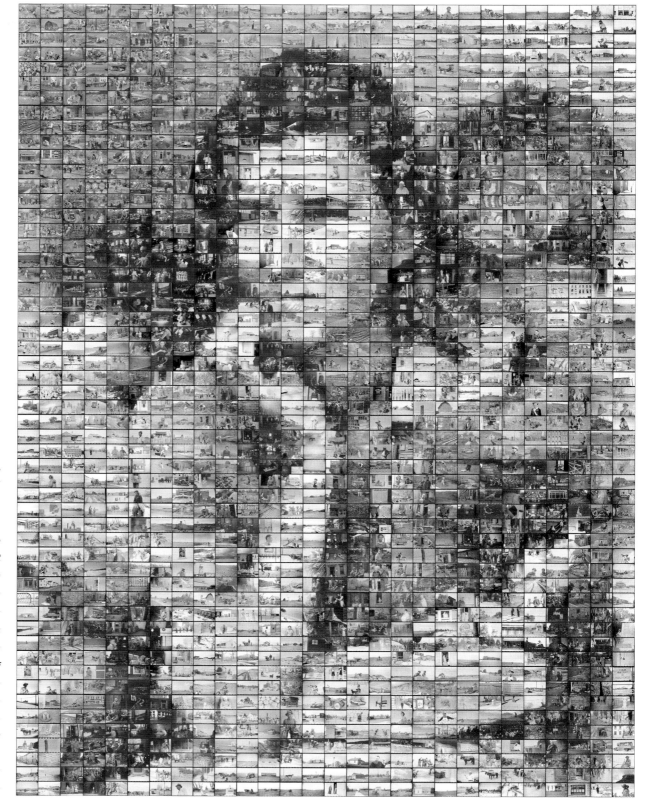

Robert Silvers,
Migrant Mother, 1997

ROBERT SILVERS

** 1968 in New York. Robert
Silvers works with the medium
of photo-mosaics. Out of an
almost infinite number of photo-
graphs he assembles motifs
that often reproduce famous
works from the history of
art or represent personalities
from the realms of politics
and cinema. To do this he uses
a software which he developed
himself, so that his works
might be designated as a kind
of "high-tech pointillism."*

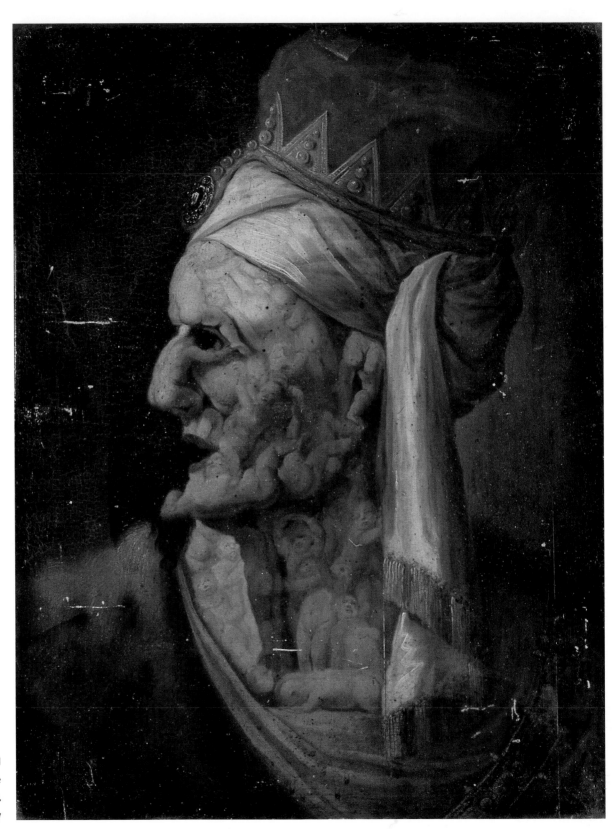

Anonymous, head of Herod
composed of the bodies of the
massacred innocents,
seventeenth century

Childhood

Salvador Dalí,
Portrait de mon frère mort
Portrait of My Dead Brother, 1963

DALÍ'S DEAD BROTHER

For the first time in my life I experienced, with incomparable shudders, the absolute
truth about myself: a psychoanalytic thesis had revealed the drama that was at the
very basis of the tragic structure of my personality. It was a question of the unavoid-
able presence, in the depths of my being, of my dead brother, who was so hugely
loved by my parents that when I was born they gave me his name, Salvador. The shock
was terrible, like that of a revelation. It explains, moreover, the terrors that assailed
me every time I entered my parents' bedroom and saw the photograph of my dead
brother: a very beautiful child, bedecked in delicate lace, whose picture had been so
prettified that, by way of contrast, I would spend the whole night imagining this ideal
brother in a state of total putrefaction. I could go to sleep only by thinking about my
own death and accepting that I was in a coffin, finally at rest. Thanks to Pierre
Roumeguère, I have been able to prove that an archetypal myth like that of Castor and
Pollux has for me a sense of visceral reality.

Salvador Dalí, quoted in: Ian Gibson, The Shameful Life of Salvador Dalí
(London, 1997), p. 490.

Salvador Dalí,
Untitled (Donkey's head), 1936

DALÍ THE HALLUCINATOR

The great vaulted ceiling which sheltered the four sordid walls of the class was discolored by large brown moisture stains, whose irregular contours for some time constituted my whole consolation. In the course of my interminable and exhausting reveries, my eyes would untiringly follow the vague irregularities of these mouldy silhouettes and I saw rising from this chaos which was as formless as clouds progressively concrete images which by degrees became endowed with an increasingly precise, detailed and realistic personality.

From day to day, after a certain effort, I succeeded in recovering each of the images which I had seen the day before and I would then continue to perfect my hallucinatory work; when by dint of habit one of the discovered images became too familiar, it would gradually lose its emotive interest and would instantaneously become metamorphosed into "something else", so that the same formal pretext would lend itself just as readily to being interpreted successively by the most diverse and contradictory figurations, and this would go on to infinity.

The astonishing thing about this phenomenon (which was to become the keystone of my future esthetic) was that having once seen one of these images I could always thereafter see it again at the mere dictate of my will, and not only in its original form but almost always further corrected and augmented in such a manner that its improvement was instantaneous and automatic.

Salvador Dalí, The Secret Life of Salvador Dalí *(London, 1949), p. 45–6.*

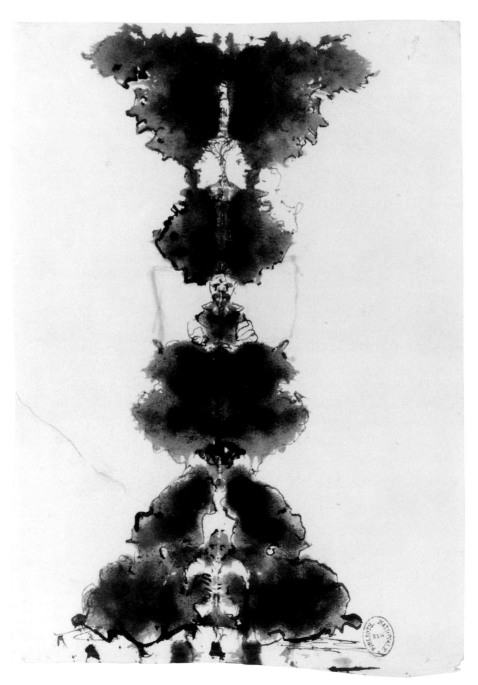

Victor Hugo,
ink blot on folded paper, c. 1850

VICTOR HUGO

** 1802 in Besançon, † 1885
in Paris. The French poet and
novelist turned his hand to
caricatures at an early age.
Apart from the basics of
engraving, which he acquired
under Maxime Lalanne in 1863,
he was completely self-taught.
A journey to Switzerland and
Burgundy in 1825 spurred his
enthusiasm for historical
monuments and inspired him to
make sketches of landscapes
and buildings which are a blend
of archaeological interest
and dramatic mise-en-scène.
This romantic feature of his
drawings intensified, resulting
in fantastic architectural
inventions more typical of an
oriental fairy-tale world.
In addition to brush, pencil,
paint, and ink, he also used
goose feathers, matches,
coffee grounds, and cigar ash
as artistic tools.*

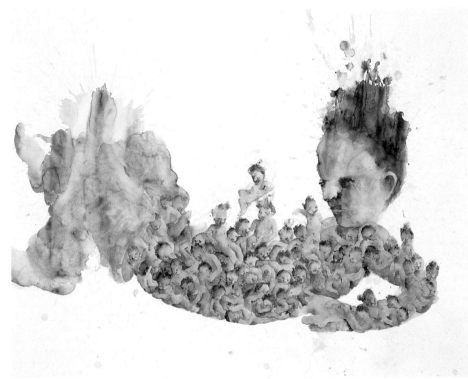

MICHAEL KALMBACH
** 1962 in Landau, Germany,
lives and works in Berlin and
Frankfurt am Main. After
studying at the Städelschule
Frankfurt under Michael
Croissant, Kalmbach started
producing plaster sculptures,
drawings, and watercolors.
The abstract formal world of his
sculptures and paintings is
occasionally reminiscent of
surrealist excrescences such as
those found in Yves Tanguy's
paintings. His watercolors
depict quasi-angelic youths,
sometimes using a composite
technique. In his watercolors
he works partly with a
composite process and depicts
angel-like child forms.*

Michael Kalmbach,
Untitled, 2002

OUT THERE AND IN **CHAPTER 2**

OUT THERE AND IN THEREER 2

Just as it had been easy for me, since Señor Traite's school, to repeat the experience of seeing "anything I wished" in the moisture stains on the vaults, and as I was able later to repeat this experience in the forms of the moving clouds of the summer storm at the Muli de la Torre, so even at the beginning of my adolescence this magic power of transforming the world beyond the limits of "visual images" burst through to the sentimental domains of my own life, so that I became master of that thaumaturgical faculty of being able at any moment and in any circumstance always, always to see something else, or on the other hand—what amounts to the same—"always to see the identical thing" in things that were different.
SALVADOR DALÍ*

■ Wild ideas about evoking the unity of creation and imbuing it with life by animating the whole of nature. External surroundings become completely active; cliffs, clouds, flowers, and trees are inhabited by both benevolent and malevolent monsters. Wherever we look, spirits, angels, wild animals, child-eaters, or the frightening figure of an authoritative father appear. Symmetrical mirror-images engender secret contents in which pretty flowers become wild companions. European and non-European anthropomorphic landscapes. This interpretation of the world is to be found in all cultures. *StA*

* *The Secret Life of Salvador Dalí* (London, 1949), p.118

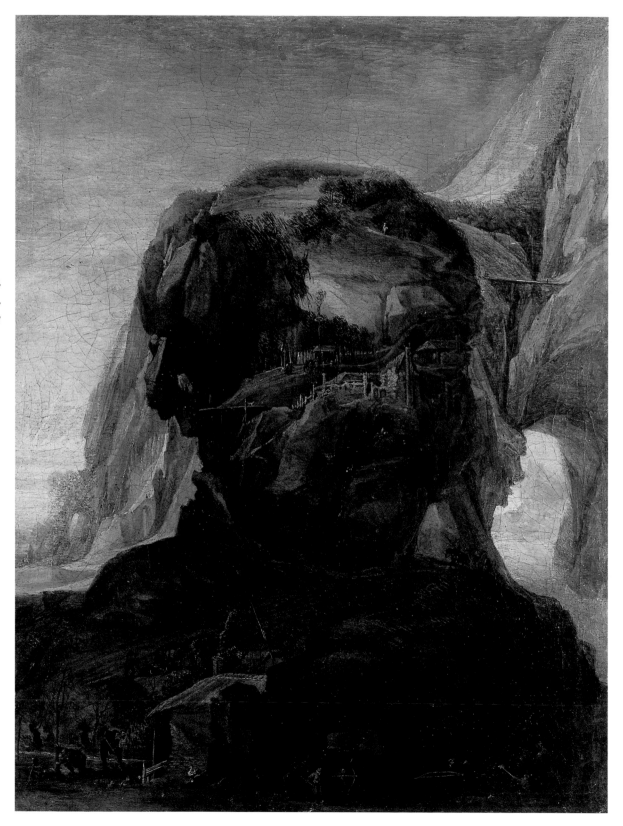

Josse de Momper,
Allegory of Spring,
seventeenth century

Josse de Momper,
Allegory of Summer,
seventeenth century

JOSSE DE MOMPER

** 1564 in Antwerp, † in 1635
Antwerp. The landscape painter
de Momper entered the Guild
of Saint Luke as early as 1581,
during his father's term of office
as dean. He himself presided
over that guild in 1611. The
oeuvre attributed to de Momper
is very diverse in terms of
composition, painting style, and
quality. What almost all
the paintings have in common,
however, is a mountainous
landscape. Some of these paint-
ings show anthropomorphic
landscapes which were later
rediscovered by the surrealists.
Based on the work of Pieter
Breughel the Elder, de Momper
perfected the creation of depth
of field. Artists like Jan Breughel
the Elder and the Younger and
David Teniers the Younger were
employed in his workshop.*

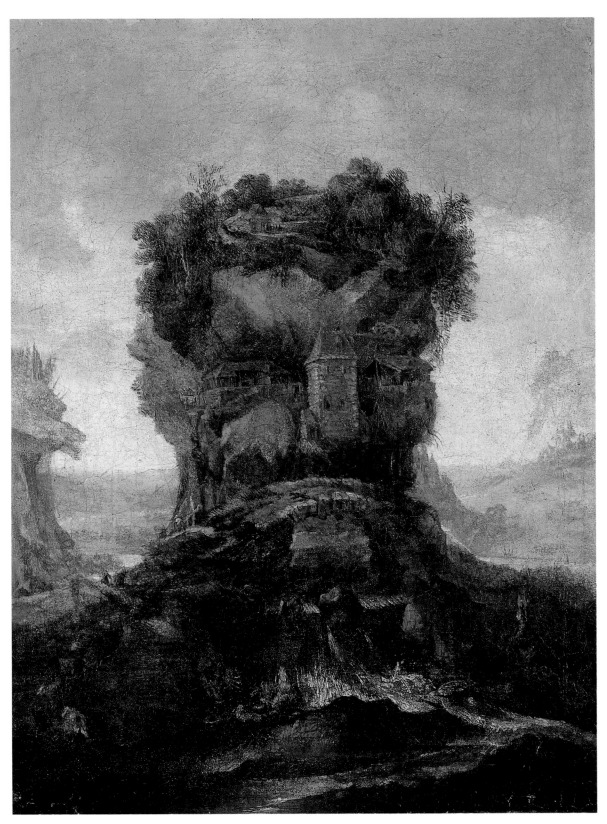

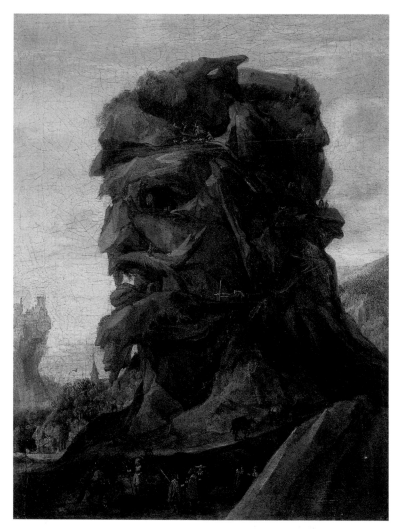

Josse de Momper,
Allegory of Autumn,
seventeenth century

■ The towering cliffs that our perception clearly associates with human heads—eyes, nose, and mouth seem to be clearly recognizable, though the next minute they are once again only trees, houses, and cliffs—are stamped with the dramatic quality of Flemish landscapes of the baroque and yet simultaneously recall the pictorial inventions of Arcimboldo. Art historians often lump these four paintings (fig. p. 62–65) together as a cycle of the seasons and associate them with the name of Josse de Momper. In fact, though, in his late work de Momper preferred close-up views, and especially in the 1620s he largely rejected framing motifs that draw the eye into the depths of the picture. Accordingly, central emphasis and the filling up of broad spaces were seen as hallmarks of his work. The anthropomorphic character of this painting, seeking to puzzle the eye of the beholder, must surely have been exceptional in his oeuvre. *HI*

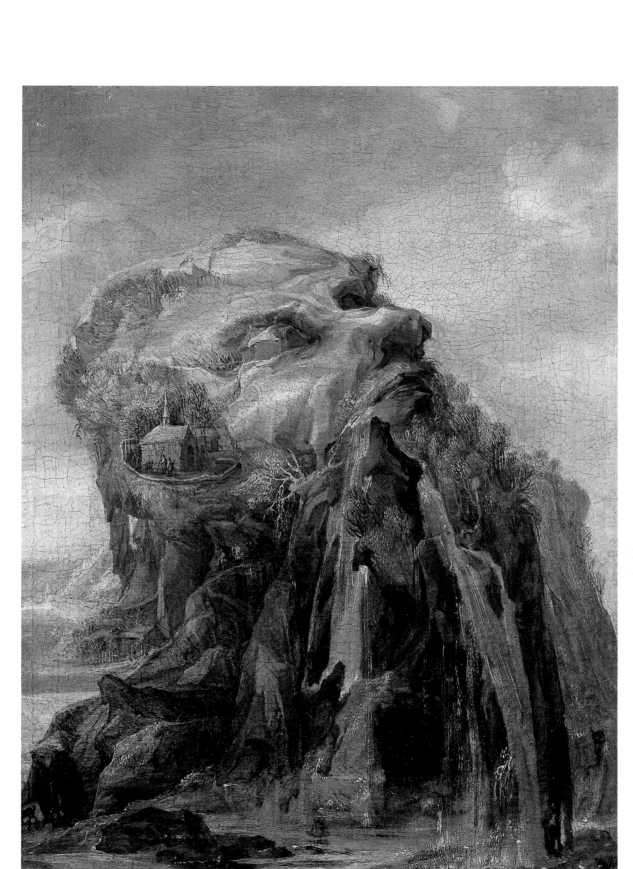

Josse de Momper,
Allegory of Winter,
seventeenth century

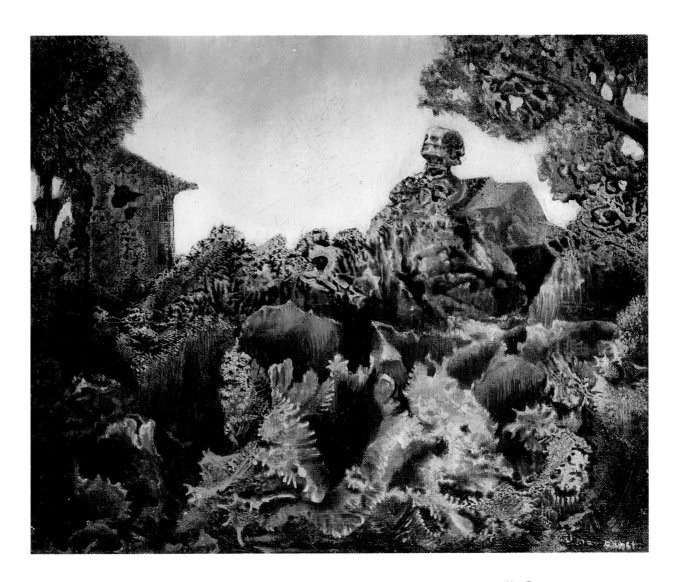

Max Ernst,
The Meal of the Sphinx, 1940

■ Q.: What is it like, a painter's daily round?
A.: To start with, in the morning he bores a hole in the crust of heaven that leads into nothingness. Then he beheads a pine tree and loses his way on his path through life. He inspects his hobby-horse, and then sets up his easel in front of it. He creeps under the earth's crust, and he's in a good mood. He paints a keyhole on the wall and through it discovers the weak flames of light.
He lets a couple of weak feathers of light take to the air. He greets a few dark gods and the nymph Echo. A footprint beside an open grave shows him that the day will be fine, the hill will be imbued with spirit, and humanity will know nothing about it.

Translated from: Max Ernst, Die Nacktheit der Frau ist weiser als die Lehre der Philosophen *(Cologne, 1970), pages unnumbered.*

Stones

Dreamstone, China,
late eighteenth century

■ In the southern Chinese province of Yunnan, long known for its marble, these highly artistic wafer-thin slices are cut from the block and polished. The characteristic colored veining is due to mineral deposits, and in China they are called "dreamstones," being regarded as invocations of the powers of the earth. Many such stones, whose markings are supposed to depict rugged or snow-covered mountains, are embellished with calligraphic symbols that serve as short poems or poetic passwords to interpret the imagined images. In the context of Far Eastern philosophy and religion, in which the synthesis of opposites plays a major role, dreamstones embody the harmony of the visible and invisible. *AZ*

Top left:
"Small bird," cut stone

Top right:
"Crown of Thorns," cut stone

Left:
"Fish," cut stone

"Landscape," cut stone

■ Various designations are attached to blocks of marble like this, though generally they are subsumed under the name of ruin marble. In the baroque period these objects were highly prized, and were known above all as Ferrara marble. The special characteristic of Ferrara marble is its chestnut-colored veining, which gives it a particularly lively texture. Ruin marble was also cut in other places, such as Salzburg and near Klosterneuburg. Its principal use was in luxury furniture.

Translated from: Eugen von Philippovich, Kuriositäten Antiquitäten: Bibliothek für Kunst- und Antiquitätenfreunde, *vol. 46 (Braunschweig, 1966), p. 76.*

Jacopo Ligozzi, *Mary Magdalene in the Desert*, sixteenth century

JACOPO LIGOZZI

** c. 1547 in Verona, † 1626 in Florence. The Italian painter, draftsman, and miniaturist served as court artist to the Florentine Grand Dukes Francis I to Ferdinand II, from 1575 onwards. As a draftsman with an interest in natural science, he was particularly taken by exotic animals and plants, but religious and secular allegorical works by him, some after old German models, have also survived. His keen powers of observation, his careful rendering, and his fine range of colors bear witness to Ligozzi's dual talent as draftsman and miniaturist.*

Antonio Tempesta, *The Rape of Europa*, sixteenth century

ANTONIO TEMPESTA

** 1555 in Florence, † 1630 in Rome. The Italian artist and copper-engraver was a pupil of Jan van der Straet and Santi di Tito. Under Giorgio Vasari's supervision he was involved in painting the Palazzo Vecchio in Florence. In Rome he was employed at the court of Pope Gregory XIII and while there devoted himself more and more to copper-engraving and etching. Some impressive late-sixteenth-century works on stone have been attributed to him.*

THE PAINTING GROUND AS SOURCE OF INSPIRATION

There is ample evidence from antiquity of painting done on stone. Finds mainly in Pompeii and Herculaneum indicate that as early as the first century A.D. artists used stone as a ground for their works. Inventories of important art collections in the late sixteenth century indicate that such objects enjoyed an increasing popularity at the time. If we are to give credence to Vasari's notes of 1568, then the first artist to rediscover and use this form of painting was Sebastiano del Piombo. Among his early works on stone is a depiction of the birth of the Virgin Mary in the Church of Santa Maria del Popolo in Rome. Del Piombo's choice of slate as the base for his painting meant he could avail himself of that stone's excellent resilience; it was not yet the case that the material inspiration emanated from the stone itself. This only became evident in the late sixteenth century when, in addition to slate, artists began to opt for different types of stone with particularly striking surfaces. Marble and lapis lazuli were especially popular, and the arteries, veins, and colored streaks in those types of stone inspired artists to various religious and mythological motifs.

A particularly beautiful example is the work by Antonio Tempesta reproducing one of the most frequently depicted episodes from Ovid's *Metamorphoses*. The scene shows the rape of Europa. Zeus, who has transformed himself into a bull in order to be able to kidnap Europa without being recognized, can been seen bearing his hostage across the sea. As Europa's companions are left behind gesticulating, his hind legs sink into the waves of stone; the offshore island is also formed by the grain of the stone, and Tempesta has merely painted in the sparse vegetation on the embankment.

This artistic notion of drawing creative impulses for the composition of a work from the natural constitution of the material can be regarded as being in the tradition of Leonardo da Vinci. In his *Trattato della pittura* Leonardo encourages artists to allow themselves to be inspired by the irregularities on the walls. *UH*

Antonio Tempesta, *Moses and the
Rock of Horeb*, sixteenth century

Andrea Meldolla (known as
La Schiavone), *Christ Supported
by an Angel*, first half of the
sixteenth century

Landscape Paranoia II

Jean Le Gac,
Les rochers; ou, L'escalade
The Rocks; or, The Ascent, 1973

JEAN LE GAC

** 1936 in Tamaris, France, lives
in Paris. Up to 1968 Jean le Gac
worked as an art tutor, painter,
and draftsman in Béthune.
His painted work ranges from
large-format abstract landscapes
to narrative pictures. His own
life as an artist has been the
main focus of his conceptual
approach to art. The relation-
ship between text and image
plays an important role in
his work. Le Gac often uses
illustrated booklets and
the books from his childhood.
After 1968 he turned to photo-
graphy and copies details from
nature onto paper by means
of slides and stencils. He is also
influenced by photographic
theory.*

Antoní Pitxot i Soler,
Sleeping Beach, 1974

ANTONI PITXOT I SOLER

** 1924 in Figueras, Spain, where*
he still lives. Pitxot comes
from a family of artists. His
uncle Ramón Pichot Gironés
was a close friend of Picasso's.
On numerous visits Pitxot
expressed his enthusiasm for
Dalí, leading to a friendship
in 1972. Dalí admired Pitxot's
work and invited him to
join him in building up the
Teatro-Museo in Figueras,
of which Pitxot is currently
director.

Bernard Voita,
Untitled, 1994

Bernard Voita,
Untitled, 1988

BERNARD VOITA
*1960 in Cully, Switzerland,
lives and works in Brussels.
Photographer, who has had
solo shows of his work in
Vevey, Nîmes, Paris, Essen,
Lausanne, Zurich, Brussels,
New York, and Geneva since
1988.*

Lois Renner, *Tower*, 1999

LOIS RENNER
** 1961 in Salzburg, lives in Vienna. From 1984 Renner studied at the Salzburg Mozarteum, moving to the Kunstakademie Düsseldorf in 1985. His photographs show, in ever-different variations, bewildering views of imaginary studios that nonetheless really exist, albeit on the scale of a miniature model. The carefully created images put our perceptions of perspective and of size relationships to the test.*

SUZANNE LAFONT
** 1949 in Nîmes, lives and works in Paris. Suzanne Lafont is a French photographer. In 1991 her work was honored with a one-woman show in Geneva.*

THOMAS HENNINGER
** 1971 in Offenburg. Painter, studied art at the Burg Giebich-stein College of Art and Design in Halle. Represented in the exhibition* Kunststudenten stellen aus *at the Kunst- und Ausstellungshalle der BRD in Bonn, 2001.*

Suzanne Lafont,
Les gardiens
The Guards, 1993

Thomas Henninger,
Wiegenlied 2
Lullaby 2, 2001

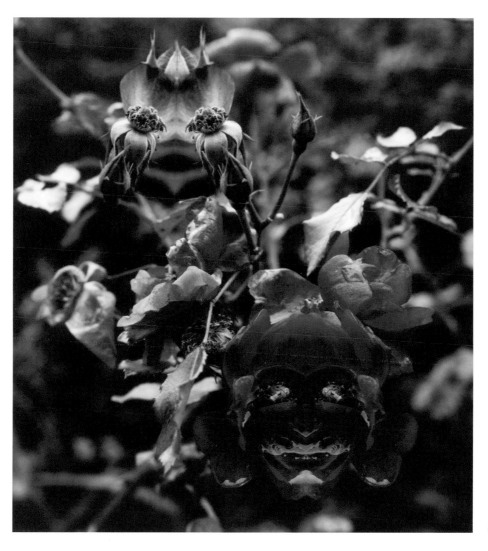

Christian Müller, *Rose*, 2000

CHRISTIAN MÜLLER
** 1961 in Wolfenbüttel. Studied
art in Kassel, then in Düsseldorf
with Fritz Schwegler, whose
principal pupil he became.
From 1989 to 1990 he was an
overseas student at the Academy
of Fine Arts in Alexandria
(Egypt).*

Landscape Paranoia III

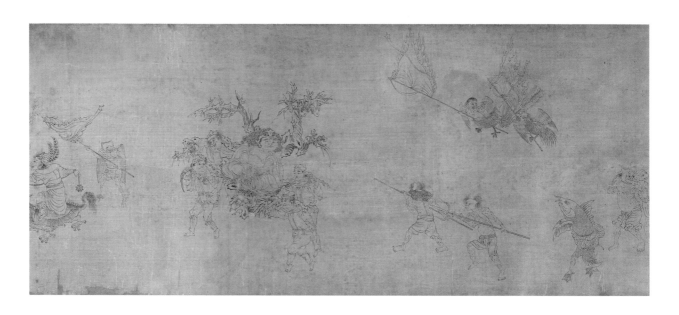

Li Longmian,
The Legend of Guizimu, 1081

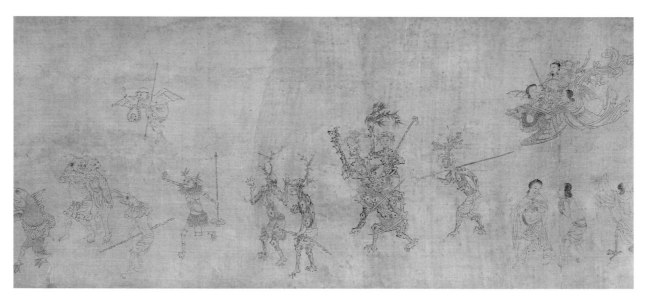

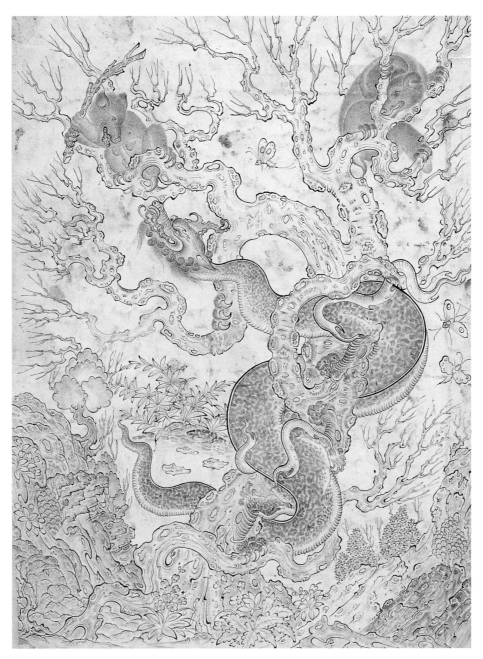

Follower of Mehmed Siyah Qalem,
*Pair of Bears Pursued by a
Dragon*, late fifteenth century

■ Both the Seljuks and also the Osmanli Turks, who were late converts to Islam, remained linked to their pre-Islamic tradition. The fifteenth-century work of Mehmed Siyah Qalem shows clear influences from Chinese painting. The protagonists of his pictures are often the leaders of nomadic tribes, who battle with the spirits and demons of the underworld.

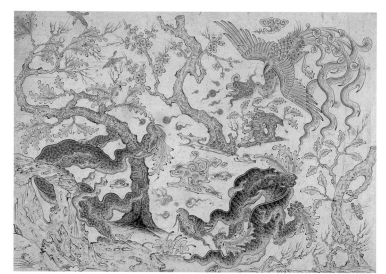

Follower of Mehmet Siyah Qalem,
The Dragon's Battle with the
Simurgh, late fifteenth century

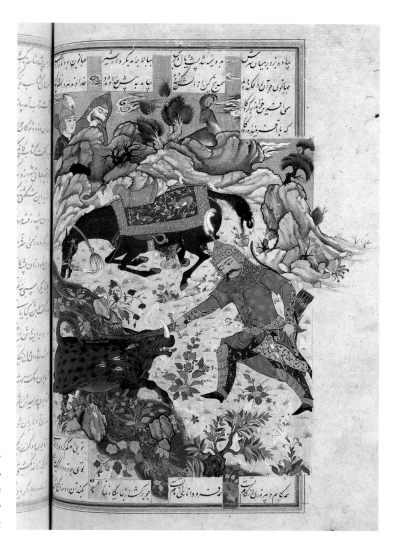

Anonymous, *Firdausi*,
Shahnama; Persian manuscript,
Iranian national epic poem
dating from 975–98 in a copy
made in 1605, p. 552

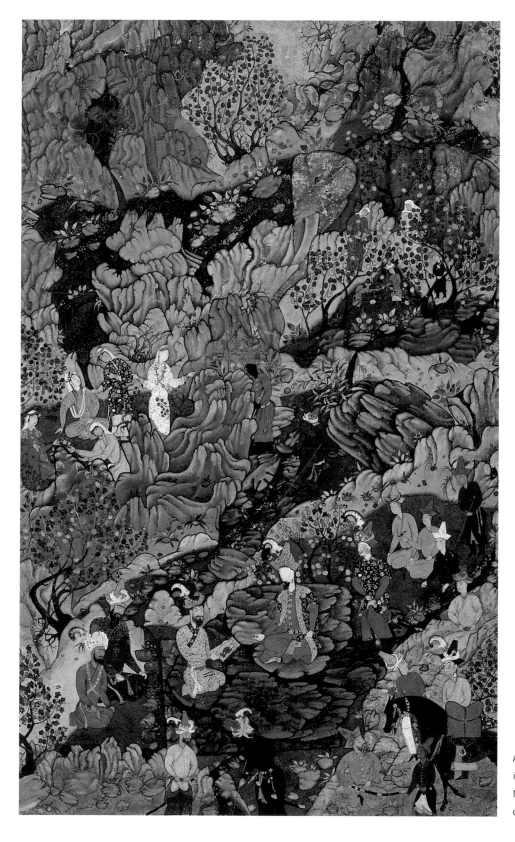

Anonymous, *Emperor Humayun
in the Mountains*, from: album of
Nur-ad-dîn Muhammad Jahangir,
c. 1551

Anonymous, *The Raven
and the Owls*; from the animal
fable collection *Kalila and Dimna*,
Persian manuscript, 1392

■ In our world every form has a living soul. God is able to direct our gaze, so that we recognize life even in that which seems to be inanimate. In the hereafter this revelation becomes a general principle. For this reason God also calls this other world the "animate abode." Truly, you will see no thing there that is not vested with life and capable of speaking—unlike the state of things here on earth. As it is written in the authentic tradition: "When placed on the palm of the Prophet's hand, even a stone will immediately start praising God." People believed that this event was extraordinary, but there is nothing special about it. Instead it is astonishing when a person succeeds in understanding words brought forth by things that seem by their nature to be mute.

Ibn' Arabi (1165-1240), al-Futûhât al-Makkiyya
(Thanks to Abdelwahab Meddeb for research and translation)

Anonymous, *Waqwaq* tree,
seventeenth century

THE TALKING TREE

This subject is not uncommon in Persian and Indian miniature painting but is very
variously treated. Once again, it relates to a tale that goes back to an ancient Indian
legend: during his Indian campaign, on the mythical island of Waqwâq, Alexander the
Great is said to have come across a tree composed of snakes' bodies, with humans and
animals growing from its branches. The onomatopoeic name mimics the language in
which the heads converse. *The Book of Marvels* says: "Waqwâqs are the beings that
most resemble humans. They are the fruits of great trees, from which they hang by
their hair. They have breasts and sexual organs like those of women." *StA*

Karin Rührdanz

THE ISLAMIC ORIENT: AMBIGUITY IN DÉCOR AND IMAGE

Playing with ambiguity—in the sense of the intermingling of natural forms experienced separately in reality but also the intermingling of abstract shapes—developed into an essential element of Islamic art at quite an early stage. Since the late seventh century the phenomenon has appeared repeatedly in various forms in the geographic area extending from Spain and North Africa to Central Asia and the Indian subcontinent. One early indication of this is the mosaics in the Dome of the Rock in Jerusalem, where branches of trees and tendrils are composed of decorative stones and pearls "grow" on the tendrils.

In later centuries this world of unusual combinations extended to representations of creatures with tortoise bodies and human heads, or humanlike forms with dogs' heads.[1] Believing in the unlimited richness of the creator's ideas, people met such images with astonishment, sometimes even horror, though they did not question the existence of the strange creatures. For both artists and observers they were merely imitations of creatures that existed in nature—components of the very rich plan of creation, which was perfect in its individual phenomenal forms and in their interrelationships.

Ornament, by contrast, was the field in which artist and artisan created multiple meanings based on original ideas. This interaction with the various fields of ornamental décor was fostered by a high degree of abstraction in the reproduction of natural forms, which developed within a brief period. The highly abstracted vegetal forms lent themselves especially well to being fused with calligraphic and geometrical elements or with figures of living creatures. Certain media and techniques that blurred the boundaries between object (with outline and interior drawing) and background were also particularly apposite. This can be seen in the plaster or wood décor used to fill in spaces or in the rock crystal decoration of the Abbasid and Fatimid periods. But even there, where the décor was essentially borne by a single pictorial object, ambiguity proliferated. Birds are relatively common, with outspread wings that are transformed into

palmettes or flowers, or occasionally merging into tendrils where the motif was repeated many times.

Vegetal and figurative forms were, in all media, closely connected to calligraphic décor. The long verticals of Kufi script seemed to cry out to be transformed into the stems of tendrils or leaves. Dots at the end of the hastae

Anonymous, fragment of a decoration in the form of a bird, Egypt, late ninth century

were associated with faces as early as the eleventh century, and later the verticals grew heads and arms; finally, like the other parts of letters, they developed into human and animal figures. The full development of this transformation, however, is found only in metal works of the late twelfth and thirteenth centuries.

Often the elements of which the newly created form is composed are clearly visible on closer examination, but sometimes it is simply left to the observer's eyes to work them out. The aesthetic pleasure in the play with unexpected forms certainly united the artist and the observer. "For the moment that triggers the aesthetic appreciation and the effect of beauty ... consists in seeing two things as equal and opposite, at once corresponding and yet different."[2] The function of ambiguity in ornamental décor can thus be easily understood from an aesthetic perspective: it produced an intensification of pleasure by means of its surprise effect and the demonstration of artistic virtuosity.[3] Taking a model from nature and making it abstract, as the first step, and then overcoming it in ambiguity, as the second step, would then have been understood as a way of perfecting nature through art.[4]

The question of the interpretation of subject matter arises both for each new construction of forms and for the phenomenon of ambiguity in general. In any given case, it can only very rarely be answered. Tendrils that terminate in animal or human heads, or on which such heads are placed, naturally suggest the idea of the "Talking Tree" (the waqwaq motif, fig. p. 95), one of the strange things at the edge of the world.[5] When, however, the handle and base of a pot form vegetal shapes, a consensus on the interpretation of its significance seems neither possible nor desirable. This is not true of the phenomenon in general. If we understand the richness and elaborated organization of the ornamental décor as a form of abstract reflection on the world and its transcendental creator,[6] then the fusing of forms habitually experienced separately would fit well into this view: as an allusion to the transitions and connections within a subtle network that is only partially accessible to human perception.

The occurrence of ambiguous forms in ornamental décor was both chronologically and regionally uneven.

They appear to have been more frequent in the classical Abbasid period (ninth and tenth centuries) and in the area under Fatimid rule during the tenth through twelfth centuries than in the late Abbasid caliphate (eleventh through thirteenth centuries), which, despite bewildering combinations of vegetal, geometric, figural, and epigraphic décor, was dominated by a clear differentiation of the individual forms. Only the "animated script" (script with anthropomorphic and zoomorphic letters) and the waqwaq motif moved toward other emphases, especially in the thirteenth century. The possibility cannot be ruled out that the tendency to ambiguity was repressed for a time during a phase of the revival and consolidation of orthodox Sunni ideas,[7] which tended to prefer clarity even in multiplicity.

A comparably widespread phenomenon, but one that manifested itself in turn in a highly differentiated way, is found in the "rock faces" that first appear in Persian miniatures in the fourteenth century and that continue to be found in Persian painting into the seventeenth century. This phrase is used to characterize a specific way of outlining rocks in whose structure an attentive observer will perceive faces and heads, and in rare cases even complete animal figures. They are often rendered with great delicacy of line and gradation of color. Sometimes, even mere dots and tiny circles near the edges of the rock formations can coax us into seeing them as eyes or mouths and consequently, discovering the profiles of living creatures in the contours.

Bernard O'Kane has collected a series of such examples, some more convincing than others.[8] The artistic idea was transmitted through Chinese painting, whose landscapes strongly influenced Persian painting from the thirteenth century on and led to the development of a new way of depicting landscape. The idea's acceptance, in O'Kane's view, was based on human experience with ambiguous rock formations in nature and the pleasure of both artist and viewer in playing with hidden forms.

Such works were no doubt playing with the astonishing detail as well. Given the formal constraints within which classical Persian miniature painting developed, it was not least in the detail that a painter could give his work something special: evidence of particular skill in

CHAPTER 3

BEHIND THE WORLD OF THINGS

One cannot begin a poem without a tiny seed of error about oneself and the world,
without a trace of innocence at the first words
RENÉ CHAR

■ "Markus Raetz's ideas appear to form a kind of circular movement," writes a friend
of the artist. This chapter is dedicated entirely to this Swiss artist, whose lifework deals
with ambiguity, interpretability, and the subjective perspective. Circling around turns
a head on its head, a bottle becomes a glass and the glass a bottle. Behind the world of
things we discover how much hare is in Beuys, and "yes" quarrels with "no." A bright
enchanted chapter to put the viewer in a spin. *StA*

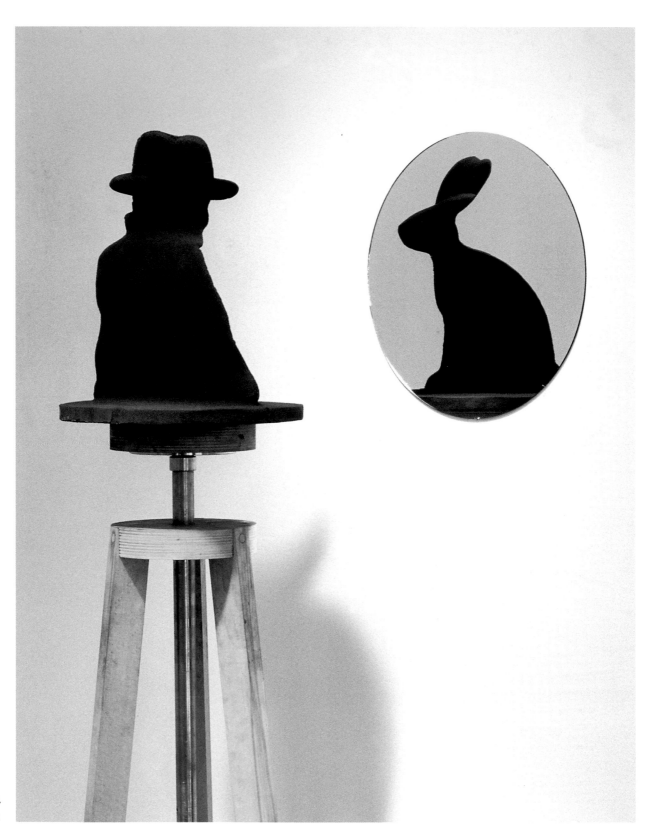

Markus Raetz,
Metamorphose II, 1991

EXPOSING PERCEPTION AS A PROCESS

At first glance Markus Raetz's works would seem to transpose a spontaneous idea; on closer observation, however, we realize that they are based on an intense involvement with human perception. They make the observer aware of the whole process of perception, promoting a form of conscious seeing.

Normally we look at paintings from the front and complement what we see by our idea of what we have seen. We try to understand sculptures by walking round them and unifying what we have seen to form a whole in our memory. Markus Raetz's works reveal themselves to us not when we add up our perceptive sequences, but only at that moment when we reflect on perception. To conjure up that moment the artist playfully uses a kind of successive surprise effect.

In his sculptures in particular he exploits our impulse to move, leading the movement around the sculpture on to an act of reflection on perception. The successive element in movement gives rise to a processual perception. The apparently unambiguous object reveals its ambiguity when the observer's standpoint is shifted. The altered perspective transforms the "yes" just perceived into an equally clear "no." By allowing what is seen to be turned into its opposite, Markus Raetz encourages us to question both our perception and our powers of judgment. This procedure is both deeply ironic and poetic. Markus Raetz condenses the components work, movement, process, and perception, with the result that we are confronted with the brittleness of our subjective observation.

The materials Markus Raetz uses for his works are very diverse. For him, the material is not just a carrier for what he wants to express, instead it is examined in terms of its capacity to instigate perception. Thus a bent wire can combine the perception of light and shade and also achieve the effect of line and plane. By testing the materials in this way, Markus Raetz ultimately touches on the question of the creative process. The main theme of his work, however, from its genesis to its reception by the observer, is always perception. *UH*

MARKUS RAETZ

** 1941 in Büren an der Aare, Switzerland, lives in Berne. Markus Raetz is a central figure in the generation of "artistic truth-seekers." His parallel juxtaposition of the conceptual and precise and the intuitive and playfully effervescent mirrors a concept of a world that is mathematically and structurally based, but one in which any intervention can lead to change and chaos. Translated from: Schweizerisches Institut für Kunstwissenschaft (ed.),* Biografisches Lexikon der Schweizer Kunst *(Zurich and Lausanne), p. 848.*

 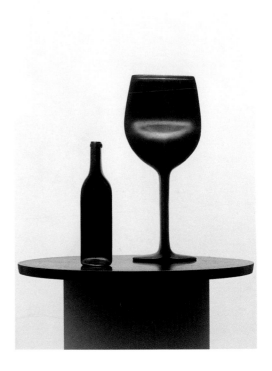

Markus Raetz, *Groß und klein*
Big and Small, 1992–3

Markus Raetz, *Kopf I*
Head I, 1992

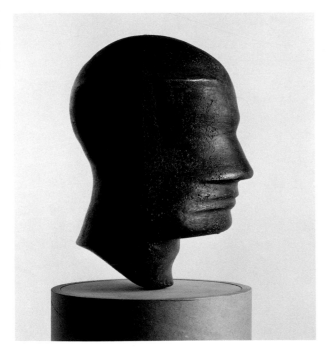 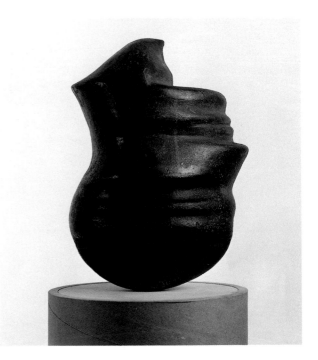

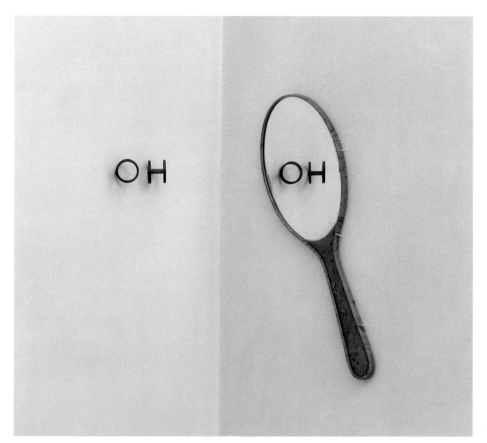

Markus Raetz, *Echo*, 1993–6

Markus Raetz,
Impressions d'Afrique
Impressions from Africa, 1980

When you are thinking of it least, the grasshopper springs! Horror of horrors! And it was always thus. At the heightened moment of my most ecstatic contemplations and visualizations, the grasshopper would spring! Heavy, unconscious, anguishing, its frightfully paralyzing leap reflected in a start of terror that shook my whole being to its depths. Grasshopper - loathsome insect!
SALVADOR DALÍ*

■ Just as in the second chapter dead nature was transformed into a landscape of souls, so here living nature withdraws and becomes submerged in the background— for tactical reasons! Everyone knows what a shock it is when solid ground suddenly starts moving. Fear of the unreliability of one's own perception is gaining ground. *StA*

** The Secret Life of Salvador Dalí*
(London, 1949), p. 128.

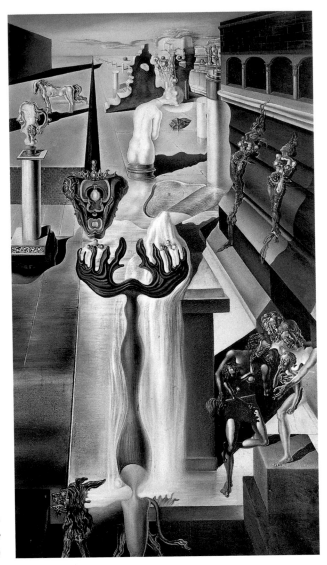

Salvador Dalí,
L'Homme invisible
The Invisible Man, 1929

THE CRITICAL PARANOIAC

In his *Minotaure* essay "Paranoiac-Critical Interpretation of the Obsessive Image of Millet's *Angelus*" (1933) and his diary, *The Secret Life of Salvador Dalí,* Dalí dates the birth of "critical paranoia" to 1929. In that year he met Lydia Sabana de Costa, a woman of around fifty, from whose fishermen sons Dalí and Gala acquired their first house in Cadaqués. In "Lydia of Cadaqués, godmother to my madness," who had already come to the notice of Picasso and the Spanish writer Eugenio d'Ors, Dalí encountered what he recalled as "the most marvelously paranoiac brain aside from my own that I have ever known. … She … plays on words that one could not fail to wonder at the bewildering imaginative violence with which the paranoiac spirit can project the image of our inner world upon the outer world, no matter where or in what form or on what pretext." Lydia's neologisms, sense compressions and flights of fancy, which Dalí "collected and analysed as paranoiac documents of the first order," were the main cause behind his creation of the first paranoiac anamorphosis in 1929—even though it has been

shown that at that time Dalí knew of Arcimboldo's anamorphic work from a conversation with the Spanish painter José María Sert (1876–1945). This source is explicitly mentioned in connection with the genesis of the anamorphic painting *Invisible Harp, Fine and Medium*. Probably the emblematized head that so often appears in Dalí's pictures, like the blazon of ubiquitous paranoiac activity, goes back to the grotesque phenomenon of Lydia. The very first anamorphic work is a sketch drawing, *Study for the Invisible Man* of 1929, which gave rise to the first critical-paranoiac painting *The Invisible Man* in the same year. This depicts in outline a man of whom the modeling inside the outline, after considerable contemplation, becomes transparent and dissolves into a landscape. Or, *vice versa*, the elements of the landscape coalesce into the shape of a seated man. This reversibility in the function of the outlines gives rise to the double-view of a man and of a landscape.

All the same, the reversal of outline function, the optical ambivalence or coalescence, is only the formal aspect of anamorphosis: the perceived exterior of an internal psychic complex. That complex finds expression in the encoded symbolic form of the anamorphosis. For Dalí, the right way to perceive the anamorphosis is to enjoy simultaneously the sensual pleasure of an optical deception and the cerebral challenge of decoding a psychical complex symbolically hidden within that. The loss of clear visual contours in a puzzle picture can correspond in psychological terms to a crisis of personal identity, the phenomenon of divided consciousness.

Translated from: Peter Gorsen, "Der kritische Paranoiker," in Axel Matthes and Tilbert Diego Stegmann (eds.), Salvador Dalí: Unabhängigkeitserklärung der Phantasie und Erklärung der Rechte des Menschen auf seine Verrücktheit: Gesammelte Schriften *(Munich, 1974), p. 467–8.*
© 1974 by Rogner & Bernhard GmbH & Co. Verlags KG, Hamburg.

It now seemed to me indispensable to my treatise to set up a system of connections that allowed me, for example, to set aside the perspectival inconsistencies whose meaning in Vermeer and Giorgio de Chirico I had long studied (at least cursorily). I am thinking of the analytical inadequacy of the section in which I claim, on grounds of perspectival inconsistencies combined with illumination, to prove the unconsciously somber ambiance of these two painters. Specifically, I think of Vermeer's painting known as The Letter. *It is impossible for me to imagine it as a whole and as clearly as I want to. This is because of the exciting significance that the curtain in the left foreground of the picture has just radiated—has just unleashed. . . . I have just located the curtain from Vermeer's picture in a dream I had a few days ago. In the dream this curtain—absolutely identical in its form, its placing, and especially its emotional and moral significance—covers several small cows in the depths of a very gloomy cowshed in which I, lying on ordure and befouled straw and highly aroused by the place's stink, am sodomizing the woman I love.*

SALVADOR DALÍ*

■ Paintings imbued with great force and mystery. Dalí's attempt to detach himself from the superego in the figure of the father and of Vermeer. The most compelling and mysterious picture puzzles, very magical, metamorphotic. The father gave the child Gowan's Art Books, his first encounter with Vermeer's *Woman Reading a Letter.* *StA*

* Translated from "Träumerei," in: Axel Matthes and Tilbert Diego Stegmann (eds.), *Salvador Dalí: Unabhängigkeitserklärung der Phantasie und Erklärung der Rechte des Menschen auf seine Verrücktheit: Gesammelte Schriften* (Munich, 1974), p. 467 f. © 1974 by Rogner & Bernhard GmbH & Co. Verlags KG, Hamburg

Salvador Dalí,
L'image disparaît
The Image Disappears, 1938

Salvador Dalí,
*Métamorphose d'un buste
d'homme en scène inspirée par
Vermeer: La triple image
Metamorphosis of a Man's Bust
into a Scene Inspired by
Vermeer: The Triple Image*, 1939

Salvador Dalí, illustration to
Les chants de Maldoror, c. 1933

CLASSICAL GREEK FORM

115

Salvador Dalí, *Double image:*
Profil classique et une personne
Double Image: Classical Profile
and a Person, c. 1940

Salvador Dalí, *Doubles images*
Double Images, c. 1940

Dawn Ades

DALÍ'S OPTICAL ILLUSIONS

Sigmund Freud was one of many who have been dazzled, whether in admiration or with disapproval, by Dalí's virtuosity as a painter. By contrast with both modernist and surrealist painters who have tried to unlearn skills in the interests of the spontaneous and the idea of an authenticity of innocence, Dalí unashamedly displayed his gifts and his technical learning as a painter. But about this Dalí was himself ambivalent. The relationship between his ever-increasing command of optical and representational devices and his purposes as an artist was a complex matter.

In late conversations Dalí scorned his own abilities, saying of his pictures that "They don't count pictorially. They're badly painted ... If you compare me with any classical painter whatsoever then I'm an absolute nonentity."[1] But his confession—for someone not given to modesty—that he would be incapable of doing even a mediocre copy of a canvas by Bouguereau or Meissonier[2] was made in the full awareness that these nineteenth-century academic painters were the most reviled by twentieth-century artists; no one else was even trying to emulate them, and moreover if Dalí described his pictures as badly painted, they were still in his estimation and by these unregarded standards incomparably better than anyone else's. The models against which he later measured himself were Vermeer, Velázquez, Raphael, and Leonardo. This line of enquiry, in these terms, is a dead end; what mattered in the deployment of skill was its purposes and possibilities. For Dalí "the pictorial means of expression are concentrated on the subject,"[3] not to be wondered at for their own sake.

The pleasure, though, that Dalí took at that baptismal moment in 1929 when he both entered the surrealist movement and a life-long relationship with his future wife Gala, in painting "such tiny things so well, and even better when enlarging them" was a cause of hesitation for the surrealists.[4] Breton, in this ambiguous praise, was weighing up Dalí's pride in painting, among the other "fleas" (or flaws) in his personality (such as his pride in Catalonia and Spain, which affronted the surrealists' anti-nationalism), against his unrivalled powers of "voluntary hallucination" and mental liberation. Technical

ingenuity or even visual pleasure for its own sake was suspect for the surrealists. There was basic agreement with Dalí that painting should be at the service of an exploration of the labyrinths of the mind, unconscious and conscious. But whereas for them the visual means were ideally meager or transparent—the rudimentary record of a dream, chance gestures, found objects—Dalí increasingly persuaded himself of the imperative to make his paintings as convincing, deceptive, and illusionistic as possible. His aim, put crudely, was to give form to the formless and invisible, to dreams, reveries, delusions, desires, and fears. His ambition, both in what he was aware of depicting and what remained fortuitous and concealed was to make the world of the imagination "as objectively evident, consistent, durable, as persuasively, cognoscitively, and communicably thick as the exterior world of phenomenal reality."[5] His desire to give substance to the phantoms destined always to remain virtual led to one of the most sustained investigations into the relationship between vision, perception, and representation of the century.

To make the irrational concrete was not a matter of illustrating fantasies. Dalí's text *The Conquest of the Irrational* rewards close attention, not least for the conflicting attitudes it reveals to his own work. Impatience and frustration both with its powers and its shortcomings are evident in his verbally abusive comments on "clever tricks," "abjectly arriviste and irresistible mimetic art," and "analytically narrative and discredited academicism." While abasing these practices he simultaneously elevates them as part of his pictorial armory. The two main representational modes he annexes here for his own practice are color photography and what he calls "great realist painting—Velázquez and Vermeer de Delft." These should not be elided—both are regarded as analogies to his own practice as well as resources for a particular kind of materialization of his ideas. It is not a matter of "painting photographically," although "precision" is the aim, for the materialization can only be within and through the process of making an image.

The photographic model for Dalí is that of instantaneity, a sudden and total but hitherto unknown image. The special resources of painting, on the other hand, are to do with texture, light, tone, perspective; scale-manip-

ulable, associative, and suggestive. On both of these models Dalí was to draw, linking and expanding both of them in conjunction with the "discoveries" of modern science.

The gap between Freud's appreciation of Dalí and the painter's anticipation of their encounter is poignant and also highlights the difficulty of the role that Dalí intended painting to play. Dalí had taken with him to show Freud his painting *The Metamorphosis of Narcissus* (fig. p. 189), fully cognizant of Freud's work on the subject of narcissism and prepared to explain his intentions with all the eloquence of his own poem on the subject, and also his article on paranoia from *Minotaure* (probably "Interpretation paranoiaque—critique de l`image obsédante *'L'Angélus' de Millet"*). Freud, old and sick, was also suffering from hearing problems that day: instead of listening to Dalí, he watched him. Afterwards he thanked Stefan Zweig for bringing the young Spaniard "with his candid fanatic's eyes and his undeniable technical mastery,"[6] who led him to revise his low opinion of the surrealists. But Freud's assessment of Dalí was based on a double misapprehension: firstly of the nature of his "technical mastery," and secondly of the consequences of Dalí's familiarity with psychoanalysis. Freud found that Dalí's "mystery was manifested outright," that he had done the work of analysis for himself, and thus that his paintings were the result of conscious rather than unconscious thought. For Freud, the interest of a painting or work of literature lay in what it revealed unconsciously of the mechanisms of dreams or neuroses, though he admits that it "would be most interesting to study analytically the genesis of a picture of this type."[7] Whether this made of Dalí's paintings more or less of a "psycho-pathological document" in Freud's view is unclear, but it is evident that he misprised Dalí's pictorial ambitions and creative use of psychoanalytical ideas. However cognizant of the ideas of psychoanalysis the painter might be, the pictorial mechanisms by which they are made manifest remains a matter for invention. Moreover, psychoanalysis is only one of many sets of ideas cannibalized by Dalí. "The new frenzied images of concrete irrationality tend toward their real and physical possibility." They go beyond the domain of psychoanalyzable "virtual hallucinations and manifestations."[8]

Although Dalí was one of the most prolific of twentieth-century painters, he has, curiously, much in common with one of the most restrained and fastidious, Marcel Duchamp. Both rejected the idea that painting should address itself only to the eye—the dominance since Courbet of the "retinal frisson" as Duchamp called it[9]—while at the same time exploring purely optical phenomena as part of an investigation into the complex nature of perception. To re-engage visual art with the mind and with human experience as a whole runs counter to the idea of the autonomy of visual experience that has by and large conditioned modernism. Both artists also envisaged a close dialogue between their writing and their visual work, another divergence from modernist orthodoxy. Dalí was, in fact, as prolific and diverse a writer as he was an artist,[10] and his writings both undermine the idea of the autonomy and selfsufficiency of the paintings, and reveal his ideas about the problems and possibilities of art and visual representation in a mechanical and post-Freudian world subject to scientific rather than metaphysical definitions.

Dalí regarded himself as "swimming between two kinds of water, the cold water of art and the warm water of science."[11] His work was sustained by an omnivorous and eclectic curiosity in contemporary science: physics, genetics, and mathematics, and a passion for observing the natural world and especially insect and marine life. His interests in the field of optics, of perception, of vision and the visible also brought his art into conjunction with science. Dalí was, though, deeply skeptical of the claims of rational science to explain the real: "The world of logical and allegedly experimental reason, as nineteenth century science bequeathed it to us, is in immense disrepute. The very method of knowledge is suspect. The equation has been formulated by skipping over the unknowns ... In the end it will finally be officially recognized that reality as we have baptized it is a greater illusion than the dream world."[12]

These "unknowns" would have included the relations between eye and brain, dream and the unconscious, as well as the physical nature of the universe. From the perspective of an amateur scientist the latitude for imaginative speculation, the possibilities of giving visual form via the analogical and symbolic to invisible structures,

forces, and motions seemed immense. He liked to say that "fifteen years before Crick and Watson I drew the spiral of the structure of DNA (the basis of all life),"[13] and claimed that he was "capable of conceiving the discontinuity of matter by watching flies fly and understanding the significance of their Brownian movements."

The surrealists underpinned their objection to the narrow definition of "reality" as it was understood under the auspices of rationalism and the "reign of logic" with the ideas of the new science of psychoanalysis, which they felt had proved beyond doubt the existence of an extended psychic reality. The mind contained, as Breton argued in the first *Surrealist Manifesto* (1924), hidden forces manifested in such things as dreams, parapraxes, and neuroses which are a no less real experience for the human subject than that of the external world. Surrealism was a significant part of a more general movement not only in psychoanalysis but also in physiology and physics itself that questioned the empirical foundations of knowledge and sought to understand the concealed mechanisms that condition reality.

It is now generally accepted that the "reality" of the object world as given to us by immediate experience is misleading; the "real" character of color, or of matter, for example, are not derivable from optical or tactical principles. The incredible speed and complexity of perception gives us knowledge of our own sensations, but its relation to consciousness, let alone the unconscious, is still little understood.[14] The fallibility of perception and the strange role of illusion have been studied equally avidly by physiologists, psychologists, and psychoanalysts. But the role of memory, of association, and of cultural patterning in what we see, or the eruption of hypnagogic images as we fall asleep, or the delusional readings of the world in paranoia—and here we are squarely in terrain appropriated by Dalí—remain largely unexplained. The long pursuit in pictorial representation of methods of deceiving the eye to persuade it of the "truth" of what it sees, and the invention of technologies to replicate the visible world as accurately as possible always existed in some relation to an idea of "reality." In the twentieth century it could be said that "reality" has been sought in the hidden mechanisms of psychic and political life, in what is concealed rather than revealed.

In consequence, the status of the "visual" has been rendered problematic, even devalued. Modernism in art is concerned with the abstract, the formal, the conceptual, the pure material object. Surrealism alone has systematically sought the interface between internal and external realities, illusion and vision, perception and thought.

Dalí confronted this problem with energy, not just in his construction of an iconography rooted in psychoanalysis but in a closely linked and wide-ranging exploration of the relations between perception, vision, and optical effects. This exploration was conducted both in his extensive writings, and in paintings, photography, photomontages, collages, films, prints, the construction of objects, and installations. "Experiment" is a term frowned on in the context of modern art, with its connotations of a future aim, a search, not necessarily achieved, which consorts badly with artistic practices that value the medium, or accept the found, in their own right; as Picasso is often quoted as saying "I never seek, I only find." But Dalí undoubtedly conducted what we and he would understand as visual experiments, especially towards the end of his life with holograms and stereoscopy. He also explored the laws and possibilities of perspective, which "even today poses unresolved problems,"[15] and the technological inventions in the photographic field, which provided him with some of his most sustained and flexible resources.

In the early decades of the twentieth century photography began to be valued not as a reflective but as a revelatory mechanism. A persistent but theoretically awkward current began to link it to the idea of an unconscious, even if metaphorically. André Breton described automatic writing as a "true photography of thought," and went on in the same 1921 text to recognize a new reality through the camera:

"As the use of slow motion and fast motion cameras becomes more general, as we grow accustomed to seeing oaks spring up and antelopes float though the air, we begin to foresee with extreme emotion what this timespace of which people are talking may be. Soon the expression 'as far as the eye can reach' will seem to us devoid of meaning, that is, we shall perceive the passage from birth to death without so much as blinking, and we shall observe infinitesimal variations."[16]

Very early in his career, before making the definitive move to Surrealism, Dalí began to argue for a distinctive role for photography in its capacity to surprise and reveal the unknown or unseen, what Walter Benjamin was later to call its "unconscious optics."[17] Dalí was indebted to Moholy-Nagy, who wrote in *Painting Photography Film*: "The photographic camera [can] make visible existences which cannot be perceived or taken in by our optical instrument, the eye,"[18] and borrowed his examples. For Moholy-Nagy microscopic photography, close-up enlargements, long exposure, X-rays, the instantaneous arrest of movement were the beginning of "objective vision." Dalí, on the other hand, perceived the extraordinary register of a new world provided by such photography, not in terms of a futurist utopia, with a mechanical device supplementing and complementing man, but of a new poetic medium which would capture the "most delicate osmoses which exist between reality and surreality."[19] He was evidently contemplating, if initially rejecting, a comparison with the unconscious "Photographic imagination! More agile and rapider in discoveries than the murky subconscious processes!"[20] but welcomed photography's capacity for total invention and "the capture of an unknown reality."[21] We are in 1928, and Dalí is still testing out his responses to Surrealism, joining the movement the following summer. By then, he and Buñuel had fully justified the camera as a poetic instrument at the service of Surrealism in their film in *An andalusian Dog*, made in the spring of 1929. This film caused a sensation in Paris avant-garde circles, being totally unlike the kind of experimental abstract film then in vogue. *An andalusian Dog* makes use of close-ups, slow motion, superimposition, montage, and fades but always linked concretely to the imaginary, to the dreams and desires of the protagonists.

Dalí's earliest memory of the magical power of moving pictures was an "optical theater" that he saw at the age of seven in the private study of his ancient school teacher. This must have belonged to the family of scientific optical toys invented during the latter part of the nineteenth century in that urge to add movement to the photographic capturing of "reality" that also produced the cinema. But despite the detailed descriptions in his autobiographies, its exact identity is unclear. The strobo-

scope, phanakistoscope, and zoetrope all produce the illusions of a moving image, but as Dalí persists in calling it "stereoscopic," it must also have produced the illusion of three-dimensionality: "a kind of stereoscope that took on all the hues of the prism and ran moving pictures before your eyes,"[22] and again "The pictures themselves were edged and dotted with colored holes lighted from behind and were transformed one into another in an incomprehensible way that could be compared only to the metamorphoses of the so-called 'hypnagogic' images which appear to us in the state of 'half-slumber.'"[23] It may have been the stereophantoscope, which "Helmholtz described as using 'revolving stroboscopic disks … in the panoramic stereoscope' to create wide-angle views of moving forms in three dimensions."[24] Dalí later returned to stereoscopy himself, but the images of this magical theater had another significance: among them was one of a little Russian girl swathed in white furs, riding in a troika and chased by wolves with phosphorescent eyes. "She was looking out at me,"[25] Dalí remembered, and so strong was the sensation that not only was he looking at her but that she was also returning his gaze, that this image took on a determining role in his life, and Dalí was to identify it with his Russian wife, Gala, whom he met in the summer of 1929 when she and a party of surrealists visited him at Cadaques.

The invention of the stereoscope, and of subsequent attempts to create three-dimensional effects in the cinema like Todd-AO, were aimed at producing some of the functions of binocular vision. Stereoscopes—with two lenses through which the viewer looked at two photographs of the same image which magically sprang into three dimensions—became all the rage after the Great Exhibition of 1851. Dalí began to experiment with stereoscopic paintings in the early 1970s, possibly prompted by the three-dimensional construction of a sequence of double images in the "Mae West Room" in his museum in the former Figueres theater. However, it could also be said that the doubling or repetition of images in separate configurations within paintings, which had taken various forms—for example in the *Metamorphosis of Narcissus* where the youth is echoed by the matching form of a bony hand—was a precedent to his actual stereoscopic images.

Paranoia-criticism

To Dalí, anamorphic hysteria was one example of the re-creation of the world through what he called paranoiac activity. Anamorphosis was not only linked to his ambivalent anatomies, but also to the whole paranoiac-critical method which Dalí first described in the texts published as *La Femme visible* in 1930: in other words, to "double images" like that of the anonymous *St Anthony of Padua and the infant Jesus*, reproduced in *Documents Nr. 4*, September 1929.

Dalí demonstrated his idea in *Le Surréalisme au service de la révolution* no. 3 (1951), with *Communication: visage paranoiaque* (fig. p. 124). Following a period of reflection on Picasso's African-period cubist paintings, he had come upon, while searching for an address in a pile of old papers, a photograph which he instantaneously read as a reproduction of a Picasso. Puzzled by the second "mouth" in the cubist head, he realized that what he had taken for a vertical image was in fact a horizontal snapshot of an African village. The alteration in viewpoint here, shifting from the vertical to the horizontal is not typical of the paranoiac double image, and in this the latter also differs from the anamorphic. The configurations, which could be read in multiple ways, were normally also viewed from a single position. What struck Dalí about his "paranoiac face" was not only the momentary illusion of a totally alternative reading, but the fact, confirmed when he showed the photograph to André Breton, that the illusion was directed by a personal obsession; where he saw a Picasso head, Breton saw a bust of the Marquis de Sade, with powdered wig, conforming to his own preoccupations.

Dalí inscribed the paranoiac double image within the surrealist doubt about reality: "The miserable mental expedient hidden behind the word 'reality' is the object today of a systematic denunciation whose revolutionary consequences are indisputable."[26] More specifically, he referred to Breton's "Introduction to the discourse on the paucity of reality" in which Breton proposed inserting dream objects among the utilitarian tools of the world to sow confusion.[27] "I believe the moment is at hand when by a paranoiac and active thought process it will be possible (simultaneously with automatism and other passive states) to systematize confusion and contribute

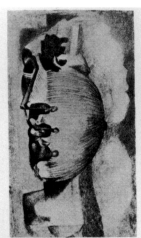

Salvador Dalí, *Communication: visage paranoïque*
Communication: Paranoiac Face, from: *Le Surréalisme au service de la révolution*, No. 3, Dezember 1931

to the total discredit of the real world."[28] Paranoia, Dalí continued, "uses the external world to realize the obsessive idea, with the troubling particularity of making the reality of this idea valid for others. The reality of the external world will serve as illustration and proof, and is put at the service of the reality of our mind."[29] Obviously related to the surrealists' simulations of neurotic and delusional mental states, as in the collection of texts by Breton and Eluard, *Immaculate Conception*, Dalí's paranoiac activity found its most complete and sustained expression in his book *The Tragic Myth of Millet's Angelus*, which is closely and expertly based on Freud.

Two of Dalí's early experiments with the painted double image were *Invisible Sleeper, Lion, Horse* and *The Invisible Man* (fig. p. 125). The former, which he also planned as a film scenario, was probably inspired by Fuseli's *The Nightmare* (fig. p. 126). The dream-pun of Fuseli's Gothic scene of a sleeping woman haunted by a mare seems to be the origin of the configuration which produces successively the image of a woman with her arm thrown back over her head, a horse whose head is formed by the sleeper's arm, and a lion whose head becomes visible in the horse's tail. Although Dalí never made the Fuseli painting the subject of an extended Freudian study as he was to do for Millet's *Angelus*, its place in the Gothic tradition which strained the limits of rational thought and placed value on the marvelous and the dream, as well as its eroticism, links it to surrealist taste. *The Invisible Man*, on which Dalí worked for several years, was conceived as a major painting. The image is partially based on a child's picture book of ancient Egyptian architecture, but it was to include iconography from the William Tell and Gradiva themes which Dalí was developing at the same time.

Salvador Dalí, *Dormeuse, cheval, lion invisibles*
Invisible Sleeping Woman, Horse, Lion, 1930

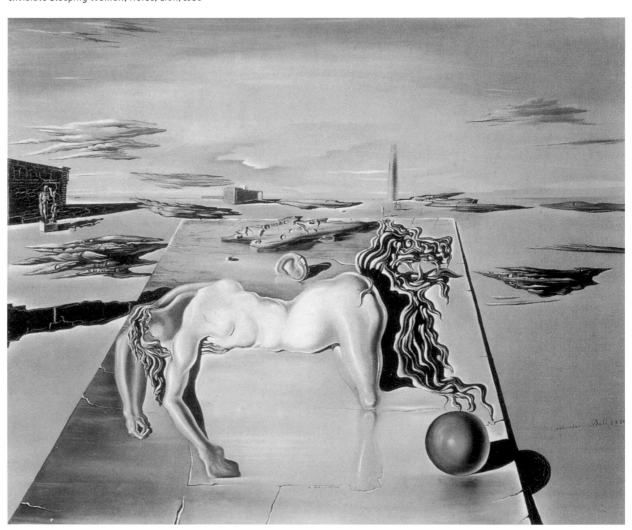

The visual conceits of Arcimboldo intrigued Dalí and have affinities with his "paranoiac-critical method," but there are certain differences between them. Whereas with Arcimboldo and his school there is a binary relationship between the individual objects and the overall head or landscape, with Dalí there are often more than two possible readings of a given configuration. The capacity for a "paranoiac reading-in" of an image was potentially unlimited; the spectator was free in theory to interpret according to his or her delusions, though in practice Dalí directs the readings. A measure of morphological ambiguity, however, is necessary, and the objects are not locked so definitively into a lexical structure as they are with Arcimboldo. Also, the slight "click" of surprise as the "other" image is revealed in Arcimboldo is relatively short, and little in the way of a perceptual switch is necessary to maintain both the "fruits," say, and the head simultaneously in view. With Dalí, the images remain alternatives, as in the "duck-rabbit" puzzle, to which Dalí alludes in a detail in *Apparition of a Face and Fruit Dish on a Beach*.

Dalí refined his paranoiac-critical technique by the end of the 1930s; one of the remarkable things over and above the multiplicity of alternative readings that reached its apogee with the *Endless Enigma* (fig. p. 202) is the extremes of scale on which he can operate. *Impressions*

Heinrich Fuseli, *The Nightmare*, 1781

of Africa, for instance, has a cluster of double images that are virtually invisible from more than a few inches away from the canvas, whereas in *Apparition of a Face and Fruit Dish on a Beach* (fig. p. 127) the whole canvas resolves itself into a dog.

Dalí's uses of techniques of illusion to give the world of the imagination the "communicable thickness" of the phenomenal world was never meant to become an end in itself. The furious desire to fix and transmit his vision and his ideas is like a warding off of dissolution and a sense of a void; the ambivalence of his own attitude to his paintings which shifts between abjection and masterly pride, whose alternations are apparent in the extraordi-

nary range of modes, of the sizes of the paintings, of the grotesque beside classical harmonies, of subjects and motifs. In his double images, as in his manipulations of persepective, space, scale, and light, Dalí aims to produce the maximum "optical insecurity." All manner of forms of representation were explored—cinema, photography, prints, theater, opera, objects, jewelry, installations, as well as words, but always he returned to oil painting as that which came closest to the impossible need to double the world into life.

"All painting before oil is dry, harsh and as it were against the grain. It was not possible, as it was later, to scumble with a fleeting badger hair brush the pigments

Salvador Dalí, *Apparition d'un visage et d'un compotier sur une plage*
Apparition of Face and Fruit Dish on a Beach, 1938

of gold, of air, the infinitesimal and suprasensitive shades with which reality itself appears to us to be 'bathed,' that is to say phenomenally solarized with the oils and the honeys of light itself. No atmospheric illusionism was possible. Nor could one paint the mystery of the flesh, the glory of painting, with that subsurface iridescence which characterizes it, nor the mystery of the azure of the sky, which is the very mystery of the transparencies of pictorial technique...."[30]

Notes

1 Alain Bosquet, *Conversations with Dalí* (New York, 1969), p. 22.

2 Bosquet 1969 (see note 1).

3 Salvador Dalí, "The Conquest of the Irrational," translation by Joachim Neugroschel of *La Conquète de l'irrationnel* (Paris, 1955), in Bosquet 1969 (see note 1), p. 113. Other published translations include Julien Levy (1955) and Haakon Chevalier (1968, see note 11).

4 André Breton, "Dalí," *Salvador Dalí*, exh. cat., Galerie Goemans, Paris, 20 November–5 December 1929.

5 Dalí 1955 (see note 3).

6 Freud, letter to Stefan Zweig as quoted by Dalí in Salvador Dalí, *The Unspeakable Confessions of Salvador Dalí* (London, 1977), p. 120. The meeting with Freud took place in London in July 1938.

7 Ibid. For a recent reading of *Metamorphosis of Narcissus* see David Lomas, "The Metamorphosis of Narcissus: Dalí's Self-Analysis," in Ades and Bradley, *Salvador Dalí: A Mythology*, exh. cat. Tate Gallery, London (London, 1998).

8 Dalí 1955 (see note 3).

9 Pierre Cabanne, *Entretiens avec Marcel Duchamp* (Paris, 1967), p. 74.

10 Within the surrealist notion of peinture-poésie fall *La femme visible*, the texts and poem that introduce his notion of "critical paranoia" and have a close bearing on his paintings of 1929–30, and the poem that accompanies *The Metamorphosis of Narcissus*; throughout the 1930s he published startlingly original texts in the surrealist journals on themes ranging from psychoanalysis to the Pre-Raphaelites and art nouveau, the latter part of a crusade to undermine modern taste for the "authentic naive and primitive." *The Tragic Myth of Millet's Angelus* was the first sustained marriage between psychoanalysis and art history; a mammoth "History of surrealist painting through the ages" was never finished, although fragments of his thinking about favorite artists like Arnold Böcklin survive; *Hidden Faces* is in the great tradition of erotic novels, while his autobiographies like the indispensable *Secret Life* are an extraordinary exercise in self-analysis compounded of fact and fantasy. All are closely bound with his visual work, but the latter is in no sense an illustration of them.

11 Salvador Dalí, "The Conquest of the Irrational" (1935) as translated by Haakon Chevalier in Salvador Dalí, *The Secret Life of Salvador Dalí* (London, 1968), p. 446.

12 Salvador Dalí, *The Unspeakable Confessions of Salvador Dalí* (as told to André Parinaud) (London, 1977), p. 143.

13 Dali 1977 (see note 12) p. 153.

14 See Richard L. Gregory, ed., *The Oxford Companion to the Mind*, 1987; Richard L. Gregory, *The Intelligent Eye*, 1970.

15 Hubert Damisch, *The Origin of Perspective* (Cambridge, Mass., 1994), p. 38.

16 André Breton, "Max Ernst" (1921), in Max Ernst, *Beyond Painting* (New York, 1948), p. 177.

17 Walter Benjamin, "The Work of Art in the Age of Mechanical Reproduction," 1956 reprinted in *Illuminations*, 1973, p. 239; *A Small History of Photography*, 1931; "One Way Street," 1979.

18 Laszlo Moholy-Nagy, *Painting Photography Film* (Bauhaus Book 1925) (London, 1969), p. 28.

19 Salvador Dalí, "La dada fotogràfica," *Gaseta de les Artes* (Barcelona, February 1929): pp. 40–2 translated as "The photographic donnée," in *Salvador Dalí: The Early Years*, exh. cat., London, South Bank Centre, 1994, p. 227.

20 Salvador Dalí, "La Fotografia, pura creació de l'esprit," *L'Amic de les Arts* (Sitges, September 1927):, pp. 90–1 translated as "Photography, pure creation of the mind," London 1994 (see note 19), p. 216. Dalí's slighting reference to "murky subconscious processes" was an early sign of a fundamental disagreement with Surrealism over the value and nature of automatism, which had in the first years of the movement, 1924–29, been the established mode of investigating the unconscious. Dalí found it too passive an activity, and contrasted automatic processes like drawing with his own active form of "interpretation," "paranoia-criticism."

21 "La dada fotogràfica," see note 19.

22 Dalí 1977 (see note 6), p. 27.

23 Dalí 1968, (see note 11), p. 41.

24 Martin Kemp, *The Science of Art* (New Haven and London, 1990), p. 217. See also Ian Gibson, *The Shameful Life of Salvador Dalí* (1997), p. 29.

25 Dalí 1977 (see note 6), p. 27.

26 André Breton and Paul Eluard, Preface to Salvador Dalí,
 La Femme visible (Paris, 1930).

27 Dalí is virtually paraphrasing a passage from Breton, "Introduction
 to the Discourse on the Paucity of Reality," proposing to put into
 circulation dream objects "to throw further discredit on those crea-
 tures and things of 'reason.'" Rosemont, ed., *What is Surrealism*
 (London, 1978), p. 26.

28 Salvador Dalí, "L'Ane pourri," *Le Surréalisme au Service de la Révo-
 lution* (Paris, 1930), p. 9 (subsequently published in *La femme visible*).

29 Dalí 1930 (see note 28), p. 41.

30 Salvador Dalí, *50 Secrets of Magic Craftsmanship* (New York, 1948;
 reprinted 1992), p. 23.

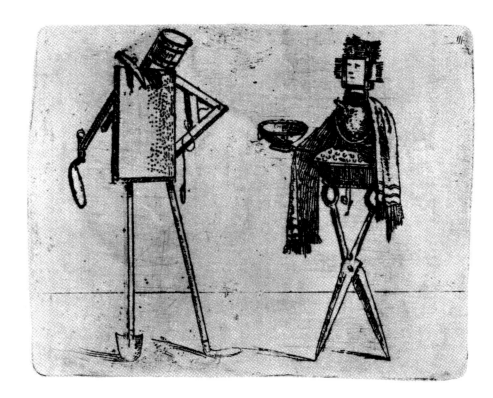

Giovanni Battista Bracelli,
Bizzarie di varie figure, 1624

BIZZARIE DI VARIE FIGURE

With this cycle of 50 etchings completed in 1624 Giovanni Battista Bracelli proffered an especially striking example of how intellectual games could be translated into art, a popular mannerist preoccupation. Unlike the antecedents by Jacques Callot, which appeared in 1617 in Florence under the heading *Capricci di varie figure*, or caprices of various figures, Bracelli entitled his work *Bizzarie di varie figure*, or extravaganzas of various figures. He thus deliberately emphasized that he was not interested in "capricci," or imaginative inventions, but was striving with his etchings to present his extravagant ideas in a manner heightened to the point of absurdity.

Consequently, Bracelli's cycle of etchings is not a closed complex of motifs or themes. Instead they represent a heterogeneous artistic game with the figure of man. His figures are composed of the most varied of objects; sometimes these cite existing, generally comprehensible pictorial solutions, sometimes they are imbued with highly individual significance. This syncretistic amalgamation of the most diverse sources of inspiration is what characterizes Bracelli's etchings.

This series of etchings contains numerous allegories. In addition to the prevalent personifications of the four elements, Bracelli also invented original embodiments of professions. Thus he depicts a mason using various items common to that profession and combines this male figure with a depiction of a seamstress composed in the same manner. Furthermore, he created numerous imaginative figures made up of geometrical

GIOVANNI BATTISTA BRACELLI

Italian artist, engraver, and etcher who worked in Florence, Livorno, Rome, and Naples in the first half of the seventeenth century. The foreshortening and light effects in his paintings are indicative of the influence of Lodovico Cigoli. His most important graphic work is his Bizzarie di varie figure cycle, dedicated to Pietro de Medici.

shapes, pieces of furniture or sections of buildings. The cycle contains not only composite images of this kind but also ambiguous picture puzzles: a city can also be seen as a reclining woman, a harbor as a man.

Because his representations are so ambiguous and often contradict reality, Barcelli's cycle of etchings became an important source of inspiration for the surrealists. His composite figures can therefore be regarded as precursors of Carlo Carrà's doll-like and Salvador Dalí's drawer-figures. *UH*

Nicolas de Larmessin (?),
Habit de sellier
The Saddler's Garment, c. 1750

Politics and Society

Marcus Gheeraerts the Elder,
Allegory of the Iconoclasts, 1570

**MARCUS GHEERAERTS
THE ELDER**

** c. 1530 in Bruges, † c. 1590.
Gheeraerts entered the Bruges
Painters' Guild in 1588 as
a pupil of his father, and was
later reputedly a pupil of
Marten de Vos. In 1571 he
became court painter to Queen
Elizabeth I of England. Inter
alia he executed the originals
for a 1566 illustrated
edition of Aesop's Fables.
In 1561 he completed a Passion
altarpiece commissioned
by Margaret of Austria.*

■ This etching of 1570 reflects an artist's reaction to the iconoclasm that broke out in the Netherlands in 1566. The Protestant Calvinists absolutely rejected religious images, seeing them as nothing but superfluous cult objects of the old Catholic faith. To vent their rage at the occupation of the Netherlands by Catholic Spain, Calvinist fanatics looted over five hundred churches and destroyed carvings and altars.

Marcus Gheeraerts symbolizes the historical event in the form of a portrait head, whose tonsure identifies it as a member of the Catholic priesthood. The grotesque face is composed of the elements of a landscape populated by countless adherents and opponents of the iconoclasm. In the right foreground one can make out the burning of works of art that have been collected up like rubbish. In the upper two-thirds of the painting, on the other hand, a series of multi-figured individual scenes illustrates the idolatrous practices of Catholic believers. These culminate in veneration of the Pope—who in Calvinist eyes was the greatest exploiter of misdirected reverence. Not only does Gheeraerts mock Catholic forms of worship, this double-meaning etching is also an ironic commentary on Catholics' devotion to images. *HI*

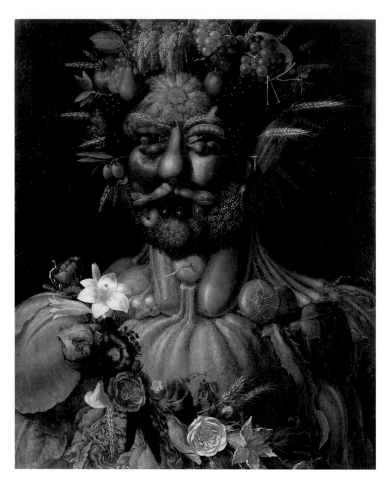

Giuseppe Arcimboldo,
Vertumnus, c. 1590

■ Arcimboldo's composite heads were not just the witty diversions of an exuberant vitality; his art had much more to do with political imagery. Even after turning his back on the Habsburg imperial court in 1587, Arcimboldo still enjoyed the esteem of Rudolf II. This close relationship is demonstrated in the painting *Vertumnus*. This portrait of around 1590 bears hardly any relationship to Rudolf II's characteristic features as depicted in other likenesses that have come down to us. It is much more an allegorical painting—as shown by a poem by the Milanese poet Gregorio Comanini (in: *Il Figino, Overe del fine della pittura*, Mantua, 1591). Vertumnus (derived from the Latin *vertere*, to turn or change) was the Roman god of the seasonal cycle, who also had the ability to change his form. It is assumed that this work was originally the final picture in a cycle of the seasons or elements. Arcimboldo therefore composed the portrait head not of semantically matching elements but rather of fruits, cereals, and vegetables that flowered or came to ripeness at many different times of year. He was thereby celebrating Rudolf as master of the course of nature and, in so doing, created an allegory of rulership that invested the emperor with untrammeled, supreme power. *AZ*

Seasons and Flora

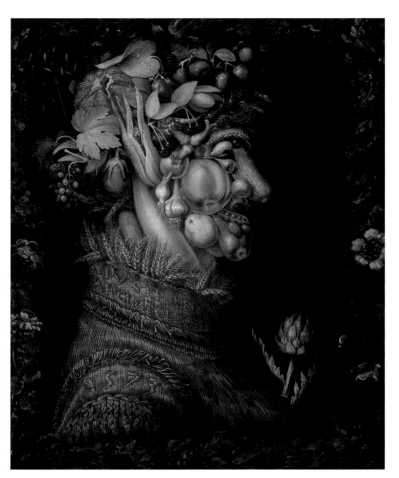

Giuseppe Arcimboldo,
Allegory of Summer, 1573

■ Giuseppe Arcimboldo conceived Aestas as a male figure, although only the head
and part of the upper body are visible, in profile. This allegorical figure, made up ent-
irely of the produce of summer, illustrates the richness of this season: various fruits,
vegetables, and cereals constitute the body and clothing of a man who symbolizes the
intensity of the connection between Man and the fruits of the earth from which this
anthropomorphic assemblage is composed. They nourish Man, but it is Man that culti-
vates them.

The painting (*Summer*, 1563, Kunsthistorisches Museum, Vienna) is thought to form
part of a cycle of paintings of the *Seasons* that, possibly along with a series depicting
the *Four Elements*, was presented to Emperor Maximilian II on New Year's Day 1569.
Winter (Kunsthistorisches Museum, Vienna, Inv. 1590) and *Spring* (Real Academia de
Bellas Artes, Madrid) survive, while the allegory of *Autumn* can only be reconstructed
on the basis of a second *Four Seasons* cycle by Arcimboldo, intended for Elector Augus-
tus of Saxony, which survives as a complete set in the Louvre. Although depicting the
seasons in the form of human heads is not an invention of Arcimboldo's, it provided
him with a very good artistic solution. The contemporary term for this emphatically
mannerist concept, "grilli," has diverted the study of art into recognizing in it first and

foremost the grotesque and the comic. However, on the basis of some texts by the humanist Giovanni Baptista Fonteo, who worked with Arcimboldo at the Vienna court, DaCosta Kaufmann has shown the deep allegorical meaning of paintings of the seasons. In a poem dedicated to Maximilian II, Fonteo mentions "Caesares tabellas," empire-related pictorial concepts that embodied "Concettismo" in a higher form. The seasons, which in allegorical terms were also closely related to the elements, symbolize the supreme power of the emperor, who, according to a complicated system of analogies, ruled equally over Microcosm and Macrocosm—and hence ruled not just mankind but Nature in her fundamental as well as her evanescent forms.

Translated from Michaela Krieger, in Zauber der Medusa: Europäische Manierismen, *ed. Werner Hofmann, exh. cat., Künstlerhaus Wien (Vienna, 1987), p. 142.*

Follower of Arcimboldo,
portrait with flowers, c. 1600

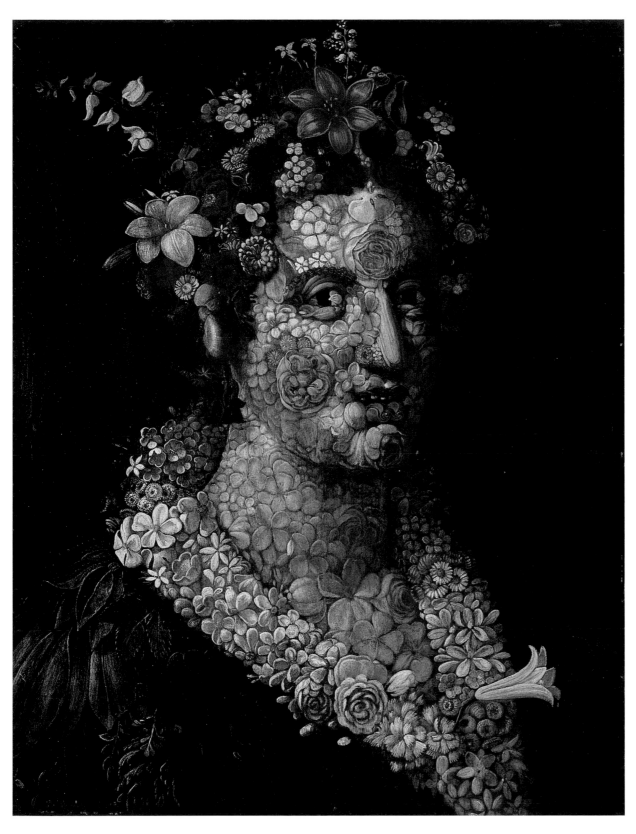

Giuseppe Arcimboldo,
Flora, c. 1591

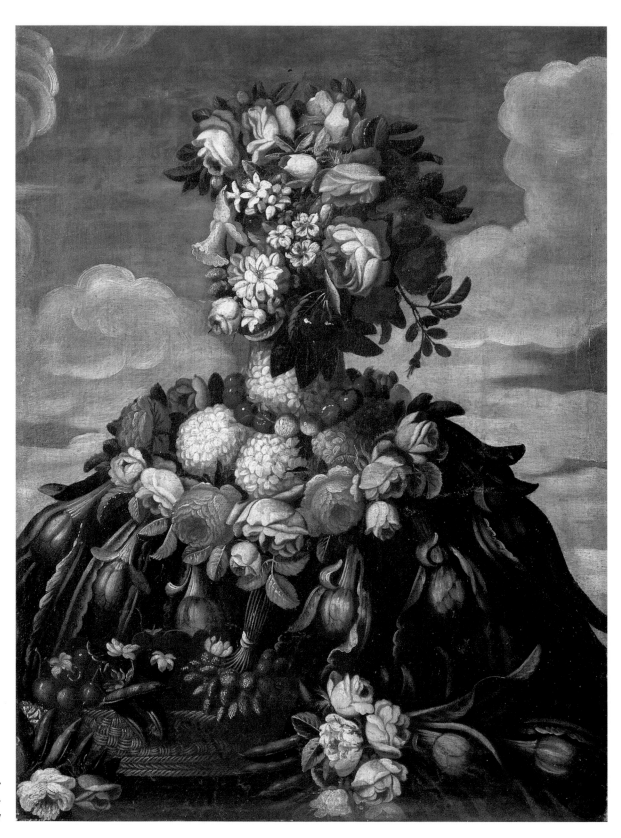

Follower of Arcimboldo,
Allegory of Spring,
seventeenth century

Elements

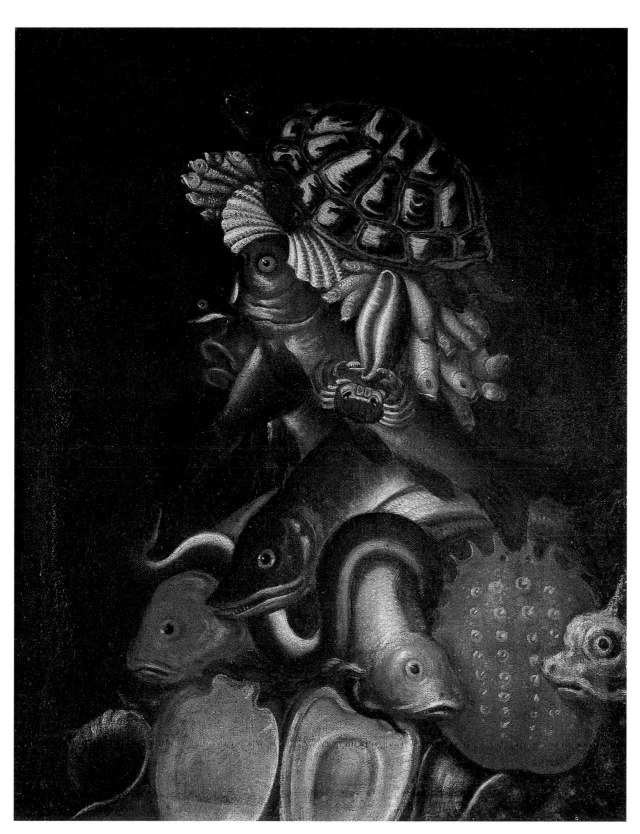

Follower of Arcimboldo,
Allegory of Water,
c. 1600

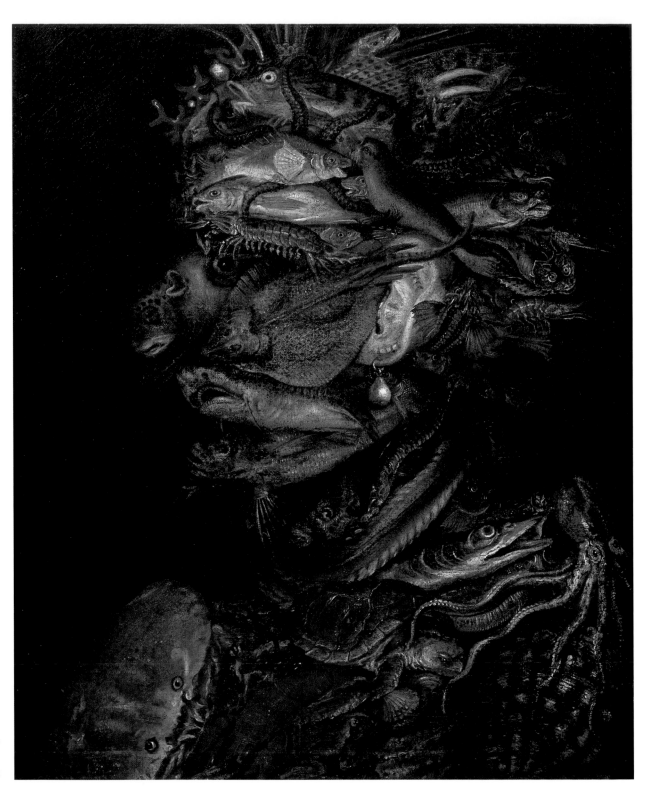

Follower of Arcimboldo,
Allegory of Water,
c. 1565–70

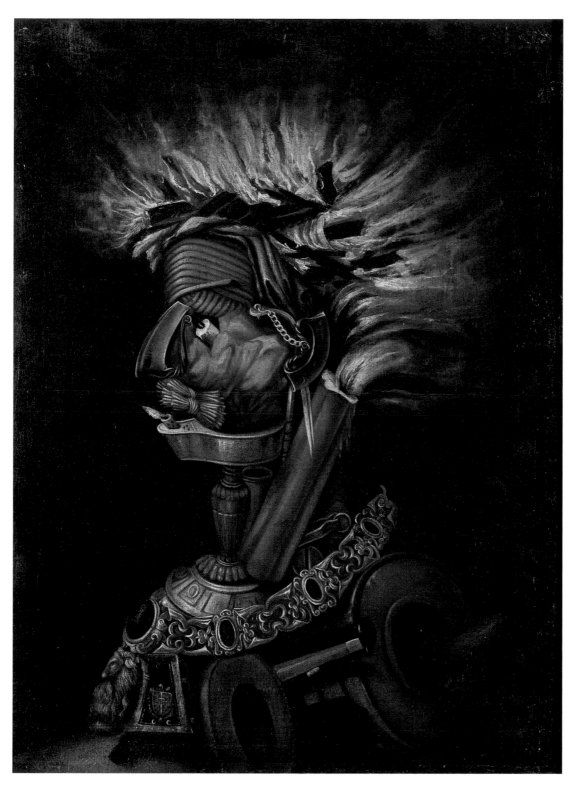

Giuseppe Arcimboldo,
Allegory of Fire,
c. 1572

Giuseppe Arcimboldo,
Allegory of Air,
c. 1572

Matters Culinary

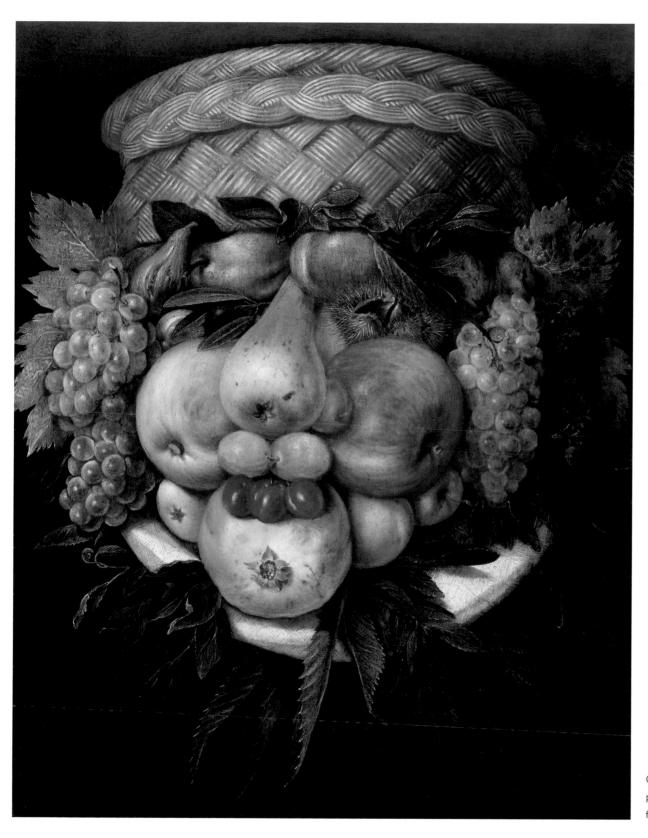

Giuseppe Arcimboldo,
portrait of a man composed of
fruit, c. 1580

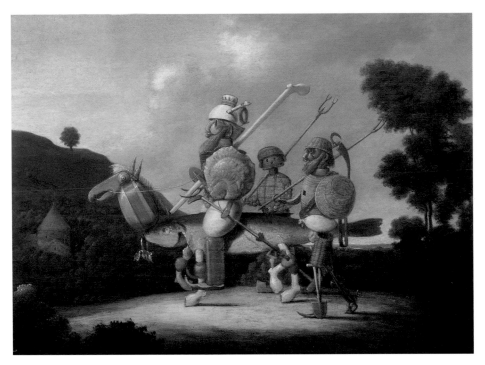

Follower of Arcimboldo,
Don Quixote,
seventeenth century

■ The knight riding through an atmospherically lit landscape, flanked by two marching squires, has probably acquired his name of "Don Quixote" in error. Only his unhappy look is reminiscent of the idealistic Manchego nobleman whose sublime ideas are taken seriously neither by the world nor by his crafty companion Sancho Panza. But the latter does not figure in this picture; neither of the footmen can be characterized as Sancho, whose character and appearance are the exact opposite of his lord's spiritual and physical qualities. In this picture the footmen resemble the rider, whose coronet is the only sign of his higher social status.

The utensils, largely drawn from agriculture and fishing, are combined without regard to their relative sizes in real life. What is noticeable, in contrast to Arcimboldo's compositions, is that the objects are not subtly subordinated to a higher principle (the content of the picture), but rather the additive accumulation of objects determines the appearance of the figures—and this emphasizes the ridiculous disarticulatedness of the protagonists. In particular, the depiction of the knight and the foremost squire are related to some of Arcimboldo's (or his school's) late pictorial ideas, such as the now lost paintings *Cook* and *Cupbearer*. In pictorial inventions like these, the comic prevails over coded, allegorical content, and this painting is no doubt to be taken as satirical—its irony probably directed at the representatives of the lower social classes.

Translated from: Michaela Krieger, in Zauber der Medusa: Europäische Manierismen, *ed. Werner Hofmann, exh. cat., Künstlerhaus Wien (Vienna, 1987), p. 151.*

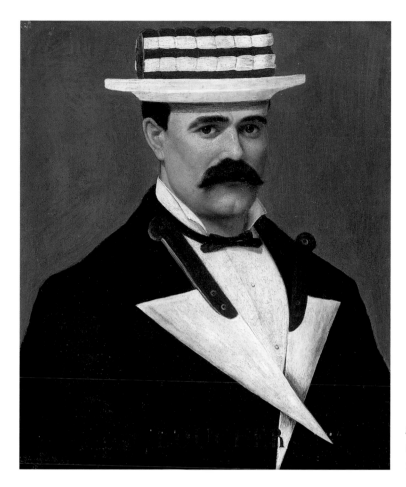

Arsène Symphorien Sauvage,
Le boucher
The Butcher, 1877

■ Don't forget one thing: a lovely snipe, well hung, flambéed in strong alcohol and served in its own excrement, as is the custom in the best Paris restaurants—for me in the serious realm of gastronomy that will always be the most delicious symbol of true culture. On the plate the slender anatomy of a naked snipe, as one might say, matches the perfect proportions of the Raphaelites....

I really only like eating what has a form that is clear and intellectually comprehensible. And if I abominate that frightful, humiliating vegetable called spinach, it is because spinach is as shapeless as liberty....

Spinach in particular, but also any other sort of food, I associate generally with fundamental aesthetic and moral values. The opposite of spinach is an oyster. I love eating oysters, indeed all shellfish, which, only when the shell is parted, open themselves to the royal conquest of our palates....

The jaws are our best recognition tools....

The sentinel of revulsion is ever-present, watching over my meals with anxious severity and compelling me to rigor in selecting my nourishment.

Translated from: Salvador Dalí, Die Diners mit Gala *(Frankfurt, Berlin, and Vienna, 1974), p. 10.*

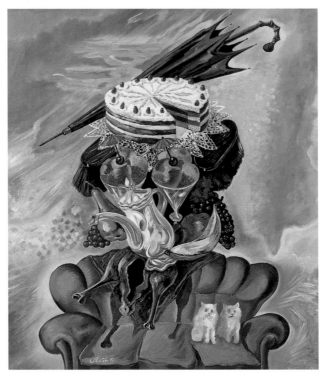

Right:
Milan Kunc, *Kulinarischer Kopf,
Culinary Head*, 1976

Bottom:
Emmett Williams,
*Food Faces – Portraits of the artist,
who comes from proud but honest
stock, and who regards himself
as a man of the left, within
reason, impersonating some
of the crowned and uncrowned
heads of past and present. The
pharaoh is easy to recognize – is it
Amenhotep III or Tutankhamun?
No matter, he is easily confused
with Louis XIV*, 1984

MILAN KUNC

** 1944 in Prague, lives in
Cologne and elsewhere.
Milan Kunc studied in Prague
before emigrating to the West
in 1969. Kunc's joyfully colored
painting is sometimes
labeled Ost-Pop (East-Pop),
since he uses his pictures to
express humorous and
sometimes biting criticism of
Western consumerism.*

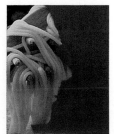

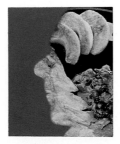
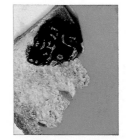

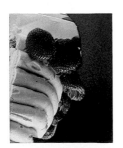

PORTRAITS OF THE ARTIST, WHO COMES FROM PROUD BUT HONEST COMMON STOCK,
AND WHO REGARDS HIMSELF AS A MAN OF THE LEFT, WITHIN REASON,
IMPERSONATING SOME OF THE CROWNED AND UNCROWNED HEADS OF PAST AND PRESENT.
THE PHARAOH IS EASY TO RECOGNIZE — IS IT AMENHOTEP III OR TUTANKHAMUN?
NO MATTER, HE IS EASILY CONFUSED WITH LOUIS XIV,
WHO BEARS SOME RESEMBLANCE TO MONTEZUMA,
WHOM THE ARTIST'S BRITISH WIFE MISTOOK FOR QUEEN VICTORIA,
WHO IS ACTUALLY THE IRISH POTATO STARING AT LUCREZIA BORGIA.
COLONEL GADDAFI IS TRAVELLING INCOGNITO,
BUT THAT RED PATCH — IS IT JELLY OR JAM? — OVER HIS RIGHT EYE DOESN'T FOOL ANYBODY.
THERE IS SOME CONFUSION REGARDING THE IDENTITY OF THE REMAINING TWO BLUEBLOODS.

emmettwill 1984

EMMETT WILLIAMS

** 1925 in Greenville (South
Carolina), lives in Berlin. As a
multi-media artist and poet,
he belongs to the Fluxus
movement, along with Robert
Filliou, Daniel Spoerri, and
Dieter Roth. He is, inter alia,
a performance artist, and for a
while worked for the Something
Else Press. Emmett Williams
was Visiting Professor at
the Hochschule für bildende
Künste in Hamburg and the
Hochschule der Künste in Berlin.*

Alphabets

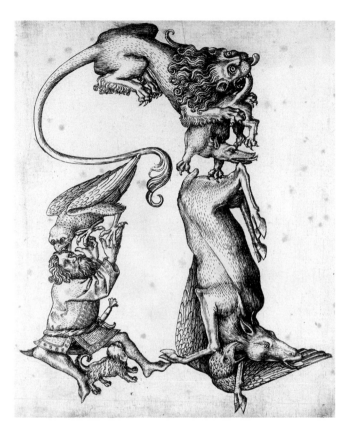

Meister E. S.,
the letter "a," from a figural
alphabet, c. 1460

THE FIGURAL ALPHABET OF MEISTER E. S.

MEISTER E. S.
** c. 1420, † c. 1468*
Meister E. S., inventor of copper-
engraving in the modern sense,
was most probably a qualified
goldsmith. He lived and worked
in the Upper Rhine region. His
wealth of themes ranged
from the depiction of religious
and secular motifs to the
creation of a figural alphabet
which is considered one of
his most important later works.
In it he varies certain favorite
motifs in a highly imaginative
way and consistently replaces
the painterly by the
three-dimensional effect.

The figural alphabet comprises 23 gothic minuscule (lower-case) letters made up out of all sorts and conditions of humans, sacred figures, and fantastic creatures. ... Throughout the Middle Ages the initials (opening letters) were elaborated by hand—the space surrounding them was decorated or the letters themselves served as frames for pictorial compositions....

The creatures press against each other, intertwining and sinking their teeth into each other, in the process perhaps symbolizing the eternal struggle within mankind between good and evil. Against the background of the Last Judgment, these beings certainly testify to the medieval dread of demons and the temptations they held out.... Behind the portrayal of foolish license, though, the secret lust of the medieval voyeur may lie concealed.... Whether the figural alphabet subsumes a cryptic system of meaning is an open question. Certainly some letter forms can be interpreted as satirizing rank and class, and in these—for instance, the pages depicting monks—a critique of contemporary society is clearly discernible.

Translated from: Meister E. S.: Ein oberrheinischer Kupferstecher der Spätgotik, *exh. cat., Staatliche Graphische Sammlung, Munich (Munich, 1987).*

Noël Garnier,
Letter from a figural alphabet,
c. 1540

THE FIGURAL ALPHABET OF NOËL GARNIER

The alphabets of the Vendée-born French engraver Noël Garnier are striking proof that the late Middle Ages did not simply come to an end on one day around 1500. Sadly, no details of the life of this Paris-based master have come down to us, although his alphabets offer attractive proof that around 1540–45 late-medieval stylistic notions were by no means *passé*. In his alphabets—which scorn the new geometrized world—Garnier develops a wealth of figural and abstract ornamental motifs that astonished the generation that succeeded Tory and Dürer.

Translated from: Joseph Kiermeier-Debre and Fritz Franz Vogel, Menschenalphabete *(Marburg, 2001), p. 22.*

Asiatica

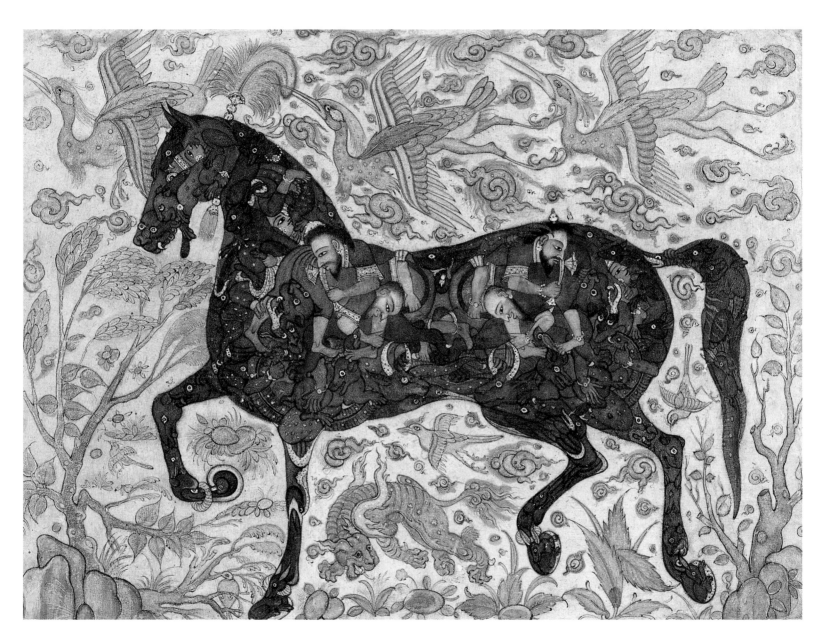

Anonymous (Deccan school),
composite horse, India, first half of
the seventeenth century

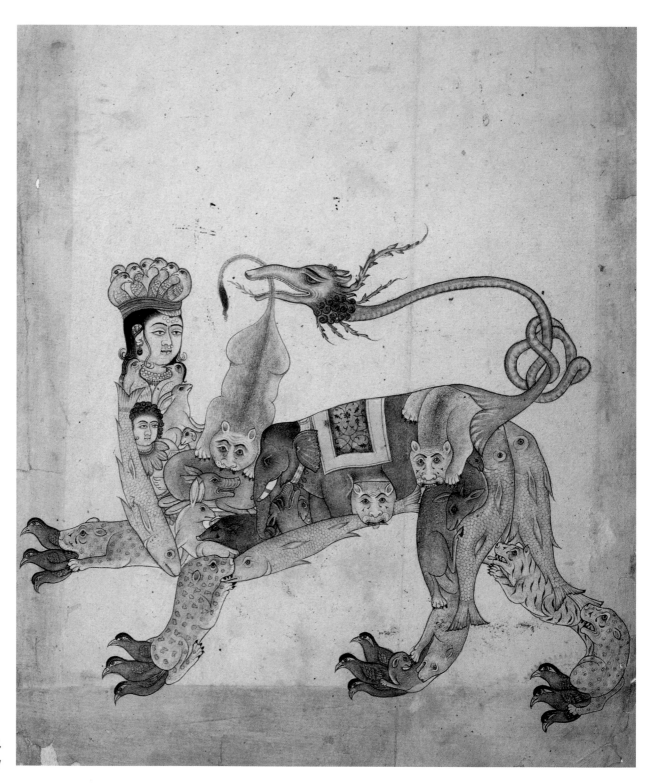

Anonymous, mythological animal,
mid-eighteenth century

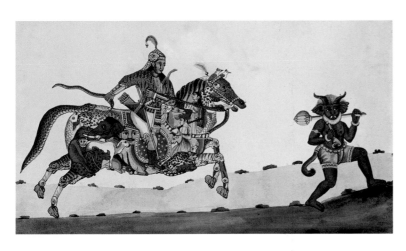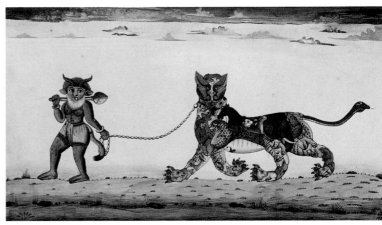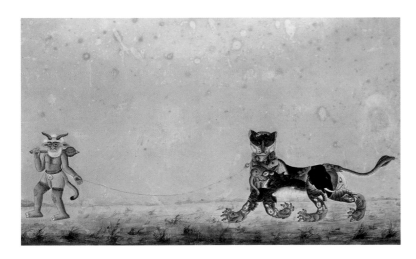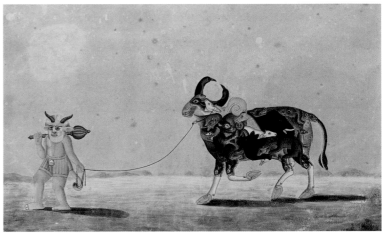

Anonymous, mythological figure, followed by a rider,
Orient, eighteenth century

Anonymous, mythological figure leading a wild cat,
Orient, eighteenth century

Anonymous, mythological figure leading a giant cat,
Orient, eighteenth century

Anonymous, Kalan and the buffalo
(mythological figure with composite bull), Orient, eighteenth century

Anonymous, illustration of the flows within (Neijingtu), Ching Dynasty, China, nineteenth century

■ Allegorical portrayal of the physiology of the human body according to Taoist ideas. The illustration shows the circulation of human bodily energies, represented by a landscape formed by the human body.

CHAPTER 7

Jasmine in blossom and a bull, throat cut
Endless paving. Map. Hall. Harp. Early morning.
A maiden dreams a bull, all of jasmine,
And this bull a bloody twilight that roars.
FEDERICO GARCÍA LORCA*

■ The disputed territory and the disputed woman. Military heroes, soldiers, dictators, and corrida matadors. Equation of sexuality and aggression, the distant loved one emerges from the bloody battle. This is a collection of images of male fantasies of power and suppression. The double image comes to symbolize an attitude of complete entitlement. *StA*

** On a Dream Under the Open Sky*

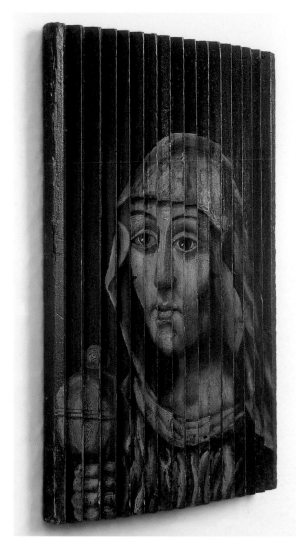
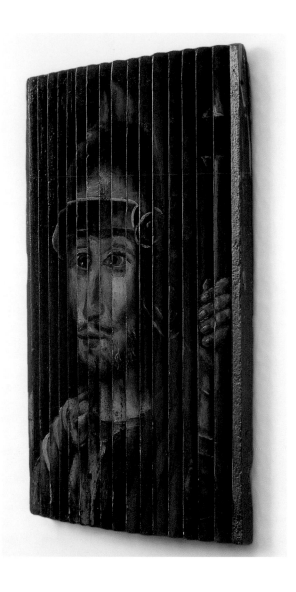

Anonymous,
"harp image" with Christ,
Saint Magdalene, and soldier,
nineteenth century

■ "Prism images," "ribbed images," and "harp images" contain either two or three subject planes, which reveal themselves when the picture is viewed from one or other side. In a "prism image" the wooden picture surface consists of prism-shaped rods arranged vertically and glued down. The leftward-facing and rightward-facing sides of the prism are painted with two different subjects. The same effect is achieved in "ribbed images" by means of slats mounted vertically in a picture box about two centimeters deep. "Prism images" and "ribbed images" are known from the second half of the sixteenth century. "Harp images," on the other hand, which became widespread in the nineteenth century, are a cheap modern variant. A box frame is strung with catgut, to which engravings or oleographs are attached, in such a way as to form a system of compartments that can be viewed from two angles. "Harp images" with religious subjects, for example, were big sellers at places of pilgrimage. *AZ*

Renato Bertelli,
Continuous Profile of Mussolini,
1932

Salvador Dalí,
study for *Espagne*
Study for *Spain*, 1936

Salvador Dalí,
*"... become uninterruptedly
something else ...,"*
illustration for *The Secret Life
of Salvador Dalí*, 1941

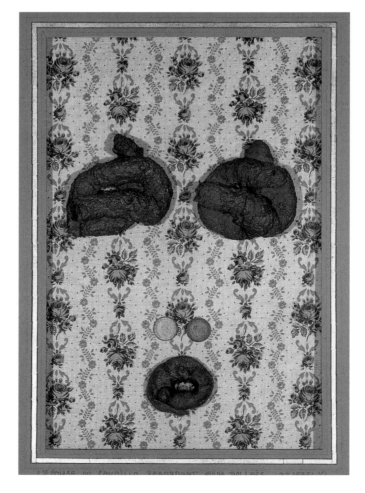

Jean-Jacques Lebel,
*Caudillo's Wife Looking at the
"Avida Dollar,"* 1961

JEAN-JACQUES LEBEL
** 1936 in Paris, where he lives
and works. Lebel is a sculptor,
performance artist, and
author working in the tradition
of Dadaism and Surrealism.
In 1960 he organized the first
happening in Europe. In 1979
he founded the "Polyphonix"
series, a festival for poésie
directe, performance, video,
and music.*

Monika Bartholomé,
Gemischte Gefühle
Mixed Feelings, 2000

MONIKA BARTHOLOMÉ
** 1950 in Neukirchen-Vlyn,*
lives in Cologne. For many years
this performance artist and
draftswoman has worked
single-mindedly on the relation-
ship between dance and line;
in the process, her techniques,
deliberately reduced to the
extreme minimum, are densely
evocative. Her protagonists are
often eccentric scientists who
coax an idiosyncratic wit out of
apparently banal problems.

YVES TANGUY

** 1900 in Paris, † 1955 in Wood-
bury, USA. This self-taught
French artist was initially
inspired by Giorgio de Chirico's
mode of painting. He joined the
Parisian surrealists in 1925,
becoming particularly close to
André Breton and Marcel
Duchamp. He moved to the
United States in 1939.
As an artist, Tanguy is famous
for his dark-toned expressively
painted and naively composed
works which gradually
abandoned all links with reality.
His studio in the Rue du Château
in Paris was an important
meeting point for the surrealists.
It was there that Cadavre
exquis was invented, a game in
which several artists worked
on a single folded sheet without
knowing what the others had
drawn before them. Later, in
a hallucinatory-automatic
manner, Tanguy populated his
dream landscapes with strange
organic constructs reminiscent
of objects by Hans Arp.*

Yves Tanguy,
Bird, c. 1937

Elisabeth Bronfen

SECRETS, POWER, AND DEATH: DALÍ'S DOUBLE IMAGES

The fascination of secrets may well lie in the ambiguity of the term itself. On the one hand we speak of a secret if something is unidentifiable or inexplicable, while on the other hand the word is also used if something is to be kept secret within a small circle of initiates, a confidential matter which then possibly becomes known to others. Whereas the first meaning refers to supernatural, uncanny, or puzzling characteristics that are fully or partially unfathomable because they exceed the bounds of human knowledge, the meaning in the latter case is precisely that we are dealing with an encoded script or a cryptic entity which can indeed be deciphered, but only by those in the know. Thus the question always arises: is the secret ontologically inacessible knowledge presented as an inexplicable mystery, or is it a consciously or unconsciously created code that can be deciphered? The ambiguity inherent in the word "secret" not only raises the question of whether the clandestine knowledge can be revealed, but also of how one responds to a message which is not directly accessible. Does the encounter with secrets force us to admit that there will always be knowledge that eludes us and that the epistemological limit thus revealed also leads us to a definition of the human subject as having limited powers of cognition? Or is concealed knowledge treated as a secret precisely in order to create clandestine alliances based on a logic of inclusion and exclusion? Does a secret help us accept our own powerlessness vis-à-vis inexplicable phenomena—whether they be of a spiritual or psychological nature? Or does the secret serve to endow the initiates with a feeling of power because not only are they able to decide who is allowed to partake of the clandestine knowledge at stake, but they also feel empowered because they are able to access something that remains concealed to others?

If one includes death as the last variable in the relationship between secrets and power then an additional ambivalence becomes evident (fig. p. 248). In our Western culture mortality has always been considered the absolute limit of human knowledge, even though death is also the one event where we can be absolutely certain that it will happen to us. Thus death, which we can do nothing to avoid, remains a mysterious power; potent because it cannot be deciphered. But this cultural platitude easily leads to fantasies of empowerment. Since antiquity the figures who dare to enter the hidden realm of death have been equipped with mysterious powers; similarly those who negotiate the murky interface between the animate and the inanimate are endowed with power, one need only think of the priests, judges, doctors, and rulers who decide over the life and death of their subordinates (Bronfen 1993). In the realm of aesthetic representation, the interplay of mystery, power, and death is just as poignant as in the realm of political representation. A visualization of the magic of secrets—as in Salvador Dalí's double images—invites the question as to whether the shifting ambivalence of a figure is meant to point out an unavoidable gap in knowledge as a blind spot or to make the viewer aware of a deciphering process through which secret knowledge, transformed into visual forms, becomes legible. Does the double image reveal its secret core in the process of being viewed? Does it demonstrate our wish for mysterious secret entities, in order that their unveiling can confirm the meaningfulness of the world? Or is the double image merely a demonstration of the vanishing point where, because it points to a void beyond the apparent, every attempt to conquer the world with our own eyes fails?

The psychoanalytical art theorist Darian Leader (2002) argues that our visual curiosity—awake since our early childhood years when we sought to fathom the hidden zones of our own body and other bodies that we came in contact with—is led by the desire to discover something that is hidden.

According to Leader, visual phenomena stir up our curiosity because we suspect that in our encounter with the everyday world something eludes our view, that something is hidden behind the reality we perceive. Double images like those of Dalí can thus be understood as a self-reflexive mise-en-scène of such a visual logic focused on the hidden, because in these images there is a conscious play on the interdependence between emptiness and overabundance. Figures are painted on the canvas in a such way that the viewer does not initially see them. Then—after changing his vantage point—the

viewer's sudden awareness of the formal ambiguity confronts him with the failure of his own perception. Thus the double image demonstrates the structural nature of all aesthetic pictures—namely that they function as a shield separating us from something that cannot be visually registered, this fundamental emptiness or void from which every visual figure is nurtured and also evoked. The assumption that our visual reality is based on an exclusion that is less the result of a moral ban than of a formal impossibility is thus central to this psychoanalytical understanding of images. In other words, our world does not receive its symbolic substance only because specific areas are concealed as social taboos, but also owing to the fact that certain phenomena—

Salvador Dalí, *Apparition d'une figure de Vermeer dans le visage d'Abraham Lincoln*
Apparition of the Figure of Vermeer on the Face of Abraham Lincoln, 1938

death would be a paradigmatic example—cannot reach the level of visualization; they can only be expressed as ambiguous distortion or as the representation of a blind spot (fig. p. 119). Double images can thus be understood as conscious commentaries on an image production that plays with the emptiness in the world, since the fascination these images hold for us springs from the fact that they clearly remind us that something always eludes our view. This is achieved through the rhetoric of secrets, which lets something hidden become visible, while at the same time holding the covert knowledge at a distance.

In Dalí's *The Image Disappears* (1938, fig. p. 116) we see the chimera-like reincarnation of Vermeer's *Woman in Blue Reading a Letter* (fig. p. 174). A female figure lost in thought, whose face cannot be seen, looks at a piece of paper which she is holding in her hands at waist height. The golden source of light shining on her is framed by a dark curtain while she herself seems to be stepping forth out of a dark cloud or to be about to be engulfed by it. As a result of this dark shape at the center of the composition only half of the picture hanging on the wall behind the reading figure can be seen. However, as the viewer changes his vantage point slightly another female figure becomes visible, now in profile, looking in the opposite direction. The head of the reading woman forms her right eye, the torso her nose, the outstretched arm her mouth. This head menacingly overshadows the standing figure, even though neither of the two figures can be made out clearly but are only hinted at. It is also uncertain which way the transformation works—whether the female head is conjured up like a phantom in the act of reading or whether the reading woman is the result of an inner reflection on the part of the woman seen in profile. Just as the woman reads her letter so we read the picture and are forced to recognize that our vision is likewise marked by a murkiness that prevents us from making out clear and unambiguous forms. The title thus refers not only to the disappearance of the quoted model behind Dalí's refiguration but also to the picture itself. As much as the viewer attempts to fix the two phantom-like figures—the face that imposes itself on the standing figure and the standing figure that seems to disappear in the face—they continually jump back and forth such that both figures threaten to disappear. The viewer might think that by changing his perspective he had discovered the secret of the work, in that by perceiving the double image he can switch back and forth between the two parts. This action can be understood as a gesture of apprehension because, had the viewer not followed the clues to the secret laid by Dalí and sought something hidden, he would not have discovered the double image on the canvas either. But by recognizing ambiguity, the viewer actually perceives less. The viewer is torn back and forth, fascinated by the transformation that he can create by changing his focus

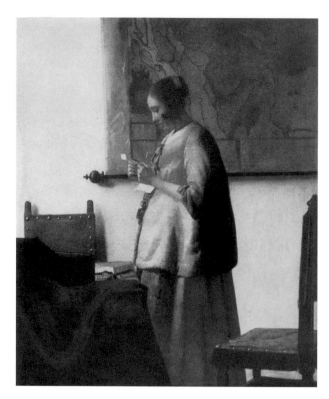

Jan Vermeer, *Woman in Blue Reading a Letter*, 1662–4

thing that is supposed to remain hidden but has come out into the open, he draws a conclusion that has a startling impact on double images: "Something has emerged from the hidden and yet its appearance intensely retains that trace of distance or depth that condemns it to a continuous labor of concealment." For the uncanniness of the puzzling image makes the alternation between "seeing that is losing" and "seeing the appearance of the hidden" the real subject of the picture. At the same time Didi-Huberman poses the question of the ability to portray unconscious processes—in a manner of central importance for Salvador Dalí's work—when he postulates "that every form that is intensive, that possesses aura is 'uncanny' in that it confronts us with the 'return of the repressed.' Metapsychologically speaking, aesthetic intensity would thus be the recurrence of the repressed in the visual sphere." (Didi-Huberman 1999, 221). Dalí himself liked to refer to his psychoanalytical approach, especially when he described his ability to change the world with his eyes— perfected in his double images— as a way both to school the eye and to train awareness. A belief in the omnipotence of his ideas started becoming prominent in his artistic view in his schooldays, when his protracted dreaming led him to teach himself how "to see everything that I wanted" in the blurred irregularities of the indistinct outlines on the ceiling and then to paint these hallucinatory transformations. He became a master, he claimed in his memoirs, of "that thaumaturgical faculty of being able at any moment and in any circumstance *always, always to see something else*, or on the other hand—what amounts to the same— 'always to see the identical thing' in things that were different." (Dalí 1949, 148).

and plagued by the puzzle of the image that cannot be resolved: the two figures are intertwined; a connection between them is postulated. However, since the double image urges the viewer to oscillate between the two foci, it remains unclear which is actually the encoded and which the decoded form. Even after the double image has been recognized, the uncertainty remains because in the aporetic logic of the double image the pictorial space threatens to empty precisely because it is overloaded. Thus Dalí demonstrates the opposite of the idea that only in a search for the hidden can something be seen. If the secret is overdetermined because the discovered figures become visible but cannot be fixed, then the viewer understands that he in fact sees nothing perfectly—not the two figures, which serve each other as ciphers, nor the blind spot that connects them.

Georges Didi-Huberman has described the aura of an artwork in general as "uncanny" because it maintains a distance, no matter how close the artwork itself is. Starting from Freud's postulate that the uncanny is some-

This aesthetic of "seeing differently," derived from a belief in the power of analogies to create meaning and which led to Dalí's "paranoiac" double images, is characterized, however, by an ambiguous rhetoric. It remains unclear whether the visual translation that discovers similarity in different forms (always seeing the same) or that causes a figure to break into different forms (always seeing something different) is aimed at revealing a hidden truth or whether it rather demonstrates the artist's creative investigation of how the world of phenomena might look in virtuality.

A basic premise of Freud's psychoanalysis lies in taking the subject's psychological reality just as seriously as his everyday reality but also in insisting that there is a gray area between possibility and truth in the sphere of fantasy. Dreams, hallucinations, and psychological symptoms, bring forth encoded messages that the subject needs because his own pleasure principle has to be censored by the laws of the reality principle, to whose restrictions his enjoyment must adapt itself. When Dalí's vision creates something new out of everyday objects, this "different way of seeing" allows him to express an intimate piece of psychological material that can only be visualization through distortion. The psychoanalytical dictum applied here maintains that a landscape of the soul expressed as an optical illusion serves to decode a hidden psychological complex. In this respect Dalí follows Freud's conviction that the subject is driven in his daily behavior, but above all in his fantasies and dreams, by unconscious desires and is reminded, precisely in the knowledge of the fragile nature of his seemingly coherent and undivided normality, of the unconscious, albeit not directly accessible, content of his psyche. In this sense the loss of unambiguous contours in the double image lets the subject recognize his own inner duality—the conscious and unconscious processes—which means that the subject is always at least partially alienated from himself.

Thus illusions train both the ability to see and the awareness in two respects. On the one hand they show the hallucinatory value of the apparently normal world; to put it more precisely, they show that our customary view is not the only way to understand visual phenomena. On the other hand hallucinations transform manifest perceptions into latent ones, thereby helping to reveal the desires repressed by the reality principle. In the double image—according to Dalí's aesthetic assumptions—we initially see a manifest figure, then a latent one, analogue to the way in which the ego, under the pressure of the superego, censors pleasure in order to retain it after translating it into another language, that of dreams, hallucination, or illusion. Dalí's celebration of the paranoiac view, which has become his trademark, should not let us overlook the following: double images require a rhetoric of distortion, not so much because the

secrets revealed in the picture are social taboos, but because the psychological truth of the subject is governed by a primal repression and for this reason is impervious to direct access. It appears at first glance as if the *interprétation paranoique-critique* is an over-interpretation of visual phenomena in the interest of the repressed fulfillment of wishes on the part of the interpreter. The two faces of the double image connect a manifest, apparently uninteresting, aspect useful to the reality principle with a latent one which serves the pleasure principle. But in fact these puzzle images demand an oscillating view, given that the overcrowding of the image involves an excess of interpretation and yet does not achieve anything, which instead of clearly revealing the secret stubbornly insists on obscuring the signs. In addition, Dalí was fascinated by the ability of paranoid individuals to discover coincidental connections and their gift for projecting images of their inner world onto the outer. One should not overlook that in Dalí's aesthetic appropriation of optical illusions both the manifest, apparently uninteresting, figure shaped by the reality principle and the delusion with its overpowering imaginary elements are ciphers. The *critique-paranoiaque* as practiced by Dalí in his double images does indeed bring to the fore forbidden fantasies which would otherwise be censored by the reality principle. In his sketch for *Suburbs of a Paranoiac-Critical Town* (fig. p. 207), for example, we see in several stages how a ribbed structure is created from the back of a horse and then fleshed into a female torso. This double vision can lead to an understanding that even everyday appearance can also be hallucination, but in Dalí's visual logic neither the woman who is formed from the horse nor the horse that contains the female figure like a secret inner core inherently has a higher claim to be the true form. The secret of this double image lies in the fact that our view oscillates between the two figures and thus creates an added value which can only be perceived as simultaneous juxtaposition not as visualized form.

Nevertheless, by assuming the duality of symptoms, Freudian psychoanalysis succumbs to the pleasure in the paranoiac view even in its own methodology. For it postulates that everything is significant—not purely coincidental—even if it is indeed coincidence that reveals

hidden connections between memories and past events, above all between present suffering and a repressed mental anguish. Whether one speaks of screen memories and protective fiction *[Schutzdichtungen]*, both of which refer to a repressed desire in the form of a distorted image; or of the gesture of the fetishist who reassures himself by saying I know (the body is weak) and yet I still believe (in my own immortality); or of symptoms in general which as a kind of red herring conceal the actual suffering while serving as a coded message—all these cases presuppose more than an exchange of two meanings where the first is transformed into its opposite through analytical interpretation. It is also assumed that there is a secret and that the hidden aspect shines through the manifest appearance marking the omission or visualizing it in a compressed form. Thus there must also be a manner of seeing which deviates from what we are accustomed to and can decipher the secret of this other seeing. Of course it is the analyst—and the artist mimicking his approach—who are especially qualified as master interpreters, not only to surmise, but also to track down and reveal the hidden wish or repressed urge lying behind the particular symptom. In this sense psychoanalysis treats every fantasy not only as phantasmatic but also as phantomatic because it assumes that as a manifestation or an embodiment of secrets, it refers to a gap in our conscious knowledge. As Georges Didi-Huberman (2000, 187) pertinently explains: "What occurs when thinking about the symptom is an economy of despair. Indeed, with respect to my own knowledge, the symptom demands uncertainty of what I see or what I believe to perceive. It was Descartes who, seeing hats and cloaks pass by his window, asked himself whether they were not worn by 'ghosts or dummies' moved by some spring." Because all phenomena can potentially harbor a secret, everything falls "under suspicion." I can only protect myself from the omnipotence of a deception controlled from the outside by confronting the world with doubt, by viewing it differently—namely by looking behind its deceptive surface.

However, the celebration of uncertainty, as found in both the psychoanalytical search for double meanings and the double image, also opens up a critical suspicion vis-à-vis psychoanalysis itself. Secrets become the objects of libidinal investment and take on the character of a fetish: "I am aware of my ignorance, but if I doubt the appearance of the world then I also believe it to have a secret meaning." For the desire to perceive phenomena as code means that they must always be encrypted anew. Behind the deceptive reality we sense a conspiracy that carries just as much meaning as unmasked normality. This basic attitude of suspicion that there is more to be known than the reality of superficial phenomena still leaves us with the question of whether the hidden side of appearance is the only truth, and thus all surface manifestations should be seen as deceptive, or whether it is not in fact a matter of alternating between the two sides. The joy of discovering that everything can be connected to everything else, that every form is not identical with itself, should not disallow the possibility that sometimes signs have no deeper meaning, but are purely coincidental, are not bound to a hidden message, and are mysterious exactly because of this contingency. That is why Georges Didi-Huberman (2000, 190) rightly warns that the doubt instilled by psychoanalytic thought only becomes magical and totalitarian if it claims the absolute character of a law, when it disregards its own limitations and blocks access to the fissures in representational forms: "Thus it is high time for representation to be seen together with its obscuring elements, and imitation together with that which could partially or entirely shatter it."

Since in Dalí's pictures of double images we are not dealing with a final dissolution of the image, nor, above all, with the discovery of a demonic God machine à la Descartes, one could describe his appropriation of the psychoanalytical economy of doubt as a turn from paranoia to cryptomania: the mise-en-scène of a perverse desire for secrets as a surreptitious source of pleasure. The "different way of seeing" that detects the changing figures on the pictorial surface gives credence to a belief in the omnipotence of ideas themselves, because it commemorates the artist's power of transformation as well as the belief that nothing is coincidental. But if this different way of seeing facilitates a deciphering process, then only to allow interconnections and analogies in respect of the artistic form to come to the fore, not to achieve a final deciphering of these phantomatic figures.

The term cryptomania is referred to here in order to emphasize that the gaps in our knowledge that are given expression in Dalí's double visions are not supposed to be closed but rather to be savored as gaps. Dalí's double images invite us to inspect their deceptive surfaces so that the magic of metamorphosis becomes visible—by changing our angle of vision—without having to seek a hidden meaning in the depth of the picture. In contrast to paranoia, which presumes a mechanical instance of evil at the center of ambiguous appearances, celebration of the obscurity of signs ultimately leads to a permanent preservation of the secret, a celebration of ignorance. The secret itself, not what it conceals, becomes a fetish and the trigger of the visual uncertainty that we perceive is not a demonic God machine but our own desire for a mysterious world, a desire that makes us indefatigable readers.

In his theoretical discussion of those cultural artifacts that lead to our everyday myths, Roland Barthes (1957) presents an analogy that can usefully be applied to describe the rhetoric of Dalí's double images. If we look out the window of a moving car, we can focus our gaze either on the window pane or on the countryside passing by. Thus we notice the presence of the window and the distance of the scenery, then once again the transparency of the window and the depth of the countryside. But the result of this oscillation remains constant—the glass is both present and empty, and the countryside unreal because, although seemingly filled with meaning, it is visible only through the medium. We have a similar situation with the double images that visualize the meshing of the female body and the skull. The image might be a ballerina, or two female figures sitting drinking at a table, or seven naked women combined into the form of a skull (fig. p. 251); in René Magritte's *The Rape* (fig. p. 191) it is a naked female torso in place of a face. As we pass through these paintings, we sometimes notice the female form, sometimes the skull or face. Sometimes we have the impression that the head shimmers through the female body that—acting like the window pane—screens it, and sometimes it appears as if the body parts prevent a direct view of the skull. In fact we might also think—to follow Barthes's formula—that as significant signs on the pictorial surface these female parts are present, but

also empty. Since they function visually as a cipher for the insight that death can only be perceived as a phantom, the viewer is encouraged to look through them. They are emptied of their manifest meaning as "female body parts." In this sense visualized death would also be unreal because it is portrayed on the one hand in a metonymic manner—as a skull—and in another as only a obscured sign: the dark core of a beautiful female figure.

But the artist's double image makes reversibility possible, a possibility which does not exist in Barthes's example of the moving car. The traditional use of the skull as a symbol of death in the iconography of art history could just as easily be read as a cipher for the transience of female beauty or the self-indulgent pleasure of sexuality, with the female figure being unreal and the death figure present, but void of its actual meaning. Does the female body serve as a cover-up image for death or is death a screen protecting us from a direct view of what female sexuality is responsibility for? Can we be reconciled with death if it appears in the shape of a female body? Or are we dealing with a paranoiac fear of femininity that sees mortal danger, in the sense of Descartes' machines, embodied in the beautiful form? Are these ciphers for mortal pleasures, for a pleasurable death or for a more fundamental statement of the frailty of human existence, abiding as it must in an ephemeral body? But it is not central to our changing view of the double image that two culturally accepted mysteries—death and femininity—are used visually to reflect each other, thereby negating a final and unambiguous interpretation and allowing only an overinterpretation. More important is that our view is constantly alternating between the female figure (the various body images) and the death figure (the skull), and in the process we come to understand that each figure serves as a cipher for the other. Both are thus present and empty, both are unreal and endowed with a mysterious content, because the phantomatic core of the respective other is present in the picture: two mysteries whose optically obfuscating doubling introduces the idea of the failure of visualization. In contrast to the classical *vanitas* iconography we are not dealing here with a symbol of death or with an allegory of female vanity. The educational impetus behind the

inextricable visual meshing of the two figures leads us instead to the view that there is no transparent visualization for the mysteries of death and sexuality: thus the two mysteries account for an unavoidable and disrupting gap in the image.

In the process of seeing too much on the one hand and too little on the other, we are continuously faced with the problem of deciphering the double images. If we play the guessing game that Dalí understood as an educational project, we not only encounter a double image that can be understood as both a symptom of an unresolved emotional conflict and the quintessential ambiguity of worldly phenomena. We also become more uncertain about whether these materialized figures actually hold a secret message for us or whether we are only projecting our own cryptomania into the picture. Do we see too much because we want to discover secrets everywhere, or do we see too little because there is no solution to the ciphers we crave, except in our longing for the mysterious? One might think of the argument between the royal couple in Shakespeare's *A Midsummer Night's Dream*. When Theseus sensibly warns against supposing a bush for a bear in a flight of fancy, Hippolyta points out the magical ambiguity of the forms that the young lovers experience in the enchanted forest commenting that the nightly atmosphere creates "something of great constancy; But howsoever, strange and admirable." She, too, is a spiritual forbear of Salvador Dalí's magic of enlightenment. We must tolerate the contradictory ambivalence of the world of appearance and choose neither the seemingly banal bush of our everyday perception nor the demonic bear of inner fantasies but instead accept the abundance provided by a view that focuses on the mutability of phenomena. What we see in a double image is always "too much": too much because it is both a seductive plane of projection for the viewer and pure contingent materiality. But "too much" also because the images contain more than the manifest or the latent meaning that we would discover in these phantomatic figures, if they were clearly delineated forms on the canvas rather than mutually enmeshing correlations. The economy of doubt that informs these images leads to an ambiguous value added that does not serve so much as a rhetoric of rejection (the manifest term stands for its latent opposite and can be replaced by it) but rather creates simultaneity of meaning. Two contradictory terms appear together following the logic "as well as." If we wish to speak of a latent meaning then only as the vanishing point of an image. This joyous cryptomania creates a counterpoint to a psycho-aesthetics that insists on the terrible suspicion that either everything is meaningful or nothing is. If the visual uncertainty in these double images leads to the insight that the meaning of forms is not fixed but rather overdetermined, then the presented puzzle cannot be solved. We move with our eyes through the image but never come to the final secret. Seeing conceals and loses something in one stroke—an inexorable movement of desire.

References

Barthes, Roland. 1957. *Mythologies*. Paris.

Bronfen, Elisabeth. 1993. *Over her Dead Body: Death, Femininity and the Aesthetic*. Manchester

Dalí, Salvador. 1949. *The Secret Life of Salvador Dalí*. London.

———. 1980. *Das Geheime Leben des Salvador Dalí*. Munich/Paris/London.

Didi-Huberman, Georges. 1999. *Was wir sehen blickt uns an: Zur Metapsychologie des Bildes*. Munich.

———. 2000. *Vor einem Bild*. Munich.

Freud, Sigmund. 1919. Das Unheimliche. Pages 227–68 in *Gesammelte Werke*. Vol. 12 (Frankfurt am Main 1947).

Gibson, Ian. 1998. *Salvador Dalí: Die Biographie*. Stuttgart.

Leader, Darian. 2002. *Stealing the Mona Lisa: What Art Stops Us from Seeing*. London.

Matthes, Axel, and Tilbert Diego Stegmann, eds. 1974. *Salvador Dalí, Unabhängigkeitserklärung der Phantasie und Erklärung der Rechte des Menschen auf seine Verrücktheit: Gesammelte Schriften*. Frankfurt am Main.

CHAPTER 8

Among all the plaster
Of the wretched fields
You were the reed of love, damp jasmine.
Amid south wind and fire
of the miserable sky
You were the snow, dropping gently on my breast.
Sky and fields
Forged chains upon my hands.
Fields and sky
Whipped my body's wounds
FEDERICO GARCÍA LORCA*

■ What in the previous chapter was still a clumsy yet cocksure mating ritual, becomes an obsession here, a compulsive awareness of the desired body. No landscape, no tree that does not stimulate erotic fantasies, the head is entangled in desire. Harmless illustrations are all of a sudden transformed into pornographic scenes, sometimes admittedly expressing themselves in embarrassed furtive banality. *StA*

* *On Wondrous Love*

bowl

(Gbene

milk ve

Utagawa Kuniyoshi,
*He Seems Frightful at
First Glance, but He Is a
Nice Man*, c. 1847–8

UTAGAWA KUNIYOSHI
** 1798 in Edo (Tokyo), † 1861 in
Edo. This Japanese artist
and draftsman began making
dye-patterns and woodcuts
as a child and was inspired by
Kitao Shigemasa's picture
books. He studied European
perspective and around 1830
started drawing caricatures.
His drawings were influenced
by Hokusai; his preferred
motifs were women and actors.*

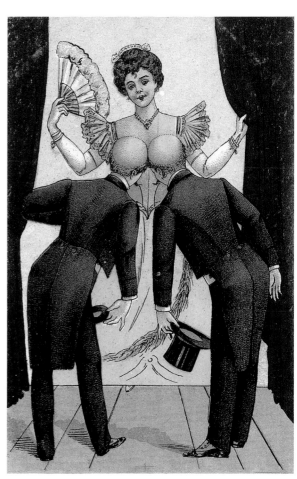

PABLO PICASSO

** 1881 in Málaga, Spain, † 1973
in Mougins, France. Picasso is
regarded as the most important
painter of the first half of the
twentieth century. His cubism
revolutionized the artist's
way of seeing, and his persistent
innovation and variations
made him the most versatile
visual artist of modernism.
Alongside his epochal key work,
Les Demoiselles d'Avignon,
his painting Guernica for the
Spanish pavilion at the 1937
world' fair is regarded as
a highpoint of his creativity.
He was also a prolific
graphic artist and sculptor.*

Pablo Picasso,
Le phallus
The Phallus, 1903

Anonymous,
erotic postcard, 1905

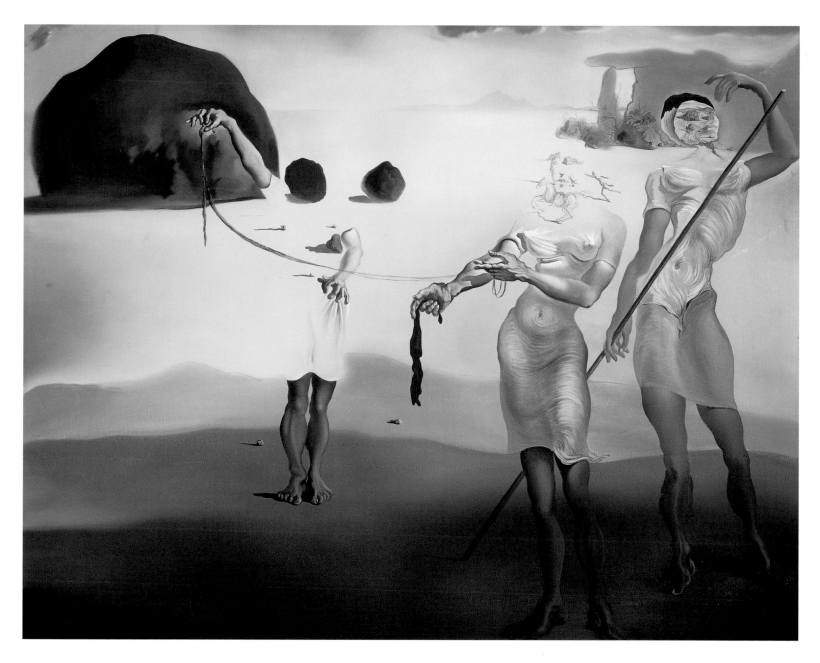

Salvador Dalí,
Plage enchantée avec trois
grâces fluides
Enchanted Beach with Three
Fluid Graces, 1938

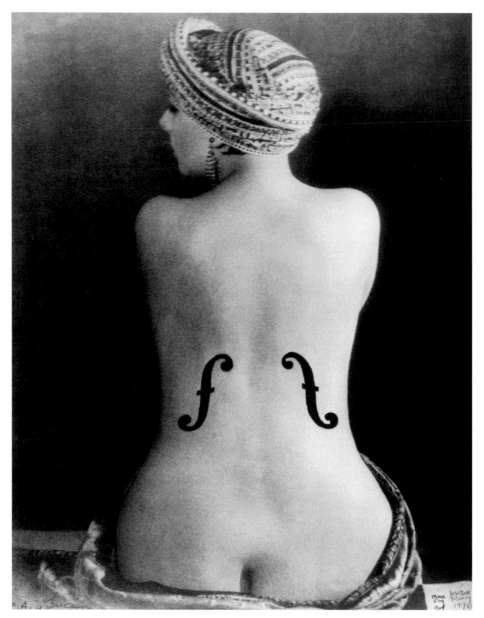

Man Ray,
Le violon d'Ingres, 1924

MAN RAY

** 1890 in Philadelphia, † in 1976 in Paris. Photographer, painter, and film-maker who was the only American adherent of the Dada movement and of Surrealism. The legendary 1913 Armory Show in New York alerted him to the European avant-garde. In the 1920s and 1930s, like László Moholy-Nagy, he worked in the field of cameraless photography.*

■ Even in the title of this work Man Ray tinkles the ivories of ambiguity with a virtuoso play on words. The French painter Jean-Auguste-Dominique Ingres (1780–1876) was a passionate amateur violinist. Hence, in French "Le violon d'Ingres" (Ingres' Violin) is a synonym for a hobby or spare-time relaxation.

Man Ray,
Minotaur, 1934

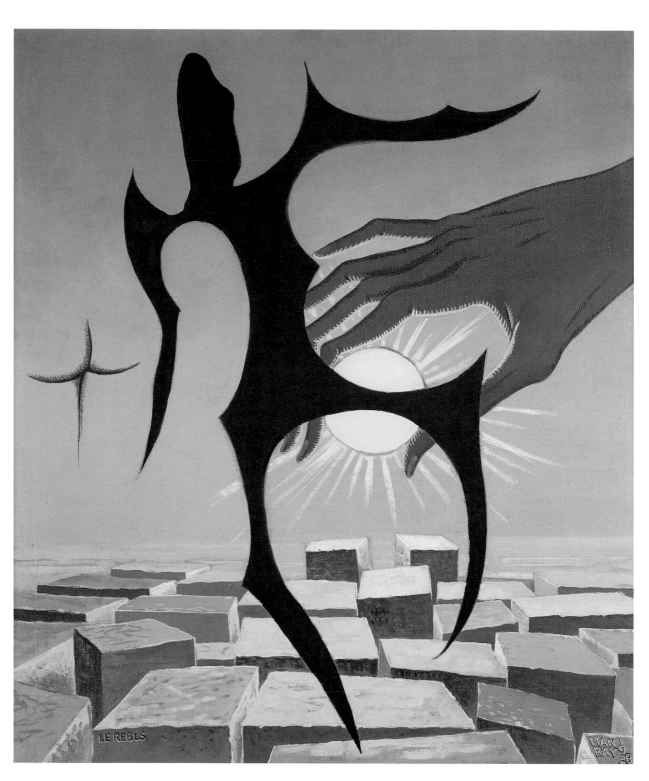

Man Ray,
Le rebus
The Picture Puzzle, 1938

Salvador Dalí,
sketch for the Walt Disney film
Destino, c. 1946

Yehuda Neiman,
Animal Head, 1966

YEHUDA NEIMAN
** 1931 in Warsaw, lives in Paris.
Artist and photographer who
grew up and studied in Israel.
Neiman shows his kinship
with Surrealism in abstruse
doublings and bewildering
focusing that give rise to the
strangest monsters.*

Roman Cieslewicz,
La Joconde
Mona Lisa, 1974

ROMAN CIESLEWICZ
** 1930 in Lwów, Poland, † 1996*
in Paris. Cieslewicz studied
at the Cracow Art Academy,
and from 1959 to 1963 was art
director of the magazine
Ty i Ja (You and I). He worked
as a commercial artist,
advertisement designer, and
illustrator, creating several
posters and book covers for
the Centre Georges Pompidou
in Paris.

The pillars of Nature's temple are alive
and sometimes yield perplexing messages;
forests of symbols between us and the shrine
remark our passage with accustomed eyes

Like long-held echoes, blending somewhere else
into one deep and shadowy unison
as limitless as darkness and as day,
the sounds, the scents, the colours correspond.

There are odours succulent as young flesh,
sweet as flutes, and green as any grass,
while others—rich, corrupt and masterful—
possess the power of such infinite things
as incense, amber, benjamin and musk,
to praise the senses' raptures and the mind

Charles Baudelaire, Les Fleurs du Mal: The Complete Text of the Flowers of Evil,
trans. Richard Howard (London, 1982), p. 15.

VOLKMAR HERRE
** 1943 in Freiberg, Saxony,*
lives in Stralsund
A musician, draftsman, and
photographer, Herre is the
great-grandson of the noted
Dresden photographer
August Kotzsch. He often
uses a camera obscura.

Volkmar Herre,
from the cycle *Der Baum und Ich,*
Vilm, 18. September 1995
From the cycle *The Tree and I,*
Vilm, 18 September 1995

TURNING AND FOLDING

If we cannot see clearly, we at least want what is unclear to be in focus
SIGMUND FREUD

■ Chapter of delicate drawings and revolving paintings. Appearance of the great magician André Thomkins, whose works hover in a slippery, ungraspable state. Perhaps the most demanding chapter for the viewer, who has to come to grips with the microcosm of this great Swiss artist. With reproductions of some of his most beautiful "rapport paintings." These are preceded by a colorful sequence of popular and high art, for example by Tony Cragg, surrounded by whirring revolving images. *StA*

Turning

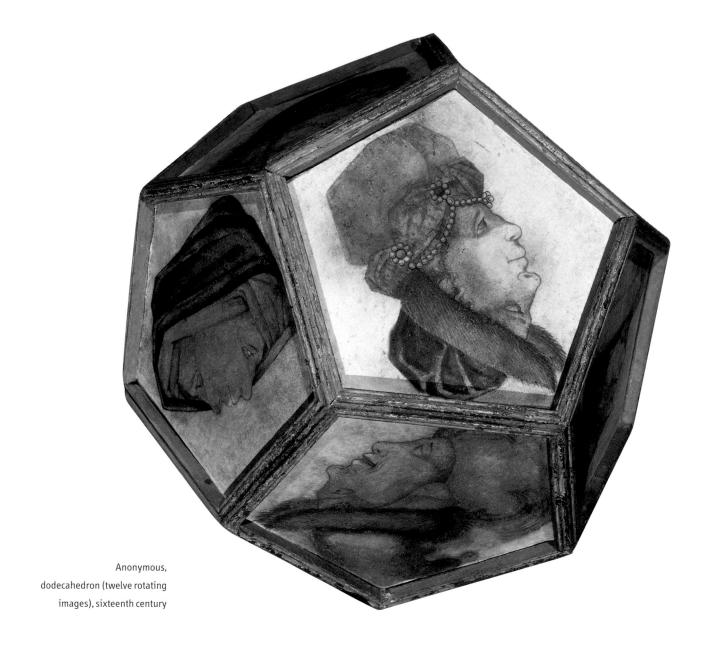

Anonymous,
dodecahedron (twelve rotating
images), sixteenth century

■ Polygon with twelve pentagonal wood-framed fields. Eleven depictions of men,
differing in age and status, and a portrayal of a horse that are all recognizable after
being turned through 180°.

Anonymous,
double portrait with pope
and devil, c. 1600

REVOLVING IMAGES

At the time of the Reformation, when the religious and political debate developed a
pictorial clout, the revolving image became widespread as a kind of early form of
political caricature. Criticism of irregularities within the Church focused mainly on
the person of the pope. Thus one revolving image combined a depiction of the pope
with one of the devil: at a flick of the wrist, the profile of the Church dignitary is trans-
formed into the antichrist; the pope's nose becomes the devil's chin and vice versa.
This direct linking of the pope and his greatest adversary served the supporters of the
Reformation to illustrate the heresy which in their view the pope embodied. Such a
view is often underscored by the addition of an inscription, such as, for example, "Des
Bapst Gebot ist wider Gott" (the pope's command is contrary to God).

This rather plain and simple form of criticism was not restricted to spiritual lead-
ers; it also applied to secular rulers. Moreover, there is a whole range of combinations
of motifs intended to be humorous. A particularly popular form linked humans and
animals, whereby the animal became man's "alter ego," as it were, with the animal's
features revealing the true character of man. Thus an old maid becomes a goat and a
cheated man an ass. Generally, these caricatures remain at the level of cliché and are
unsuitable for exercising a real criticism of individual misdemeanors. Nevertheless,
revolving images became very widespread because they were capable of gaining gen-
eral acceptance. These reversible heads were produced especially by printers, medal-
makers, and craftsmen; they are comparatively rare in paintings. *UH*

Anonymous,
shooting target, "Drei Hasen
und der Ohren drei / und doch
hat jeder ihrer zwei"
"Three rabbits and three ears /
Yet each has two of them,"
Bavaria, c. 1910

■ The leaping hares, shown in profile, are arranged to form a circle, and so positio-
ned that their ears touch and form an isosceles triangle. Thus each hare appears to
have two ears, although only three are shown. The "Three Hares Motif" is found in
medieval art, the best-known example being in a thirteenth-century tracery window
in the cloister of Paderborn Cathedral. Because it combines oneness and threeness,
this image was interpreted as a symbol of the Holy Trinity. More recently, though, it
has been thought to relate to a solar or lunar sign—perhaps symbolizing the cyclical
movement of the moon, which may be visible in full, in part, or not at all. *AZ*

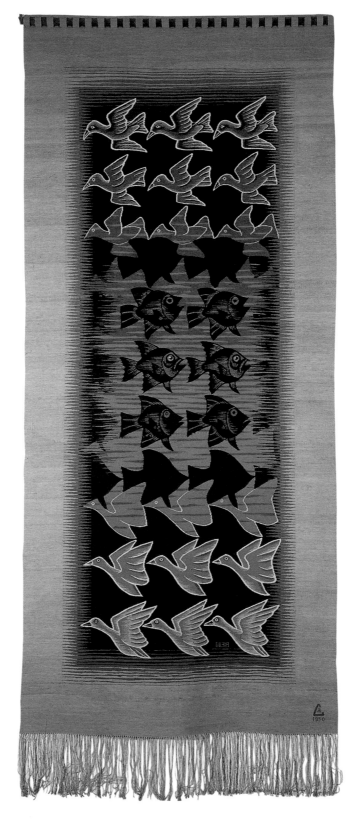

M. C. Escher,
tapestry with fish and birds,
1949–50

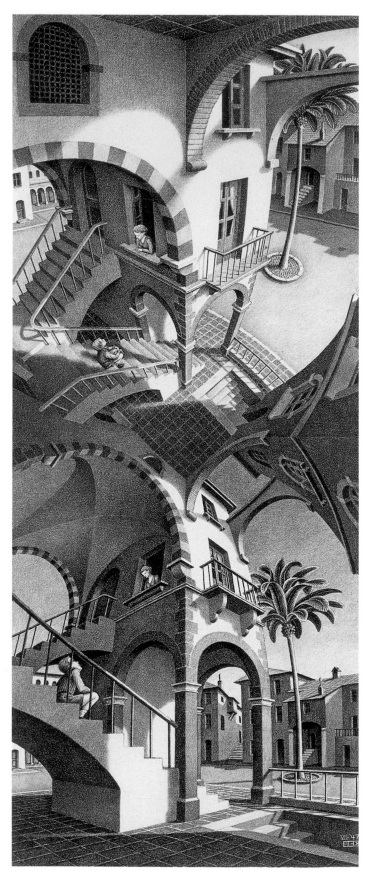

M. C. Escher,
Up and Down, 1947
© 2003 Cordon Art B. V.—Baarn—
Holland. All rights reserved.

M. C. ESCHER

**1898 in Leeuwarden, † 1972 in Hilversum. After briefly studying architecture Escher, a Belgian, gravitated to graphic art, although his teachers expressed the opinion that his work was "too literary-philosophical." After a peripatetic life that took him to Italy, Spain, Switzerland, and Belgium between 1922 and 1941, he finally settled in Holland. From 1937 he produced woodcuts, wood engravings, and lithographs that take for their themes carefully calculated paradoxes in which different planes of observation seem to be united in a single spatial perspective. He also created numerous patterns consisting of regular repetitions of stylized shapes.*

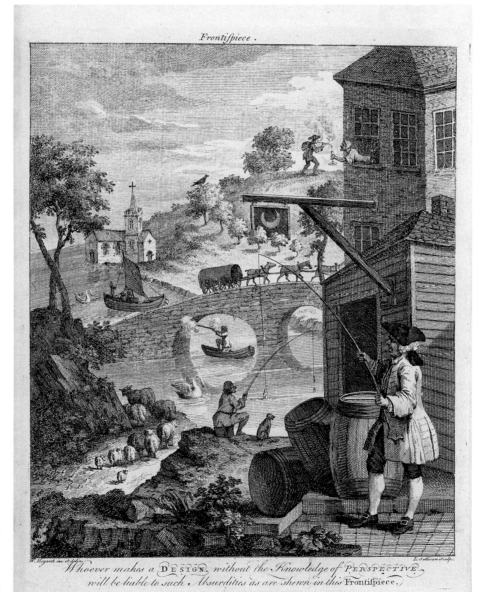

WILLIAM HOGARTH

** 1697 in London, † 1764 in London. The artist, copper-engraver and etcher was apprenticed in 1712 to the goldsmith Ellis Gamble, from whom he learnt to draw and engrave on metal. Having become independent, he went on to produce satirical drawings for publishers of books and copper-engravings. His caricatural scenes of everyday life are reminiscent of Callot in their wit and the precision of their detail and often have a social or political reference. His theoretical book* The Analysis of Beauty, *containing his views on art, was published in 1753.*

William Hogarth, frontispiece to *Dr. Brook Taylor's Method of Perspective* by Joshua Kirby, 1754

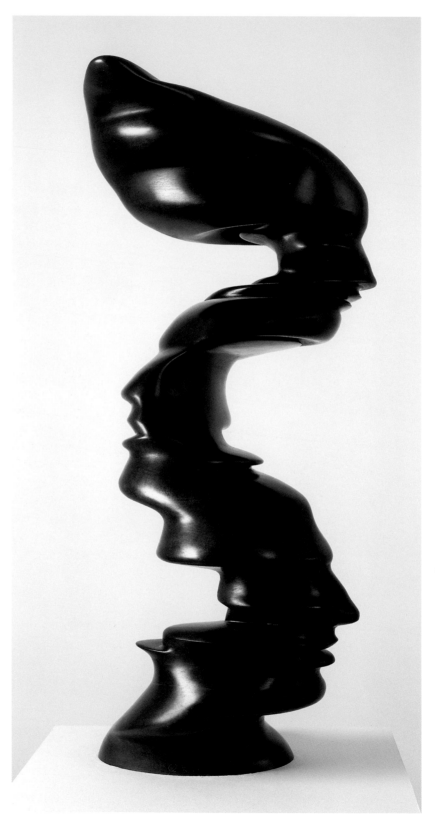

Tony Cragg,
Line of Thought, 2002

TONY CRAGG

** 1949 in Liverpool, lives in Wuppertal. His sculptures and objects have made him one of the best-known representatives of contemporary British art. For a long time Cragg experimented with making rubbish constructions out of everyday things. More recently he has increasingly moved to using ceramics, stone, and bronze to lend expression to his formal language.*

ASSOCIATIVE FORMS

Tony Cragg's sculptures constitute a metaphysical dialogue with their materials. The artist chooses his materials not from an optical viewpoint but in accordance with an affinity he senses for form. The form the artist perceives in the material is then influenced by concepts and emotions which he both brings to that material and receives from it. Thus the creative process is one by which material mutates into form, giving rise not to abstract constructs without content, but to forms charged with associations. As a result, Tony Cragg's sculptures cannot be simply consumed by the spectator. Instead they challenge him or her to enter into a dialogue with the artwork.

In the late 1990s Cragg produced works such as *Seated Woman* and *Messenger*, the very titles of which allude to the formal association with the human body. And in some of his more recent, often untitled, works the sculptural form has all kinds of associations with the human form. Through the ambiguity of their relief constellations these works become—literally—multifaceted dual images. As we walk around a sculpture our changing view of its irregular profile means we discover ever new regions which, being suggestive of eyes, nose, and mouth, combine to form a human face.

The dynamism with which these dual images emerge clearly differs depending on the material. Whereas the smooth stone slabs reveal static faces, in the cast bronze sculptures in particular we can make out the fluid modeling of the faces; at some points, they seem to ascend to the surface from within the sculptures. *UH*

Folding

Tony Cragg,
Secret Thought, 2002

Raoul Marek,
double portrait project
Fifty Vases and their Locations,
Sabine / Daphnée 6 / 50,
Mania / Bernhard 5 / 50,
Bernhard / Julia 7 / 50, 2000

RAOUL MAREK
** 1953 in Canada (?), lives in
Berne and Paris. The versatile
Raoul Marek, who works
in public spaces, producing
exhibitions, events, and
performances, operates at the
point of intersection between
fields generally regarded as
incompatible: festivities and
death, the cultural and the
workaday, inside and outside,
agility and openness—in fact,
Art and Life.*

André Thomkins

ANDRÉ THOMKINS

**1930 in Lucerne, † 1985 in
Berlin. Swiss painter,
draftsman, musician, and set-
designer. He admired Dada
and Surrealism, which formed
his artistic roots. His drawings
develop fantastic landscapes
with an equally fantastic popu-
lation that is permanently
wrestling with the existential
problem of only being drawn.
Also celebrated are his
palindromes (sentences that can
be read forwards or backwards);
he states his profession as
"Retrowordsman." Unlike the
work of many artists who
work with the double-image
method, Thomkins's picture
and word fantasies never
monopolize. The terrain in
question is not an object for his
personal possession but always
a surface on which to project
his "inner Mongolia," the
territory of his fantastic and for
ever self-referential legends.
The counterpart of his openness
to the world as a person,
is his harshly hermetic pursuit
of the inspirations of his poetic
world of words and thoughts
that double back on themselves.*

André Thomkins,
*Haus für Bewohner,
House for Inhabitants*, 1965

HERMETIC WORLDS

André Thomkins's "rapport patterns," which he initially called picture puzzles, operate by deliberately re-interpreting a rigid, constantly repeating structure.

His early work *House for Inhabitants*, 1965, is already based on a monotonous, stencil-like scheme of arches which Thomkins imbues with a completely new significance by a process of extraction, separation, and filling in. Thus the *House for Inhabitants* becomes a surreal place where laws of perspective and real dimensions no longer apply. The inhabitants, sometimes tiny, sometimes huge, enter into a rapport with the architecture through their body language, with the result that they merge directly with this fictional world. Through a rhythmic composition in individual episodes, the viewer is repeatedly thrown back on the structural network, and this enables him to move to and fro between abstract structure and the detail of the motifs.

Things are different with Thomkins's imaginary landscapes. Even though his oeuvre exhibits a fluid transition from "rapport patterns" to depictions of fantastic landscapes, a characteristic difference still exists between them. In his landscapes Thomkins clearly weakens the constructive pattern, thereby allowing the image to be taken in holistically. This involves a different kind of puzzle. The relationship between structure and detail is no longer mutual, the depicted components are now ambiguous.

An early example of these dream-like landscapes is an untitled watercolor dated 1966 (illustration on p. 223). Here Thomkins depicts a woman who is directly entwined with the landscape; her dress can also be seen as a lake, her arm consists of a plateau complete with leaning tower. Thomkins heightens the irritation caused by the ambiguity of the depiction even more by arranging the motifs in a way that contradicts our visual habits, and by instilling the image with thematic paradoxes. The artist condenses a closed, surreal world into the work by means of several changes of perspective and a combination of pictorial components that contradicts our rational mode of thought.

For Thomkins all these works are "permanent scenes" intended to function for as long as artist and viewer wish. This label provides the key to understanding them; the inexplicability of the links is what sets the continuum of the inquiry in motion. *UH*

André Thomkins,
Untitled, 1966

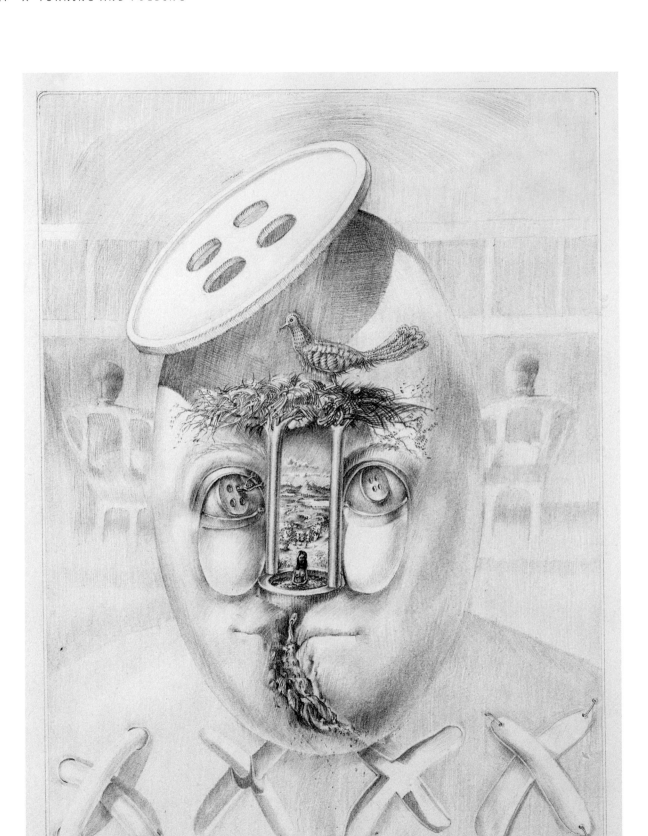

André Thomkins,
oTTo, 1968

André Thomkins,
Blut-Milch-Zirkulation
Blood-Milk Circulation, 1970

André Thomkins,
arbeiter mit frauen blau und gelb
worker with women
blue and yellow, 1971

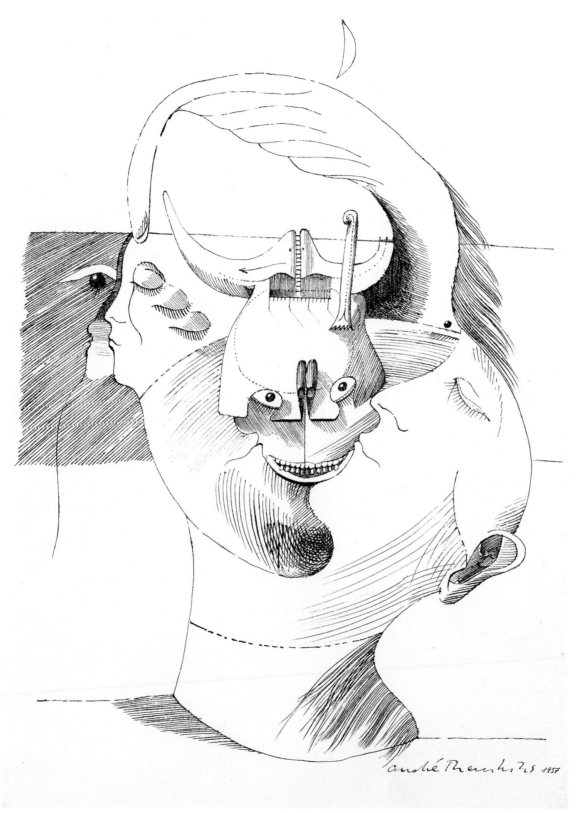

André Thomkins,
Untitled (head with faces), 1957

■ Opening with Dalí and Dubuffet. Delirium develops into an illness. Headache, flickering, or sheer madness. The chapter is devoted to *Art Brut*, which is represented by double images in the most diverse of techniques. The question is, how much illness can one allow a healthy person yet still call him healthy, and how much health a sick person yet still call him sick. *StA*

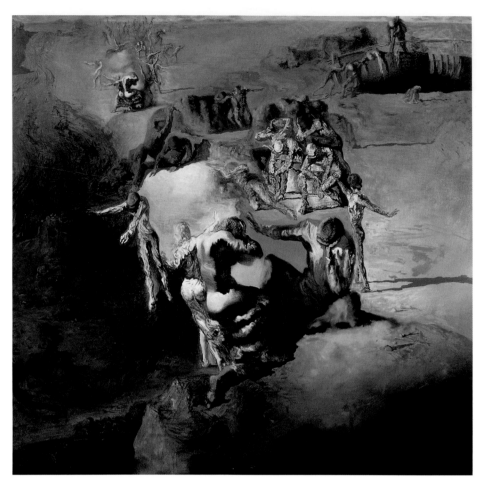

Salvador Dalí,
Le grand paranoïaque
The Great Paranoiac, 1936

■ Dalí said that *The Great Paranoiac* had been conceived after a discussion with Josep María Sert about Arcimboldo, and that the protagonist's face is fashioned on "Empordà countryfolk, the greatest paranoiacs of all". The remarkable work suggests strongly that Dalí was now convinced that the intense feelings of shame which had always troubled him were paranoid in character. The leitmotif of the person hiding his head in shame had first appeared in Dalí's work in 1929, and between then and 1936 had recurred in more than thirty paintings and drawings. In *The Great Paranoiac* it attains its most eloquent expression. Almost all the characters in the picture are burying their heads in their hands or refusing to look, particularly the seated female whose buttocks form the nose of the protagonist. Brushing against this buttocks-nose is the shapely bottom of Gala: presumably Dalí is hinting once again that his shame-imbued erotic fantasies are centred on this part of the body. The double figuration employed in the delineation of the head of the *Great Paranoiac* is as successful as any achieved by the painter, and is perhaps even more striking in the repetition of the motif in the left background, where the back of the head merges into an anguished group of people all hiding their faces or running away.

Ian Gibson, The Shameful Life of Salvador Dalí *(London, 1997), pp. 372*

JEAN DUBUFFET

1901 in Le Havre, † 1985 in Paris.
In 1918 Dubuffet began studying
art in Paris, but broke off after
six months. In Paris he met
Raoul Dufy, Max Jacob, Fernand
Léger, and Suzanne Valadon,
who like him were enthusiastic
about Hans Prinzhorn's treatise
The Artistry of the Mentally Ill
(1922). Only in 1942 did Dubuffet
devote himself entirely to art.
In 1945 he coined the concept
of Art Brut for the art objects in
his collection.

Jean Dubuffet,
La gigue irlandaise
Irish Jig, 1961

Wir lieben den Tod	We love death
Rot winde den Leib,	Wind the corpse in red,
Brot wende in Leid,	Bread turns to suffering,
ende Not, Beil wird	End of anguish, an axe becomes
Leben. Wir, dein Tod,	Life. We, your death,
weben dein Lot dir	Weave your plumb line
in Erde. Wildboten	Into the earth. Wild messengers,
wir lieben den Tod	We love death

Unica Zürn, "Anagrammatisches Gedicht, 1953/54" *

UNICA ZÜRN

The tightrope walk between mania and genius is one of the myths of modernity. As an artist, one must either go mad or else put an end to oneself in order to become immortal in one's own mystery. It was by this logic that modernity created its own heroes, whether you call them Nietzsche, Kafka, or Van Gogh. So it is the more surprising when one comes across individual artistic destinies that have been denied this dubious reward for their sufferings. Such a case is the Berlin artist Unica Zürn....

 Born in Berlin-Grunewald in 1918, Unica Zürn had a "happy childhood," according to her own writings. She already had a whole life behind her when in 1953, at the age of 37, she met the German surrealist Hans Bellmer and went to Paris with him. Her artistic life began with this relationship, which could be described as pathologically obsessive. Thereafter Unica Zürn was the woman at Hans Bellmer's side. Only rarely was her work accorded any significance of its own. Nonetheless, she began to draw and to write.

Knut Ebeling, "Von gespinstartigen Labyrinthen," Der Tagesspiegel, *22 Oct. 1998.*

* in Günter Bose and Erich Brinkmann, eds., *Unica Zürn: Gesamtausgabe in acht Bänden*, Vol. 1 (Berlin, 1988). © Verlag Brinkmann und Bose, Berlin.

Unica Zürn,
Untitled, 1966

Art Brut

Carl Lange,
Das heilige Schweißwunder
in der Einlegesohle
The Holy Sweat Miracle in the
Insole, 1898

■ [The] figures ... show how a systematic delusion can determine the whole act of creation. The patient, transferred in the 1890s from America into a German asylum where he died some time ago, perceived images like those shown only on the insoles of shoes, from which he copied them. The following excerpt from the very full accompanying texts he made for some of the drawings may increase our insight into his peculiar conglomerates of heads, birds, deer, numbers, etc:

"'Cristo viene, los muertos se levantan!' 'Christ comes, the dead arise,' is inscribed at the scene of a crime which begins with a judicial murder marked by a habeas corpus writ, and incited by insane physicians in the service of American railroad subsidy swindlers in Mexico, was hidden for 15 years behind insolent conscious falsification of documents by methodically secret poison murderers and killers in Germany, and ends with a miracle by the Holy Ghost, as represented in the attached drawing, a miracle in the insole of the victim ruthlessly sacrificed, disinherited, declared dead, by the secret violent poisoning and brain crushing of assassins possessed by Satan and mentally disturbed. A four-sided picture in an insole in connection with a new, hidden, double poison murder which can be understood and interpreted only by reference to the photographs of my dead parents Eduard and Mathilde L. née C. and their nine children. The parents, of whom the father, who died in 1893, was unwittingly defrauded

in a raw, mean way which exposes the whole German bureaucracy while my mother, whom death claimed 10 years earlier, in 1883, unmask the damnable murderers of her son in this wonderful picture, which surely appears inexplicable to everyone, including me, under the sign of the Holy Ghost, a white dove and the sign of suffering, a black cross which represents the secret brain and spine crushings, the head crucifixion which has engraved unmistakable marks of the secret crime, the falling out of beard, hair, and eyebrows, the scars and spots, while the mother demands revenge, 'a hair for a hair', by her hair, bound by a ribbon into a caption and stuck up with combs."

Hans Prinzhorn, Artistry of the Mentally Ill, *reprint (Vienna and New York, 1995).*

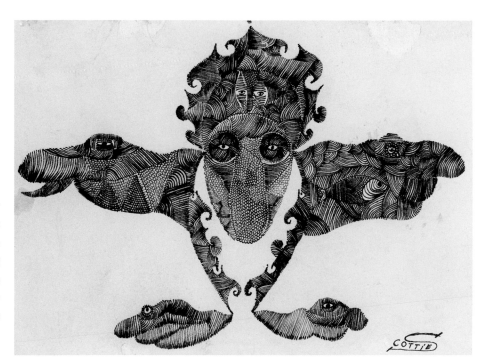

SCOTTIE WILSON (ACTUALLY LOUIS FREEMAN)

** 1888 in Glasgow, † 1972 in London. This London street trader started drawing when he believed his fountain pen was talking to him. His filigree pen-and-ink drawings, often symmetrically composed, involve mask-like heads, heraldic-looking creations, and good and evil spirits ("greedies"). The surrealists esteemed his work highly.*

Scottie Wilson,
Self-Portrait, 1940

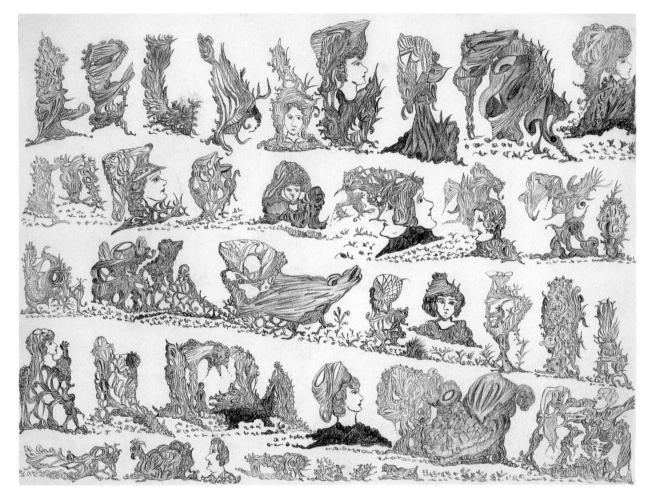

Raphaël Lonné,
Untitled, c. 1960

RAPHAËL LONNÉ

** 1910, † 1989. Raphaël Lonné
had a variety of jobs, ending
up as a postman in the
Monfort-en-Chalosse area.
An extremely sensitive and
sickly child, he showed
a great talent for verse, which
earned him the nickname
of "the Poet." From the 1950s
he took part in séances and
refined his drawing technique,
which he himself saw as
graphic-painterly poetry.
His landscapes are full of spirits,
animals, and people.*

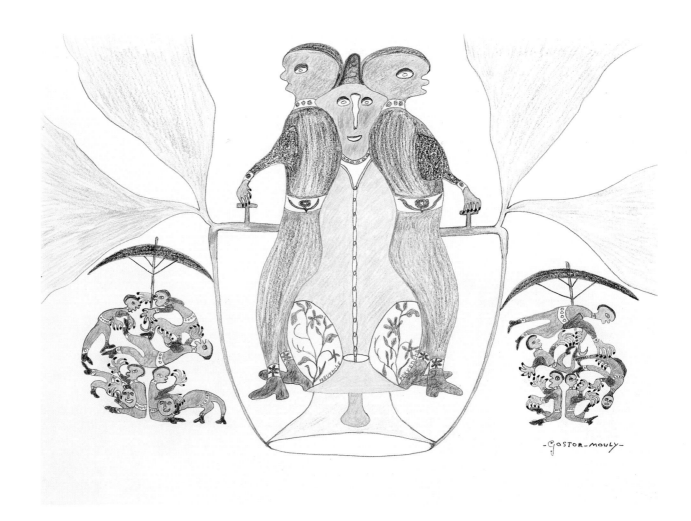

Gaston Mouly,
Les deux Laveurs – Attention les petites
The Two Bathers – Not in Front of the
Children, 1990

GASTON MOULY

** 1922 in Goujounac, France,*
† 1997 in Lherm, France. Mouly
initially worked as a building
contractor, until he became ill.
His lively drawings, inspired
by Gérard Sendrey, tell stories
of everyday life and are
shot through with apparently
surrealist humor.

■ August Neter described his own illness thus:

First I saw a white patch in the clouds, quite close at hand—the clouds were all stationary—and then the patch moved off and stood the whole time like a board in the sky. On this board, or this canvas or this stage, pictures followed one another as quick as lightning, maybe ten thousand in half an hour, so that it was only by extreme effort that I could grasp them. The Lord God Himself appeared, and the witch who created the world, and in between there were worldly scenes—images of war, of continents, monuments, battles in the wars of independence, magnificent palaces, in short the glories of the world—but all in unearthly pictures. They were at least twenty meters in size, quite clear and almost colorless, like photographs, though some were slightly colored. There were living figures that moved. At first one thought that they actually had no life, but then they were permeated by a transfiguration, transfiguration was breathed into them. Really it was like being in a cinema. The meaning was clear as soon as one saw the vision, although it was only later, when drawing, that one became conscious of the detail. The whole thing was very exciting and eerie. The images were revelations of the Last Judgment. Christ could not complete Salvation because the Jews were too quick to crucify Him. Christ said on the Mount of Olives that he quailed at the visions that appeared to Him there. The visions we have been talking about were also like the ones Christ spoke of. They were granted to me by God to complete Salvation.

August Neter, quote translated from: Die Prinzhorn-Sammlung: Bilder, Skulpturen, Texte aus psychiatrischen Anstalten (ca. 1890–1920), *exh. cat., Heidelberger Kunstverein (Königstein im Taunus, 1980), p. 238.*

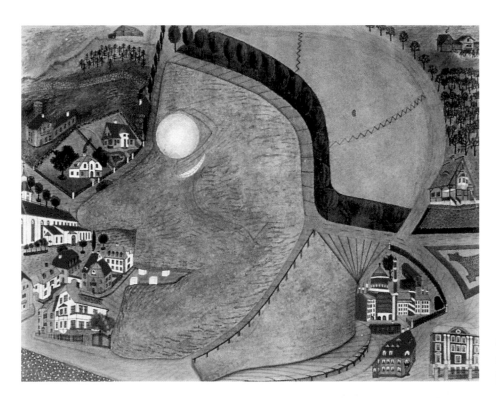

August Neter (A. Natterer),
witch's head, nineteenth century
(recto and verso)

AUGUST NETER (KNOWN AS NATTERER)

1868 in Rottenmünster am Neckar, † 1933 in Rottweil. After leaving school, Neter worked as a mechanic. When he was thirty-nine he showed signs of the severe psychosis that, after a suicide attempt, led to his committal to a mental hospital. He suffered from schizophrenia and hallucinations, and he began drawing in 1911. In 1922 his works were included in Hans Prinzhorn's book Artistry of the Mentally Ill.

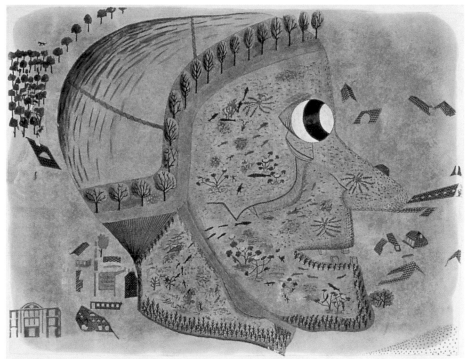

Claudia Dichter

ART BRUT—DOUBLE IMAGES

In the context of art history, *art brut* presents itself as immediate, authentic, and unspoiled. Since its beginnings with Adolf Wölfli and the artists of the Prinzhorn collection, this genre of art has been undergoing a process of emancipation. The artists of the avant-garde—the Dadaists, surrealists and expressionists—have elevated, even idealized the works of these autodidacts who stand outside the sphere of art-historical discourse. They have romanticized *art brut* as a vehicle for subversive protest and emulated its essence even to the point of plagiarism. The shift in meaning inherent in insanity or other levels of consciousness presupposes freedom from normative rules. A primordial expressive power far removed from academic training brings forth artistic production which is not bound to any style, genre, or specific iconography. Of course it was above all the surrealists who sought inspiration and an unspoiled form of creativity in the art of the so-called primitives, children, the naive, and the mentally ill. Dream, vision, automatism, the subconscious uncontrolled by conscious reason or, as André Breton expressed it, "mental reality" was the proclaimed goal. By 1930 Breton and Paul Eluard could already declare, in *L'immaculée conception*, that the behavioral and expressive forms resulting from mental illness were aesthetically worthy of imitation. Influenced by Freud's dream interpretations and Jacques Lacan's studies of paranoia, Dalí developed his own paranoiac-critical method, a method which reinterpreted pathological events in poetic form. The surrealist techniques—automatic writing and drawing, hypnosis, frottage, and pareidolia—served the purpose of freeing unconscious powers so that they could be channeled into artistic expression. It is per se these "methods" that are often found in *art brut*.

Dalí and the surrealists were familiar with the artists of the Prinzhorn collection. In only two years, between 1919 and 1921, the Heidelberg doctor and art historian Hans Prinzhorn collected 5,000 works by 450 patients in German-speaking countries. In their works he found the source of creativity which is found in all human creatures, regardless of whether they are deemed "healthy" or "ill." In 1922 Prinzhorn's standard work, *Die Bildnerei der Geisteskranken*, was published. Max Ernst brought the book back with him to Paris, where it became the bible of the surrealists. They were fascinated above all by the private mythological and anamorphic images of Heinrich Anton Müller, Karl Brendel, August Natterer, and Carl Lange: double heads, illustrated hallucinations, and visionary hermaphroditic creatures (fig. p. 234).

The pictorial world of Carl Lange and Otto Stuß reveals the psychotic causality directly. "This image was created without any human effort on my part in the right insole of my slipper and discovered by myself on 26 August 1898 … whoever can explain the origin of this wonder in which clearly the will, intention, and idea of a higher power expresses itself for a particular purpose may do so."[1] In a mixture of private and religious symbols Lange layered

Otto Stuß, *Air Drawing*, c. 1909

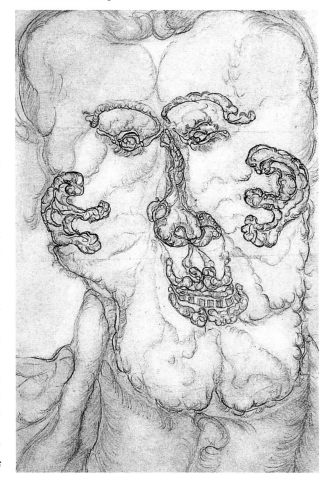

faces and body parts, doubling the eyes and mouths and letting one figure grow out of another. The cumulative pictorial event, crowned by the Holy Ghost in the form of a dove, is combined with the number five, which stands for the fifth commandment: Thou shalt not kill. Apparently he imagined, inspired by the spotty markings imprinted in the sole of his slippers from the sweat of his foot, double and triple images which he varied in a whole series of pictures entitled "Sweat Wonders." In a similar way to Lange and his footprints, Otto Stuß envisioned physiognomic patterns in cloud formations and interpreted them according to his personal inner experiences. What he called "air sketches"—penciled drawings which he created around 1909—were "not actually fantasies"; they had been drawn centuries ago and transferred to him by "drafts," which he sometimes he saw in the sky. When he finished drawing them, he did not see them any more and "another air form" would develop. Sometimes he could recognize his forefathers in these "air images."[2] Demon-like, the tumid face would appear in the swirling and proliferating contours of the clouds. Although eerie and menacing, they could nevertheless be banished through visualization. Stuß's reference to forefathers suggests a medium as the source of his images, but in reality his visions are most likely pareidolia, fantastic images arising from unclear or vague structured optical stimuli; a source of inspiration that was already familiar to Leonardo da Vinci.

The most famous metamorphic image from the Prinzhorn collection is the *Witch-head Landscape* (fig. p. 239) by August Natterer (1868–1933). Even if on first appearance it seems as if a hallucinatory experience has found adequate expression in the form of a topsy-turvy image, the work, which was executed between 1913 and 1917, is more than just an illustration of various levels of consciousness in a double image. The representation switches between the peaceful idyll of a quaint village with red-roofed houses, church, factory, and farmhouses amidst stubbly meadows and wheat-yellow fields and the face of an evil witch with loose teeth, a big nose, and a nightcap that takes on the form of a skull. Natterer's key work is based on a hallucination experienced in 1907, which led to his permanent hospitalization. "The visions in the sky appear as if they were on a screen or stage ... the

face had the appearance of a skull but was still alive—the seams on the skull created the form of a nightcap ... the entire figure is a witch: it symbolizes the creation of the world as a witch's deed."[3] But in addition to his hallucinatory experience, Natterer portrays the cliché of a fairy-tale witch while at the same time depicting landmarks taken from his own life in a historically accurate form: on the left St. Jodok's church from his native city of Ravensburg, on the right a tobacco factory in Dresden, one station in his year of traveling which led him as far away as America. The true meaning of this piece did not become clear until the 1980s, when restorers noticed that the picture was conceived as a transparent double-sided image. "If one holds the paper against the light, the head turns into a pond; wrinkles and pock marks change to waves in which fish swim amongst plants ... Using another technique—stencils that simulate darkness—twilight appears and the houses are illuminated. ... The eye of the witch comes alive, illuminated through the opaque white of its iris by the colored ring on the back."[4] As a former electrician Natterer was familiar with technical drawing as well as fine mechanical construction and he used this knowledge in his art work. He consciously decided on the deceptive play of topsy-turvy pictures with its combinatory use of images to elevate ambivalence to a principle in his work.

Another field of *art brut*—mediumistic art—moves in a sphere of expanded reality similar to hallucination. The work created under the impression of outside guidance occurs without conscious control or previously defined intent. This form of automatism often involves double images, dense compositions full of symbolism and arcane levels of meaning. Many mediumistic artists found their intellectual roots in the spiritualism that spread in North America and Europe in the wake of the changing values associated with the rise of industrial society. "It has never transpired ... that I had an idea of what was about to emerge. Wherever I stood in the process of execution, I never had an overview. The voices in me said: 'Do not try to understand what you do.' ... I followed my guides as if I were a child."[5] The miner Augustin Lesage (1876–1954) created almost 800 paintings urged on by the "voices" of his dead sister Marie, Leonardo da Vinci,

Death under Discussion

Who possesses your face?
The good the evil
The imaginably lovely
Endless acrobatics
With gestures she overtakes
The colors and the kisses
Great gestures in the night
PAUL ÉLUARD

■ Danse macabre. Night begins. Forgiving is the resurrection—we meet in heaven, home of the "supernatural being" where Sigmar Polke meets himself. The circle is closed. *StA*

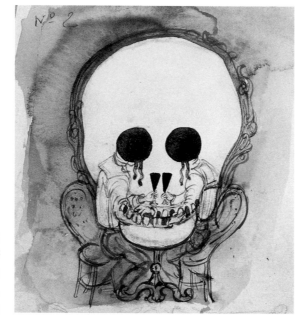

Salvador Dalí,
Scène de café
Café Scene, drawing for the film
Moontide by Alfred Hitchcock,
1941

Postcard,
L'Amour de Pierrot, France, 1904

Salvador Dalí,
Visage de la guerre
Face of War, drawing for the film
Moontide by Alfred Hitchcock,
1941

Illustrated on p. 212
Anonymous, dodecahedron
(twelve rotating images),
sixteenth century
Wood, iron, paper, and watercolor
Diameter: 39 cm
Private collection, Paris

Illustrated on p. 160
Anonymous, composite camel with
attendant, Iran, sixteenth century
Gouache on paper
15.8 x 21.5 cm
The Metropolitan Museum of Art,
Gift of George D. Pratt, 1925, New
York

Anonymous, pope and devil,
sixteenth century
Wood, painted
24 x 20 cm
Private collection, Switzerland

Illustrated on p. 213
Anonymous, double portrait with
pope and devil, c. 1600
Oil on wood
30.5 x 23.5 x 5 cm
Museum Catharijneconvent, Utrecht

Anonymous, *De Bello Belgico Decas
II Famiani Stradae Rom. Soc. Iesu*
(lion), 1647
Copperplate engraving
33.5 x 24 cm
Philographikon-Galerie, Rottenbuch

Illustrated on p. 157, bottom
Anonymous, composite elephant
with Indian princes and nobles,
seventeenth century
Opaque watercolor on paper
45.5 x 30.8 cm
Bibliothèque Nationale de France,
Paris

Illustrated on p. 158
Anonymous, composite elephant
ridden by a *diw*, album page (verso),
early seventeenth century
Ink on paper
45 x 70 cm
Bibliothèque Nationale de France,
Paris

Illustrated on p. 159
Anonymous (Mogul school),
composite camel, India, early
seventeenth century
Tinted brush drawing on paper
40 x 28 cm
Staatliche Museen zu Berlin,
Museum für Islamische Kunst

Illustrated on p. 254
Anonymous, image of the trinity—
triple face, southern Germany,
early seventeenth century
Oil on canvas
35.5 x 26 cm
Tiroler Volkskunstmuseum,
Innsbruck

Illustrated on p. 153
Anonymous (Deccan school),
composite horse, India, first half
of the seventeenth century
Opaque watercolor on paper
36.5 x 50 cm
Staatliche Museen zu Berlin,
Museum für Islamische Kunst

Anonymous, composite plant with
animal heads, northern India, Mogul
style, first half of the seventeenth
century
Pencil drawing on paper
23.8 x 13 cm
Staatliche Museen zu Berlin,
Museum für Islamische Kunst

Illustrated on p. 20, top
Anonymous, *Saint Isidore of Seville*,
seventeenth century
Oil on lapis lazuli, ebony, decorated
with lapis lazuli and gilded metal
37 x 25 cm
Giulini Collection, Milan / exhibited
2000–1 at Palazzo Reale, Milan /
featured in a film by Federico Zeri

Illustrated on p. 20, bottom
Anonymous, chest, Florence,
seventeenth century
Picture stone, painted, ebony, lapis
lazuli, and white marble
29 x 40 x 27 cm
Giulini Collection, Milan / exhibited
2000–1 at Palazzo Reale, Milan /
featured in a film by Federico Zeri

Anonymous, composite antelope,
nineteenth century
Watercolor on paper
11 x 15.5 cm
Sammlung Nekes, Mülheim an der
Ruhr

Anonymous, composite lion,
nineteenth century
Watercolor on paper
11 x 15.5 cm
Sammlung Nekes, Mülheim an der
Ruhr

Anonymous, composite horse,
nineteenth century
Watercolor on paper
11 x 15.5 cm
Sammlung Nekes, Mülheim an der
Ruhr

Illustrated on p. 163
Anonymous, illustration of the flows
within, (Neijingtu), Ching Dynasty,
China, nineteenth century
India ink on paper, mounted on silk
133 x 56 cm
Private collection

Anonymous, walking stick with
profile, nineteenth century
Ivory, ebony
87 x 2.5 cm
Sammlung Nekes, Mülheim an der
Ruhr

Anonymous, dancing figure,
nineteenth century
Root
Height: 19 cm
Musée National des Arts Asiatiques
Guimet, Paris

Anonymous, *Un bon vivant*, c. 1900
Print
8.9 x 13.4 cm
Puppentheatermuseum, Munich

Anonymous, 24 vignettes,
nineteenth century, France
Prints
Various dimensions
Musée National des Arts et
Traditions Populaires, Paris

Anonymous, eleven erotic fold-out
cards, c. 1905
Prints
20 x 9.5 cm
Private collection

Illustrated on p. 24
Anonymous, erotic folding card,
1905
Watercolor and Indian ink on paper
22 x 14 cm
Private collection

Illustrated on p. 185
Anonymous, erotic postcard, 1905
Color print on cardboard
14 x 8.5 cm
Private collection

Anonymous, *Femme et admirateur*
Woman and Admirer, c. 1905
Color print
14.2 x 9.2 cm
Private collection

Anonymous, *Abdul Hamid*, c. 1909
Phototype
13.5 x 8.5 cm
Private collection

Anonymous, *Untitled*, c. 1900–10
Colored pencils on paper
36 x 50.7 cm
abcd, Paris

Anonymous, *Cherchez le viveur*
Find the Bon Viveur, c. 1910
Phototype
13.5 x 8.5 cm
Private collection

Anonymous, *Diabolo*
Devil, c. 1910
Phototype
13.5 x 8.5 cm
Private collection

Anonymous, *Quel âge a-t-elle?*
How Old Is She?
Fold-out card, c. 1910
Watercolor on paper
9.1 x 6.7 cm
Private collection

Anonymous, *Tête de mort*
Death's-Head, c. 1910
Phototype
13.5 x 8.5 cm
Private collection

Anonymous, *Un diplomate*
A Diplomat, c. 1910
Phototype
14 x 9 cm
Private collection

Illustrated on p. 214
Anonymous, Shooting target, "Drei Hasen und der Ohren drei/und doch hat jeder ihrer zwei"
"Three rabbits and three ears / Yet each has two of them," Bavaria, c. 1910
Oil on wood
Diameter: 65 cm
Deutsches Jagd- und Fischerei-museum, Munich

Anonymous, mirror medallion with erotic motif, 1925
Mirror and cardboard pressed on metal
Diameter: 6 cm
Private collection

Anonymous, *Sinistre Trio*, c. 1935
Ink on paper
9 x 14 cm
Private collection

Illustrated on p. 209
Anonymous, Malangan mask (totem motif), New Ireland, 1939
Color painting on wood
Height: 122 cm
Musée Barbier-Mueller, Geneva

Anonymous, mandala, Czech, c. 1940
Colored pencils on paper
23.2 x 14.5 cm
abcd, Paris

Anonymous, ashtray with erotic motif, 1945
Faience
Diameter: 6 cm
Private collection

Illustrated on p. 12
Anonymous, figure, Sepik, Papua New Guinea, twentieth century
Painted wood
Height: 89.5 cm
Collection Cayetana & Anthony JP Meyer, Paris

Illustrated on p. 26, right
Anonymous, meat platter, Ugqoko, KwaZulu Natal, South Africa, twentieth century
Wood
Height: 34 cm
W. und U. Horstmann Sammlung

Illustrated on p. 26, left
Anonymous, spoon, Dan, Ivory Coast, twentieth century
Wood
Height: 46 cm
W. und U. Horstmann Sammlung

Illustrated on p. 183
Anonymous, Nimba, male fertility statue, Baga, Guinea, twentieth century
Wood
63 x 22 cm
Museum Rietberg, Villa Wesen-donck, Zurich, Gift of Eduard von der Heydt

Illustrated on p. 182, right
Anonymous, milk vessel, Zulu, South Africa, twentieth century
Wood
Height: 40 cm
W. und U. Horstmann Sammlung

Illustrated on p. 182, left
Anonymous, bowl in the form of a woman (Gbene), Jaba, or Ham, Nigeria, twentieth century
Wood
Height: 42 cm
W. und U. Horstmann Sammlung

Illustrated on p. 13
Anonymous, bird, Elek, Baga, Guinea, twentieth century
Wood
Height: 56 cm
Musée Dapper, Paris

Illustrated on p. 134
Giuseppe Arcimboldo, *The Bird Catcher*, c. 1570
Oil on canvas
125 x 70.5 cm
Sammlung Dr. Louis Peters

Illustrated on p. 146
Giuseppe Arcimboldo, *Allegory of Air*, c. 1572
Oil on canvas
75 x 56.6 cm
Private collection, Switzerland

Illustrated on p. 145
Giuseppe Arcimboldo, *Allegory of Fire*, c. 1572
Oil on canvas
75 x 56.6 cm
Private collection, Switzerland

Illustrated on p. 147
Giuseppe Arcimboldo, portrait of a man composed of fruit, c. 1580
Oil on canvas
55.9 x 41.6 cm
French & Company, New York

Illustrated on p. 141
Giuseppe Arcimboldo, *Flora*, c. 1591
Oil on wood
72.8 x 56.3 cm
Private collection

Illustrated on p. 132, right
Follower of Arcimboldo, *Adam*,
late sixteenth century
Oil on canvas
43 x 36 cm
Private collection, Switzerland

Illustrated on p. 132, left
Follower of Arcimboldo, *Eve*,
late sixteenth century
Oil on canvas
43.5 x 36 cm
Private collection, Switzerland

Illustrated on p. 142
Follower of Arcimboldo, *Allegory
of Spring*, seventeenth century
Oil on canvas
92 x 70 cm
Civico Museo d'Arte Antica—
Pinacoteca, Milan

Illustrated on p. 144
Follower of Arcimboldo, *Allegory
of Water*, c. 1565–70
Oil on canvas
63 x 53 cm
Musée d'Art Ancien—Musées
Royaux des Beaux-Arts de Belgique,
Brussels

Illustrated on p. 143
Follower of Arcimboldo, *Allegory of
Water*, c. 1600
Oil on canvas
82 x 65 cm
Private collection

Illustrated on p. 140
Follower of Arcimboldo, portrait
with flowers, c. 1600
Oil on canvas
82 x 65 cm
Private collection

Illustrated on p. 148
Follower of Arcimboldo, *Don
Quixote*, seventeenth century
Oil on wood
46 x 60.5 cm
Private collection, Switzerland

Illustrated on p. 170
Monika Bartholomé, *Gemischte
Gefühle*
Mixed Feelings, 2000
50 x 40 cm
Property of the artist

Christian Jakob Beer, *Die unglück-
liche Familie Ludewig XVI ist in vier
verborgenen Silhouetten [...] bei
dieser Guillotine in der Vollkomen-
sten Aehnlichkeit zu finden*
*The Unhappy Family of Louis XIV
Can Be Found in Four Hidden
Silhouettes [. . .] in This Guillotine,
in Most Perfect Likeness*, 1794
Etching
18 x 11 cm
Staatsbibliothek zu Berlin—
Preußischer Kulturbesitz

Illustrated on p. 186, top
Hans Bellmer, *Untitled*, c. 1939
Gouache, brown wash, watercolor,
pencil on paper mounted on
masonite
49.5 x 46.5 cm
Private collection, Switzerland

Illustrated on p. 186, bottom
Hans Bellmer, *Untitled*, 1941 (?)
Pencil and opaque white on paper
21.6 x 28.2 cm
Stiftung Sammlung Dieter Scharf
in Memory of Otto Gerstenberg,
Kupferstichkabinett Berlin

Illustrated on p. 187
Hans Bellmer, *Untitled*, 1946
Pencil on paper
16.3 x 24.5 cm
Stiftung Sammlung Dieter Scharf
in Memory of Otto Gerstenberg,
Kupferstichkabinett Berlin

Illustrated on p. 188
Hans Bellmer, *Untitled*, 1961
Pencil on paper
15 x 16.3 cm
Private collection, Switzerland

Illustrated on p. 167
Renato Bertelli, *Continuous Profile
of Mussolini*, 1932
Brass
Height: 9.5 cm
The Mitchell Wolfson Jr. Collection—
Fondazione Regionale C. Colombo,
Genoa

Illustrated on p. 135
Giovanni Battista Bracelli, *Bizzarie
di varie figure*, 1624
Facsimile prints, forty-five bound
sheets
8.5 x 10.5 cm
museum kunst palast, Düsseldorf

Werner Büttner and Albert Oehlen,
*Jenseits konstanter Bemühungen
um bruven Erfolg*
*Beyond Constant Efforts at Honest
Success*, 1983
Limited-edition leaflet
29.6 x 21 cm
Private collection

Johann Georg Bullmann (publisher),
16 geheime verborgene Silhouetten
Sixteen Hidden Silhouettes, 1795
Etching
10.5 x 15.3 cm
Germanisches Nationalmuseum,
Nuremberg

Illustrated on p. 198
Roman Cieslewicz, *La Joconde*
Mona Lisa, 1974
Silkscreen print
65 x 50 cm
Collection Chantal Petit-Cieslewicz,
Courtesy

Illustrated on p. 218
Tony Cragg, *Line of Thought*, 2002
Bronze
Height: 120 cm
Artist's collection

Illustrated on p. 220
Tony Cragg, *Secret Thought*, 2002
Bronze
Height: 85 cm
Artist's collection

Tony Cragg, *Two Moods*, 2002
Bronze
Height: 65 cm
Artist's collection

Illustrated on p. 205
Salvador Dalí, *Femme-cheval
paranoïaque*
Paranoiac Woman-Horse, 1930
Oil on canvas
50.2 x 65.2 cm
Centre Georges Pompidou, Paris,
Musée national d'art moderne/
Centre de création industrielle

Salvador Dalí, *Fantaisie érotique
sur les Prenoms de Paul (Éluard)
et de Gala: Dessin donné par Dalí
à Éluard*
*Erotic Fantasy on the Names Paul
(Éluard) and Gala*, 1932
Pen and ink on paper
24 x 33 cm
Private collection

Illustrated on p. 42
Salvador Dalí, *Minotaure* 1 (1933):
p. 65
31.5 x 52 cm
Kunstsammlung Nordrhein-
Westfalen, Düsseldorf

Illustrated on p. 68
Salvador Dalí, *Personnage surréal-
iste dans le paysage de Port Lligat*
*Surrealistic Figure in the Landscape
of Port Lligat*, 1933
Pencil on paper
106.6 x 76.2 cm
Salvador Dalí Museum,
St. Petersburg, Florida

Illustrated on p. 118
Salvador Dalí, illustration to
Les chants de Maldoror, c. 1933
Pencil on paper
22 x 16 cm
Staatsgalerie Stuttgart — Graphic
Collection

Illustrated on p. 43
Salvador Dalí, *Hommage à
Millet: Dessin dédicacé à Cécile
amicalement*
*Homage to Millet—for Cécile, in
Friendship*, 1934
Indian ink on paper
19 x 12 cm
Salvador Dalí Museum,
St. Petersburg, Florida

Illustrated on p. 230
Salvador Dalí, *Le grand para-
noïaque*
The Great Paranoiac, 1936
Oil on canvas
62 x 62 cm
Museum Boijmans van Beuningen,
Rotterdam

Illustrated on p. 54
Salvador Dalí, *Untitled* (donkey's
head), 1936
Indian ink on paper
18.1 x 23.2 cm
Salvador Dalí Museum,
St. Petersburg, Florida

Illustrated on p. 168
Salvador Dalí, study for *Espagne*
Study for *Spain*, 1936
Pencil and ink on paper
77.7 x 57.8 cm
Fundació Gala-Salvador Dalí,
Figueras

Illustrated on p. 69
Salvador Dalí, *Cygnes reflétant des
éléphants*
Swans Reflecting Elephants, 1937
Oil on canvas
51 x 57 cm
Private collection

Illustrated on p. 202
Salvador Dalí, *L'énigme sans fin*
The Endless Enigma, 1938
Oil on canvas
114.3 x 144 cm
Museo Nacional Centro de Arte
Reina Sofía, Madrid

Illustrated on p. 203, bottom right
Salvador Dalí, *Mythological Beast*,
study for *The Endless Enigma*, 1938
Pencil and ink on plaster
24.9 x 32.4 cm
Fundació Gala-Salvador Dalí,
Figueras

Illustrated on p. 204, top left
Salvador Dalí, study for
The Endless Enigma, 1938
Pencil on canvas on plaster
20 x 25 cm
Fundació Gala-Salvador Dalí,
Figueras

Illustrated on p. 204, bottom right
Salvador Dalí, *Greyhound*;
study for *The Endless Enigma*,
c. 1938
Ink on paper
25.5 x 32.5 cm
Fundació Gala-Salvador Dalí,
Figueras

Illustrated on p. 204, top right
Salvador Dalí, *Greyhound*;
study for *The Endless Enigma*,
c. 1938
Pencil on canvas on plaster
20 x 25 cm
Fundació Gala-Salvador Dalí,
Figueras

Illustrated on p. 203, bottom left
Salvador Dalí, *Mandolin, Fruit Dish
with Pears, Two Figs on a Table*;
study for *The Endless Enigma*, 1938
Pencil and ink on paper
25.7 x 32.8 cm
Fundació Gala-Salvador Dalí,
Figueras

Illustrated on p. 203, top right
Salvador Dalí, *Philosopher
Reclining*;
study for *The Endless Enigma*, 1938
Ink on paper
25 x 32.9 cm
Fundació Gala-Salvador Dalí,
Figueras

Illustrated on p. 204, bottom left
Salvador Dalí, *Beach at Cape Creus
with Seated Woman Seen from the
Back Mending a Sail, and Boat*;
study for *The Endless Enigma*, 1938
Ink on paper
25 x 32.5 cm
Fundació Gala-Salvador Dalí,
Figueras

Illustrated on p. 203, top left
Salvador Dalí, *Face of the Great
Cyclopean, Cretin*;
study for *The Endless Enigma*, 1938
Pencil and ink on paper
25.1 x 33.1 cm
Fundació Gala-Salvador Dalí,
Figueras

Salvador Dalí, *Each Evening the
Skyscrapers of New York Assume
the Anthropomorphic Shapes
of Multiple Gigantic Millet's
Angeluses*;
illustration for *The Secret Life of
Salvador Dalí*, 1938
Pen and ink drawing on paper
6.7 x 12.2 cm
M. A. N. International Arts Holding
Corps.

Illustrated on p. 116
Salvador Dalí, *L'image disparaît
The Image Disappears*, 1938
Oil on canvas
56.3 x 50.5 cm
Fundació Gala-Salvador Dalí,
Figueras

Illustrated on p. 25
Salvador Dalí, study for *L'image
disparaît*
Study for *The Image Disappears*,
1938
Pencil and ink on paper
65.7 x 51.4 cm
Fundació Gala-Salvador Dalí,
Figueras

Illustrated on p. 193
Salvador Dalí, *Plage enchantée
avec trois grâces fluides
Enchanted Beach with Three Fluid
Graces*, 1938
Oil on canvas
65 x 81 cm
Salvador Dalí Museum,
St. Petersburg, Florida

Illustrated on p. 117
Salvador Dalí, *Métamorphose d'un buste d'homme en scène inspirée par Vermeer—La triple Image Metamorphosis of a Man's Bust in a Scene Inspired by Vermeer: The Triple Image*, 1939
Ink on paper
63 x 48.4 cm
Fundació Gala-Salvador Dalí, Figueras

Illustrated on p. 24
Salvador Dalí, *Métamorphose d'un buste d'homme en scène inspirée par Vermeer—La triple Image Metamorphosis of a Man's Bust into a Scene Inspired by Vermeer: The Triple Image*, 1939
Ink on paper
63.5 x 48.5 cm
Fundació Gala-Salvador Dalí, Figueras

Illustrated on p. 246, bottom
Salvador Dalí, study for *Les trois âges (La vieillesse, l'adolescence, l'enfance)*
Study for *Old Age, Adolescence, Infancy (The Three Ages)*, 1940
Pencil on paper
48 x 63 cm
Salvador Dalí Museum, St. Petersburg, Florida

Illustrated on p. 119
Salvador Dalí, *Doubles images*, c. 1940
Ink on cardboard
17.7 x 38.9 cm
Fundació Gala-Salvador Dalí, Figueras

Illustrated on p. 250
Salvador Dalí, *Double image avec squelettes Double Image with Skeletons*, c. 1940
Charcoal on paper
35 x 75 cm
Fundació Gala-Salvador Dalí, Figueras

Illustrated on p. 119, top
Salvador Dalí, *Double image: Profil classique et une personne Double Image: Classical Profile and a Person*, c. 1940
Pencil on paper
18.4 x 13.7 cm
Fundació Gala-Salvador Dalí, Figueras

Illustrated on p. 25
Salvador Dalí, *False Memory in the Shape of a Spoon*, illustration for *The Secret Life of Salvador Dalí*, c. 1940
Pen and ink drawing on paper
15 x 16.7 cm
M. A. N. International Arts Holding Corps.

Illustrated on p. 169
Salvador Dalí, "*. . . become uninterruptedly something else . . . ,*" illustration for *The Secret Life of Salvador Dalí*, 1941
Pen and ink drawing on paper
8.5 x 9 cm
M. A. N. International Arts Holding Corps.

Illustrated on p. 73
Salvador Dalí, study for *Disparition du buste de Voltaire*
Study for *The Disappearing Bust of Voltaire*, 1941
Gouache, pencil, and Indian ink on paper
50.9 x 66 cm
Fundació Gala-Salvador Dalí, Figueras

Illustrated on p. 248
Salvador Dalí, *Scène de café Café Scene*, drawing for the film *Moontide* by Alfred Hitchcock, 1941
Pencil and ink on paper
13.6 x 12.6 cm
Fundació Gala-Salvador Dalí, Figueras

Illustrated on p. 249
Salvador Dalí, *Visage de la Guerre Face of War*, drawing for the film *Moontide* by Alfred Hitchcock, 1941
Pencil and ink on paper
17.5 x 13.2 cm
Fundació Gala-Salvador Dalí, Figueras

Illustrated on p. 72
Salvador Dalí, *Portrait de Madame Isabel Styler-Tas (Melancolía) Portrait of Mrs. Isabel Styler-Tas*, 1945
Oil on canvas
65.5 x 86 cm
Staatliche Museen zu Berlin, Nationalgalerie

Illustrated on p. 197
Salvador Dalí, Sketch for the Walt
Disney film *Destino*, c. 1946
Collage, pencil, and watercolor
on paper
31.9 x 39.5 cm
Fundació Gala-Salvador Dalí,
Figueras

Illustrated on p. 46
Salvador Dalí, *Tête raphaëlesque
éclatée
Raphaelesque Head Exploded*, 1951
Oil on canvas
43 x 33 cm
Scottish National Gallery of Modern
Art, Edinburgh

Illustrated on p. 45
Salvador Dalí, *La Madone de
Raphaël à la vitesse maximum
The Maximum Speed of Raphael's
Madonna*, 1954
Oil on canvas
81.2 x 66 cm
Museo Nacional Centro de Arte
Reina Sofía, Madrid

Illustrated on p. 47
Salvador Dalí, *Peinture para-
noïaque-critique de la Dentellière
de Vermeer
Paranoiac-Critical Study of
Vermeer's Lace Maker*, 1955
Oil on canvas
27 x 22 cm
Solomon R. Guggenheim Museum,
New York, anonymous gift, 1976

Illustrated on p. 192
Salvador Dalí, *Les métamorphoses
érotiques*, 1965
Etching
32.5 x 25 cm
Herzog-August-Bibliothek,
Wolfenbüttel

Illustrated on p. 110
Salvador Dalí, *Untitled* (anamorphic
image, harlequin), 1972
Lithograph
75 x 54.3 cm
Fundació Gala-Salvador Dalí,
Figueras

Illustrated on p. 190
Salvador Dalí, *Untitled* (anamorphic
view of a female nude), 1972
Lithograph
75 x 56 cm
Fundació Gala-Salvador Dalí,
Figueras

William Degouve de Nuncques,
Forêt fantastique, 1900
Oil on canvas
126 x 293 cm
Private collection

Illustrated on p. 231
Jean Dubuffet, *La gigue irlandaise
Irish Jig*, 1961
Oil on canvas
114 x 146 cm
Centre Georges Pompidou, Paris,
Musée national d'art moderne/
Centre de création industrielle

Illustrated on p. 70
Reproduction of Marcel Duchamp,
*Allégorie de genre (George
Washington)
Genre Allegory (George
Washington)*, 1943
31.8 x 24 cm
Jean-Luc Thierry Collection

Illustrated on p. 22
Marcel Duchamp, study for the title
page of the journal *Minotaure*, 1935
Ink on paper
14.5 x 24.5 cm
Private collection, Geneva

Illustrated on p. 52
Marcel Duchamp, study for the back
cover of the journal *Minotaure*, 1935
Ink on paper
14.5 x 24.5 cm
Private collection, Geneva

Illustrated on p. 74
Max Ernst, *Fascinant cyprès
The Fascinating Cypress*, c. 1940
Oil on cardboard
31 x 25 cm
Sprengel Museum, Hanover

Illustrated on p. 75
Max Ernst, *The Meal of the Sphinx*,
1940
Oil on canvas
25.5 x 30.5 cm
Landesmuseum für Kunst und
Kulturgeschichte, Oldenburg

Meister E. S., the letter "R," from
a figural alphabet, c. 1460
Copperplate engraving
13.9 x 17.1 cm
Staatliche Museen zu Berlin,
Kupferstichkabinett

Meister E. S., the letter "S," from
a figural alphabet, c. 1460
Copperplate engraving
14.2 x 17.5 cm
Staatliche Museen zu Berlin,
Kupferstichkabinett

Illustrated on p. 216
M. C. Escher, *Up and Down*, 1947
Lithograph
50.3 x 20.5 cm
Museum voor Moderne Kunst,
Arnheim

Illustrated on p. 215
M. C. Escher, tapestry with fish
and birds, 1949–50
Woven textile
300 x 123 cm
Museum voor Moderne Kunst,
Arnheim

Bernard Gaillot, *Crafts and
Professions*;
collection of caricatures, printed by
Aloys Senefelder (twelve composite
puzzles), c. 1820
Lithograph
Each 28 x 19 cm
Sammlung Nekes, Mülheim an der
Ruhr

Illustrated on p. 152
Noël Garnier, letter from a figural
alphabet, c. 1540
Copperplate engraving
49 x 32 cm
Bibliothèque Nationale de France,
Paris

Illustrated on p. 15, right
Heinrich Göding (?),
Allegory of Air, c. 1600
Gouache on blue tinted paper
24 x 16.9 cm
Germanisches Nationalmuseum,
Nuremberg

Illustrated on p. 15, left
Heinrich Göding (?),
Allegory of Fire, c. 1600
Gouache on red tinted paper
24 x 16.6 cm
Germanisches Nationalmuseum,
Nuremberg

Gowan's Art Book, vol. 46, *The
Masterpieces of De Hooch and
Vermeer*, 1911
15 x 10 cm
Fundació Gala-Salvador Dalí,
Figueras

Illustrated on p. 251
Philippe Halsmann and Salvador
Dalí, *In Voluptate Mors*, 1951
Photograph
34.5 x 27 cm
Philippe Halsman Archive,
New York

Illustrated on p. 88
Thomas Henninger, *Wiegenlied 2
Lullaby 2*, 2001
Oil and acrylic on canvas
Four parts, each 270 x 200 cm
Artist's collection

Volkmar Herre, from the cycle *Der
Baum und Ich, Vilm, 8. November
1994*
From the cycle *The Tree and I, Vilm,
8 November 1994*
Photograph on aludibond
100 x 75 cm
Artist's collection

Volkmar Herre, from the cycle *Der
Baum und Ich, Vilm, 8. September
1995*
From the cycle *The Tree and I, Vilm,
8 September 1995*
Photograph on aludibond
130 x 100 cm
Artist's collection

Illustrated on p. 199
Volkmar Herre, from the cycle
*Der Baum und Ich, Vilm,
18. September 1995*
From the cycle *The Tree and I, Vilm,
18 September 1995*
Photograph on aludibond
100 x 130 cm
Artist's collection

Volkmar Herre, from the cycle
*Der Baum und Ich, Vilm,
23. November 1995*
From the cycle *The Tree and I, Vilm,
23 November 1995*
Photograph on aludibond
100 x 75 cm
Artist's collection

Illustrated on p. 217
William Hogarth, frontispiece to
*Dr. Brook Taylor's Method of
Perspective* by Joshua Kirby, 1754
Copperplate engraving
20.8 x 17.2 cm
Sammlung Nekes, Mülheim an
der Ruhr

Illustrated on p. 188
Katsushika Hokusai, erotic drawing,
nineteenth century
Indian ink and watercolor on paper
26.5 x 21 cm
Private collection, Switzerland

Theodor Hosemann, *Das allergrößte
Bilder-ABC*, Verlag der litho-
grafischen Anstalt Winckelmann &
Söhne, Berlin, c. 1828
Twenty-two bound color lithographs
Each 40.2 x 32.2 cm
Staatliche Museen zu Berlin,
Museum Europäischer Kulturen

Vojislav Jakic, *Untitled*, c. 1980
Indian ink on paper
44.7 x 33 cm
abcd, Paris

Michael Kalmbach, *Untitled*, 2000
Watercolor on paper
150 x 100 cm
Museum für Moderne Kunst,
Frankfurt am Main

Illustrated on p. 57
Michael Kalmbach, *Untitled*, 2002
Watercolor on paper
117.5 x 150 cm
Artist's collection

Andreas Kordenbusch, platter
decorated with a landscape of
heads, before 1754
Faience
25 x 35 cm
Museum für Angewandte Kunst,
Cologne

Illustrated on p. 150
Milan Kunc, *Kulinarischer Kopf
Culinary Head*, 1976
Oil on canvas
104 x 89 cm
Artist's collection

Milan Kunc, *Cross the Badland*, 1995
Oil and gold leaf on canvas
190 x 220 cm
Artist's collection

Illustrated on p. 184
Utagawa Kuniyoshi, *He Seems
Frightful at First Glance but
He Is a Nice Man*, c. 1847–8
Woodcut
36.5 x 24.3 cm
museum kunst palast, Düsseldorf,
Graphic Collection

Utagawa Kuniyoshi, *Although She
May Seem Old, She Is Very Young*,
c. 1847–8
Woodcut
36.5 x 24.3 cm
museum kunst palast, Düsseldorf,
Graphic Collection

Illustrated on p. 88
Suzanne Lafont, *Les gardiens
The Guards*, 1993
Photograph
123 x 98 cm
Galerie de France, Paris

Illustrated on p. 234
Carl Lange, *Das heilige Schweiß-
wunder in der Einlegsohle
The Holy Sweat Miracle in the
Insole*, 1898
Pencil on paper
49.7 x 35.5 cm
Sammlung Prinzhorn, Psychiatrische
Universitätsklinik, Heidelberg

Illustrated on p. 136
Nicolas de Larmessin (?),
24 illustrations of various
professions, c. 1750
Copperplate engravings
26.5 x 18.5 cm
Antiquariat Gebr. Haas, Bedburg-
Hau

Lassalvy, *Les petits . . . vont bien
The Little Ones . . . Are Doing Well*,
c. 1960
Print
15.5 x 10.5 cm
Private collection

Lassalvy, *Seul avec vous . . . dans
le désert
Alone with You . . . in the Desert*,
c. 1960
Print
15.5 x 10.5 cm
Private collection

Illustrated on p. 169
Jean-Jacques Lebel, *Caudillo's
Wife Looking at the "Avida Dollar,"*
1961
Assemblage, wood, plastic, and
metal
58.5 x 60 cm
Private collection

Illustrated on p. 84/85
Jean Le Gac,
Les rochers; ou, L'esclade
The Rocks; or, The Ascent, 1973
Collage
105 x 230 cm
Artist's collection

Illustrated on p. 90
Li Longmian, *The Legend of*
Guizimu, 1081
Ink on paper
29.8 x 548.5 cm
Musée National des Arts Asiatiques
Guimet, Paris

Illustrated on p. 79
Jacopo Ligozzi, *Mary Magdalene in*
the Desert, sixteenth century
Oil on alberese stone (picture stone)
20.3 x 29 cm
Giulini Collection, Milan / exhibited
2000–1 at Palazzo Reale, Milan /
featured in a film by Federico Zeri

Illustrated on p. 236
Raphaël Lonné, *Untitled*, c. 1960
Pencil on paper
32 x 24 cm
abcd, Paris

Raphael Lonné, *Untitled*, 1963
Indian ink and pencil on paper
25 x 33.5 cm
Collection de l'Art Brut, Lausanne

Lubos PLNY, *Untitled* (large
organism), c. 2001
Colored wash on paper
91 x 69 cm
abcd, Paris

Ma Dezhao, *The God of Literature*,
c. 1870
Stone rubbing
190 x 73 cm
Private collection

Illustrated on p. 191
René Magritte, *Le viol*
The Rape, 1934
Pencil on paper
36.5 x 25 cm
The Menil Collection, Houston

Illustrated on p. 220
Raoul Marek, double portrait project
Fifty Vases and their Locations,
Sabine/Daphnée 6/50, Mania/Bern-
hard 5/50, Bernhard/Julia 7/50, 2000
Porcelain
Each 30 cm high
Private collection, Switzerland

Illustrated on p. 83
Andrea Meldolla (known as
La Schiavone), *Christ Supported*
by an Angel,
first half of the sixteenth
century
Oil on alabaster
17 x 22 cm
Giulini Collection, Milan / exhibited
2000–1 at Palazzo Reale, Milan /
featured in a film by Federico Zeri

Illustrated on p. 66
Matthäus Merian the Younger
(attributed), anthropomorphic
landscape, c. 1650
Watercolor on paper
35 x 45 cm
Sammlung Nekes, Mülheim an der
Ruhr

Illustrated on p. 67
Josse de Momper, anthropomorphic
landscape, early seventeenth
century
Oil on wood
19 x 25 cm
Private collection, Switzerland

Illustrated on p. 65
Josse de Momper, *Allegory of*
Winter, seventeenth century
Oil on canvas
52.5 x 39.6 cm
Private collection

Illustrated on p. 63
Josse de Momper, *Allegory of*
Summer, seventeenth century
Oil on canvas
52.5 x 39.6 cm
Private collection

Illustrated on p. 64
Josse de Momper, *Allegory of*
Autumn, seventeenth century
Oil on canvas
55 x 39.6 cm
Private collection

Illustrated on p. 62
Josse de Momper, *Allegory of*
Spring, seventeenth century
Oil on canvas
55 x 39.6 cm
Private collection

Illustrated on p. 150
Emmett Williams, *Food Faces –*
Portraits of the artist, who comes
from proud but honest stock,
and who regards himself as a
man of the left, within reason,
impersonating some of the crowned
and uncrowned heads of past
and present. The pharaoh is easy
to recognize – is it Amenhotep III
or Tutankhamun? No matter,
he is easily confused with Louis XIV,
1984
Collage and tempera
50 x 72 cm
Sammlung Walter und Maria
Schnepel, Neues Museum
Weserburg, Bremen

Emmett Williams, *Food Faces –*
Portraits of the artist as mnemonic
devices to help him remember
important historical dates and
facts, although he forgets which is
supposed to remind him of what,
except for the salamic reference to
Caesar's Gallic Wars. The garlic in
the salami reminds him of Gallic,
and Gallia is divided into three
parts – or rather it was in Caesar's
era., 1984
Collage and tempera
50 x 72 cm
Sammlung Walter und Maria
Schnepel, Neues Museum
Weserburg, Bremen

Scottie Wilson, *Untitled*, c. 1930
Indian ink on paper on cardboard
31.5 x 23.5 cm
abcd, Paris

Illustrated on p. 235
Scottie Wilson, *Self-Portrait*, 1940
Colored Indian ink on paper
21 x 28.5 cm
abcd, Paris

Illustrated on p. 233
Unica Zürn, *Untitled*, 1966
Pen and ink drawing on paper
38 x 25 cm
Collection Bihl-Bellmer

WE WOULD LIKE TO EXPRESS OUR THANKS TO THE FOLLOWING LENDERS:

Sammlung Sylvio Perlstein, Antwerp

Museum voor Moderne Kunst, Arnhem
Max Meijer

Antiquariat Gebr. Haas, Bedburg-Hau

Galerie Michael Haas, Berlin
Dr. Erika Költzsch

Kuckei + Kuckei, Berlin
Ben and Hannes Kuckei

Kupferstichkabinett, Staatliche Museen zu Berlin
Prof. Dr. Hein-Th. Schulze Altcappenberg
and Dr. Michael Roth

Museum Europäischer Kulturen, Staatliche Museen zu Berlin
Prof. Dr. Konrad Vanja

Museum für Indische Kunst, Staatliche Museen zu Berlin
Prof. Dr. Marianne Yaldiz

Museum für Islamische Kunst, Staatliche Museen zu Berlin, Preußischer Kulturbesitz, Berlin
Prof. Dr. Claus-Peter Haase

Nationalgalerie, Staatliche Museen zu Berlin
Prof. Dr. Peter-Klaus Schuster

Staatsbibliothek zu Berlin, Preußischer Kulturbesitz, Berlin
Dr. Antonius Jammers
and Dr. Hartmut-Ortwin Feistel

Stiftung Sammlung Dieter Scharf zur Erinnerung an Otto Gerstenberg, Kupferstichkabinett, Berlin
Julietta Scharf

Stiftung Kunst Heute, Berne
Dr. Marianne Gerny-Schild

Museum Charlotte Zander, Schloss Bönnigheim
Charlotte Zander

Sammlung Maria und Walter Schnepel, Neues Museum Weserburg, Bremen
Walter Schnepel

Galerie Rodolphe Janssen, Brussels

Musées Royaux des Beaux-Arts de Belgique – Musée d'Art Ancien, Brussels
Dr. Eliane de Wilde

Kunstsammlungen der Veste Coburg
Dr. Christiane Wiebel

Galerie Gmurzynska, Cologne
Krystyna Gmurzynska

Galerie Susanne Zander, Cologne
Susanne Zander

Museum für Angewandte Kunst, Cologne
Dr. Susanne Anna

Museum für Ostasiatische Kunst, Cologne
Dr. Adele Schlombs

Sammlung Louis Peters, Cologne
Dr. Louis Peters

Sammlung Schiefer, Cologne

Galerie Michael Cosar, Düsseldorf

Kunstsammlung Nordrhein-Westfalen, Düsseldorf
Prof. Dr. Armin Zweite

Scottish National Gallery of Modern Art, Edinburgh
Timothy Clifford

PHOTO CREDITS

This catalog is published on the occasion of the exhibition *The Endless Enigma: Dalí and the Magicians of Multiple Meaning* in the museum kunst palast, Düsseldorf (22 February 2003 – 9 June 2003).

EXHIBITION

Curators
Jean-Hubert Martin
Stephan Andreae
Project manager
Uta Husmeier
Architecture
Stephan Andreae
Mattijs Visser
Lighting
Gerhard Graef
Registrars
Dorothea Nutt
Corinna Gramatke

CATALOG

Concept
Stephan Andreae
Editors
Uta Husmeier
Heidi Irmer
Andreas Zeising
Assistant editor
Alessia Mesirca
Copy-editing
Meredith Dale
Graphic design, layout, and typesetting
Karsten Moll, Kommunikationskontor_Düsseldorf
Cover design
Andreas Platzgummer
Reproduction
Repro Wuchert Computer Publishing GmbH, Bochum
Printed by
Dr. Cantz'sche Druckerei, Ostfildern-Ruit

Authors of short texts
StA Stephan Andreae
UH Uta Husmeier
HI Heidi Irmer
DS Dieter Scholz
AZ Andreas Zeising
Artists' biographies edited by Heidi Irmer

Translations
Pauline Cumbers (catalog texts), Anne Heritage (essays Claudia Dichter, Elisabeth Bronfen) Steven Lindberg (forewords, essays Stephan Andreae, Karin Rührdanz, appendix, and all other parts), John O'Toole (essay Jean-Hubert Martin), John Wheelwright (catalog texts)

MUSEUM KUNST PALAST, DÜSSELDORF

General Director
Jean-Hubert Martin
Managing Director
Angela Eckert-Schweizer
Head of Collections
Helmut Ricke
Head of Exhibitions
Mattijs Visser
Head of Marketing and Communication
Bert Antonius Kaufmann
Head of Education
Silvia Neysters
Head of Cultural Development
Marie Luise Syring
Head of the Technical Department
Igor Kustos
Head of the Robert-Schumann-Saal
Eckart Schulze-Neuhoff
Personal Assistant to the Director
Dieter Scholz
Restoration Advisers
Restaurierungszentrum der Landeshauptstadt Düsseldorf, Donation Henkel

powered by

The museum kunst palast Foundation is a public-private partnership between the City of Düsseldorf, E.ON AG, METRO Group, and degussa AG.

This catalog is published by
Hatje Cantz Publishers
Senefelderstraße 12
73760 Ostfildern-Ruit
Germany
Tel. ++49/711/4 40 50
Fax ++49/711/4 40 52 20
www.hatjecantz.de

Distribution in the US
D.A.P., Distributed Art Publishers, Inc.
155 Avenue of the Americas, Second Floor
USA-New York, N.Y. 10013-1507
Tel. ++1/2 12/6 27 19 99
Fax ++1/2 12/6 27 94 84

ISBN 3-7757-1283-6

Printed in Germany

Frontispiece
Salvador Dalí, *L'Enigme sans fin*
The Endless Enigma, 1938
Oil on canvas
114.3 x 144 cm
Museo Nacional Centro de Arte Reina Sofía, Madrid

Front cover
Salvador Dalí, *Cygnes refletant des éléphants*
Swans Reflecting Elephants, 1937
Oil on canvas
51 x 77 cm
Private collection